# FIGURE DRAWING
# WITHOUT A MODEL

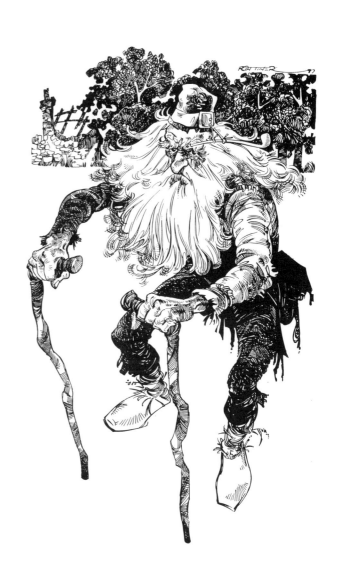

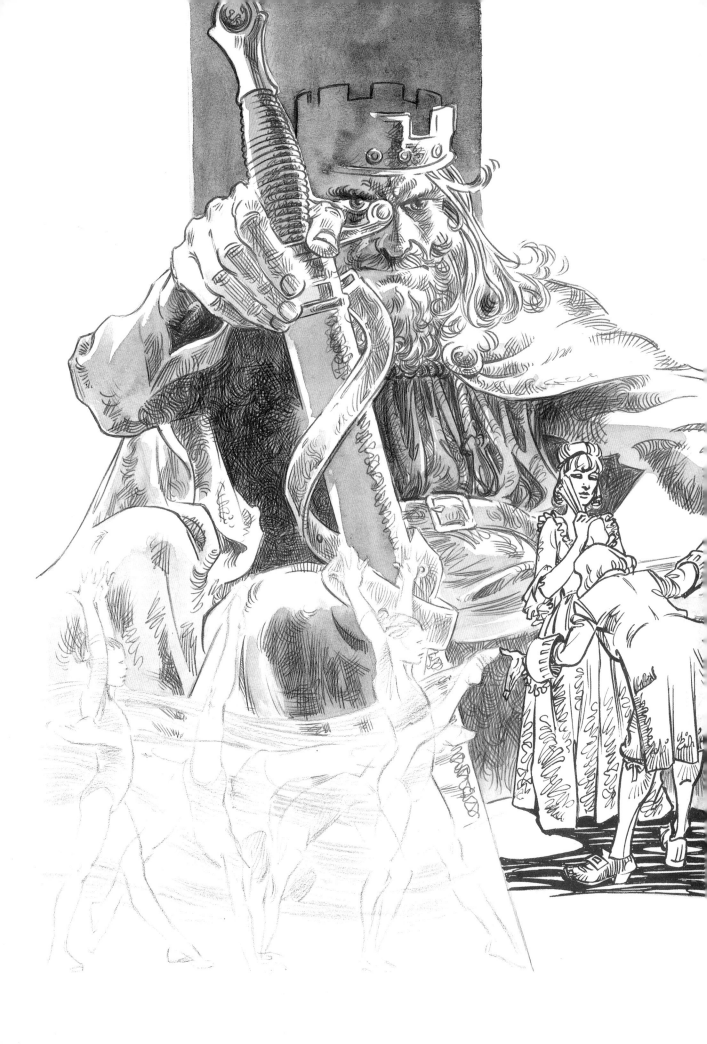

# FIGURE DRAWING
# WITHOUT A MODEL

## RON TINER

**David & Charles**

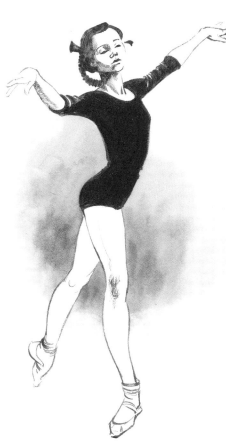

# Dedication

To Rikki. Without her it would never have been written.

*With the obvious exception of those on pages 7, 48, 88, 89, l06 and 116, the illustrations in this book are by the author, who owns all copyright unless otherwise stated.*

**British Library Cataloguing in Publication Data**

Tiner, Ron
   Figure drawing without a model
   I. Title
   743

ISBN 0–7153–9785–0

Pre-press production by John Youé, Honiton
Printed by Collins, Glasgow
for David & Charles plc
Brunel House  Newton Abbot  Devon

# CONTENTS

# INTRODUCTION

This book is about drawing creatively. It will show you how to use your imagination to create drawings that go beyond what may be set up or posed in a studio and drawn from observation – in other words, how to create drawings that originate in the mind.

This is not something that only the artistically gifted can achieve: it is possible for anybody. When an artist is described as 'gifted', 'talented', 'creative' or 'original', it is usually implied that his or her ability is very rare and somehow magically endowed at birth. Most practical books on drawing tend, however unintentionally, to reinforce this myth. Their authors usually avoid the notion of creativity, concentrating almost exclusively upon tuition in drawing from observation of a posed model, a still life or a landscape. On rare occasions they may go so far as to suggest using photographs as a basis for drawing but, aware that this can lead to sterile, lifeless results, mention the practice only as a last resort. Creativity, it seems, is the exclusive domain of that rara avis, the talented genius, who presumably doesn't need to read how-to-do-it books!

But, however uncommon such talented geniuses might be, imaginative creative artists most certainly are not. Each of us has the natural ability to conceive pictures in our mind.

If this were not the case we wouldn't read books of fiction, for in order to understand the narrative we have to be able to imagine the fictional events, settings and characters as if they were real. These imagined scenes may not be so clearly visualized as to be like a videotape playing inside our heads, but the substance is there. If we develop the necessary skills, we can use such mental pictures as sources for creative drawing.

Drawing without a model is usually referred to as memory drawing, but this term is rather misleading, because it seems to imply copying memorized images in the same way that one would draw from life. The images stored in the mind may seem to be

*From top*: Life drawing; real size 45cm (17¾in) across; sketchbook drawing reproduced at actual size; preliminary drawing for Thera – The Last Key, written by Bernard King.

visual, but as soon as we try to draw them they become elusive, and the resulting drawings can all too easily degenerate into clichés, devoid of any merit and containing little or nothing of the grand designs that the mind originally conceived.

What is needed, then, is a means of making accessible the information stored in the mind. The memory is teeming with envisaged and remembered scenes and events – some rooted in real experiences, others in films we have seen or books we have read, and still others born from the imagination in the form of wishes, hopes or fears. In this book I am going to show you a means of tapping this vast resource for the purposes of your own self-expression.

In choosing the human figure, I realize that I am selecting what is generally regarded as the most difficult subject of all to draw. Why should this be? After all, you probably know more about the human figure than about anything else in the world. This is knowledge which you have continually absorbed, without ever consciously thinking about it, throughout your life. You know how to perform very sophisticated actions using your body – you can stand upright without falling over, and you can walk, run, throw, kick, dance . . .

However, when you come to draw these actions, the learning of a lifetime is not immediately accessible to you in any usable form. This is because it is categorized in your mind as a set of physical skills, and is available to you only when you actually want to perform the relevant activity. The knowledge is so firmly and exclusively placed in your mind's 'useful skills' pigeonhole that it is impossible for you to extract it for use in drawing. You *know* this information with absolute certainty but, although any drawing you saw of the figure in action that didn't have things spot on would immediately look wrong to you, you would probably have great difficulty explaining just *why* this should be. This is why, as you read this book, you'll probably find that much of its content seems familiar to you—and yet, at the same time, fresh. You already *know* the information, but you may never have thought about it in a rational, analytical fashion.

A human figure is almost invariably one of the first things children attempt to draw. They do so uninhibitedly, without feeling the need to refer to a posed model: indeed, such a notion would most likely seem quite alien to them. At the top of this page is a child's drawing of her mother. In it, the important parts, such as the smile and the outstretched arms ready to give a hug, are drawn very prominently; while less important details, such as the neck, knees and elbows, are left out altogether. These were not relevant to the child because she was not trying to draw an accurate portrait; instead, she was drawing what her mother meant to her—her emotional response to her thoughts about her mother. The only effect the presence of a posed model might have had on this process would have been to hamper it.

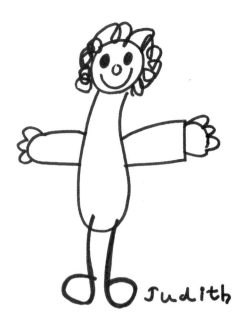

*A six-year-old's drawing of her mother.*

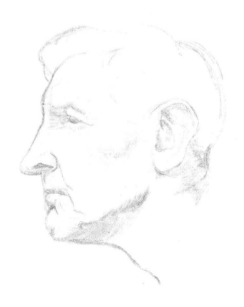

*Portrait drawing of my father.*

This concept of what a drawing is for is a contentious one. Obviously the drawing has to bear *some* resemblance to its subject, or no one would know what it was about! However, when you are drawing from a posed model the need to concentrate on close observation tends to close the door to your imagination. So, while the life class is an extremely important – probably the most important – contributor to an artist's experience, it can limit you if your figure work is exclusively done there. If this limitation is not recognized, life drawing can, rather than provide a springboard for creativity, begin to set parameters that are unnecessarily narrow.

A human figure is the most expressive single image available to the artist, and the most suitable for meaningful imaginative interpretations. We can draw anything in the world, if we know what it looks like, but only when we draw human beings can we truly claim that we know also what they *feel* like. When we draw the human figure, we are in reality drawing our experience of the world, and by subtle expressive means we can give visual form to our emotional responses. We may emphasize, stretch and distort its universally known proportions in order more easily to convey our understanding of what it is to be human.

One of the aims of this book is to develop the use of drawing as a catalyst for your imagination. Through drawing practice, both with and without a model, the very act of drawing can become the key that opens up your mind so that the flow of your ideas is facilitated and, consequently, your creativity grows.

I believe that all of us have within us the seeds of this ability. Where drawing is concerned, no one is excluded: anyone can do it. But, as with any other skill, doing it *well* demands practice – preferably structured practice, and plenty of it. The more you

**Above:** *Illustration for a magazine article on clinical depression.*
**Below:** *Two character sketches for a graphic-novel version of* Oliver Twist.

draw, the better you will become at it and the more you will unleash your own unique creativity so that your results will become infused with your own originality and individuality.

In this book we shall therefore examine the basic mechanics of imaginative drawing, limiting ourselves to that which is demonstrable. Since I am an illustrator by trade, the drawings I produce professionally should be accessible to the non-artist: I am concerned with a mode of drawing that stays close to what the normal eye can see. It is up to you, the reader, to take whatever heady flights of fancy you choose, but I hope that in these pages you will find out how to unfurl your wings.

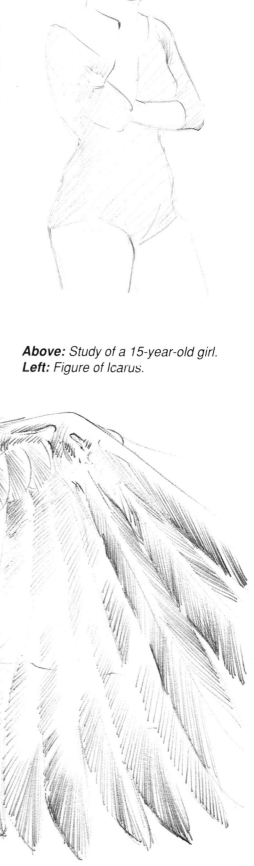

**Above:** *Study of a 15-year-old girl.*
**Left:** *Figure of Icarus.*

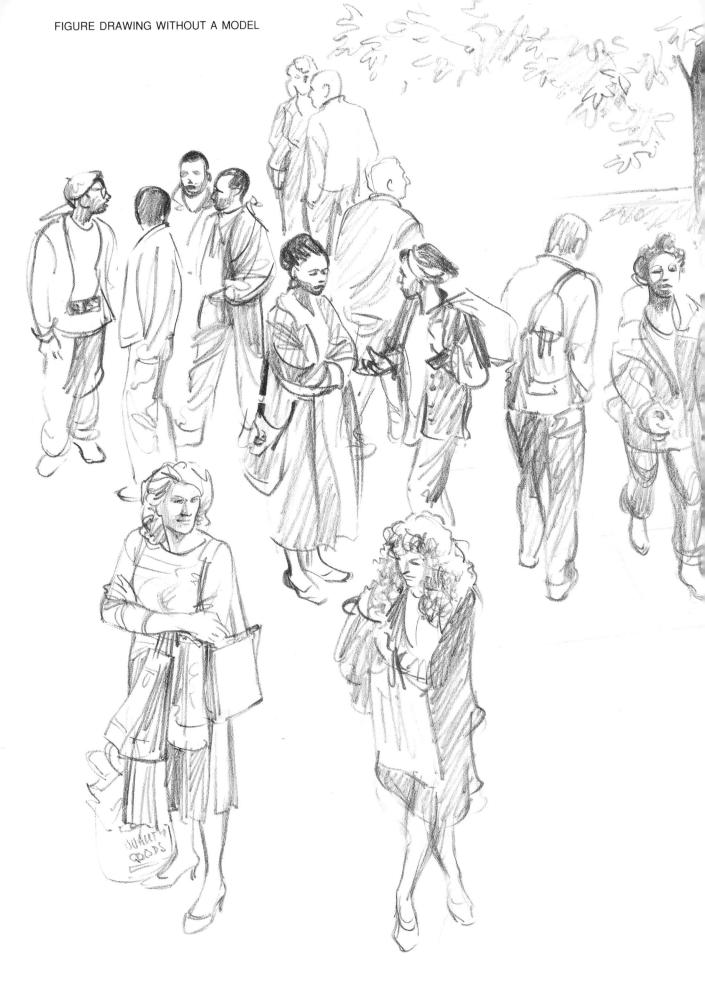

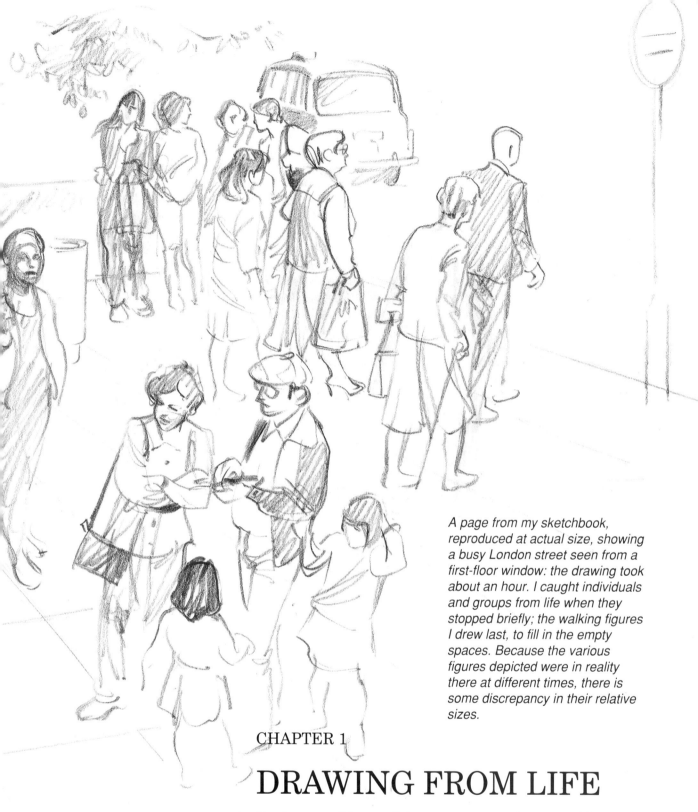

*A page from my sketchbook, reproduced at actual size, showing a busy London street seen from a first-floor window: the drawing took about an hour. I caught individuals and groups from life when they stopped briefly; the walking figures I drew last, to fill in the empty spaces. Because the various figures depicted were in reality there at different times, there is some discrepancy in their relative sizes.*

CHAPTER 1

# DRAWING FROM LIFE

To draw anything well from memory, to invent and improvize creatively, you need first to build up a store of basic knowledge of your subject. The best way to do this is through drawing from life. By making observation studies you can readily and easily absorb great quantities of information about proportion, form and structure – and, of course, in the process you will also be developing your drawing skills. No amount of factual information gleaned from instructional tomes can serve as a substitute for this valuable exercise.

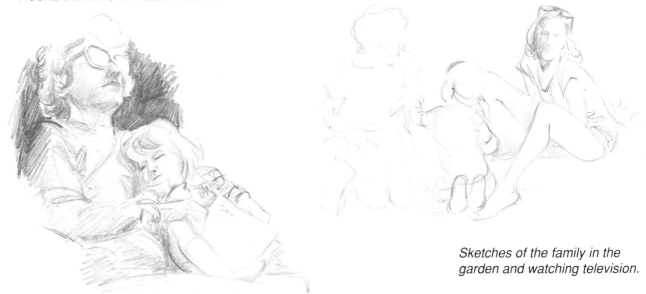

*Sketches of the family in the garden and watching television.*

All this is especially true when your subject is the human figure. Not only will you need to be able to call upon a fund of first-hand information about the body's shape and structure, you must also gain a thorough knowledge of how people stand and sit and move if you are going to be able to draw them convincingly. For this reason you should make constant use of a sketchbook.

# Sketchbooks

Just as a writer needs a notebook for jottings and thoughts and an athlete needs work-outs and physical-training sessions to keep in peak condition, so the artist needs a sketchpad to keep his or her skill and visual memory sharp. Your sketchbook is your most valuable asset and any artist who does not use one is the poorer for it. As a combination of diary, workbook and record of life around you it becomes an extension of both your learning power and your visual memory.

For the purposes of figure sketching, a small writing pad with unlined paper, about 23cm x 12.5cm (9in x 5in), is quite adequate; indeed any small book with blank pages will do. It is not necessary to have expensive, high-quality paper for this purpose – in fact, it could even work to your disadvantage, because you might begin to feel that it was a little too precious to be 'wasted' on quick sketches and notes. You have to be prepared to be profligate with your sketchbook pages, and you won't do that if you're worrying about the cost.

A number of different formats of hard-covered notebooks with unlined pages are currently available at modest prices. I regularly make use of three types: one is about 15cm x l0cm (6in x 4in) and fits easily into a pocket; the second is about 23cm x 15cm (9in x 6in); and the third, about 30cm x 20cm (12in x 8in), I stow in a bag when travelling (I find bus and railway stations perfect places for figure sketching).

The best place to start is probably at home. Members of your

family make ideal subjects because they are readily available and will often be engaged in activities which do not involve a great amount of movement, such as reading or watching television. Most people are willing to be cooperative – and, indeed, find it quite companionable to be sketched as they perform some domestic chore like washing up.

In order to maintain your subjects' willingness it is advisable not to take too long over each drawing. Virtually anyone can on occasion be persuaded to keep still long enough for you to make a detailed drawing, but most sketchbook work is anyway of greatest value if carried out with a sense of urgency. You will quickly learn how to catch the essence of a pose or character in a few lines and your work will have more vitality as a result.

Having done some drawing in familiar surroundings, you will soon feel confident enough to take your sketchbook out of doors. People will rarely bother you if you find a suitably unobtrusive spot in which to position yourself.

You need to get into the habit of drawing constantly, of taking your sketchbook with you everywhere you go. Whenever you have a spare moment, take your sketchbook out of your pocket and draw the people around you: standing at a bus stop and sitting in a café present good opportunities for you to find a convenient position and make quick sketches of the people nearby. I find a clutch pencil or ballpoint pen ideally suited to this purpose.

Use only one side of the paper. There are three reasons for this

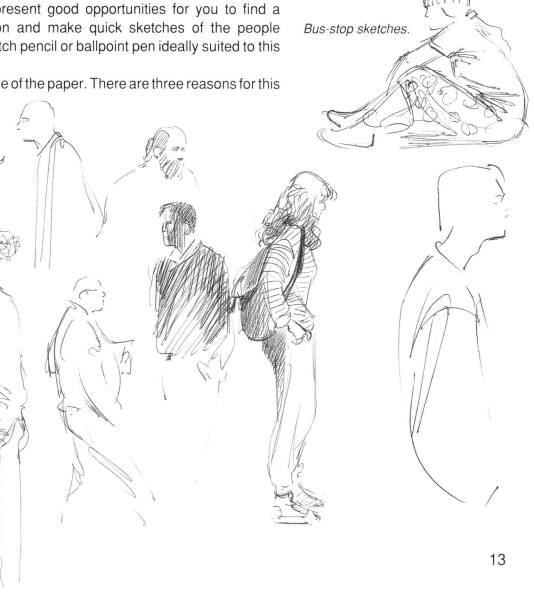

*Bus-stop sketches.*

13

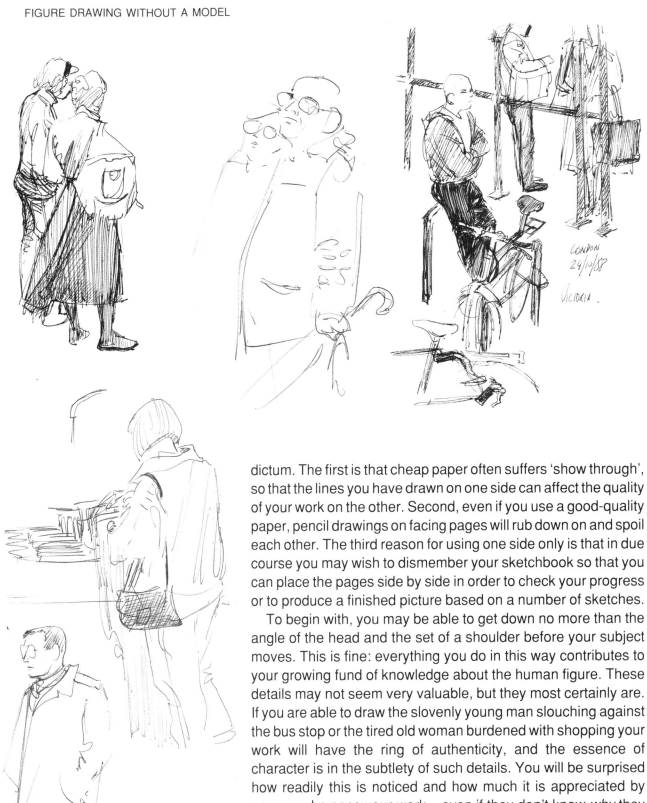

dictum. The first is that cheap paper often suffers 'show through', so that the lines you have drawn on one side can affect the quality of your work on the other. Second, even if you use a good-quality paper, pencil drawings on facing pages will rub down on and spoil each other. The third reason for using one side only is that in due course you may wish to dismember your sketchbook so that you can place the pages side by side in order to check your progress or to produce a finished picture based on a number of sketches.

To begin with, you may be able to get down no more than the angle of the head and the set of a shoulder before your subject moves. This is fine: everything you do in this way contributes to your growing fund of knowledge about the human figure. These details may not seem very valuable, but they most certainly are. If you are able to draw the slovenly young man slouching against the bus stop or the tired old woman burdened with shopping your work will have the ring of authenticity, and the essence of character is in the subtlety of such details. You will be surprised how readily this is noticed and how much it is appreciated by anyone who sees your work – even if they don't know *why* they prefer it.

Your sketchbook should generally be regarded as a personal document – rather like a diary. Indeed, many artists make notes on and add comments to their sketches, thereby increasing their usefulness later, especially if a sketch ends up being used as the basis for a finished drawing.

That having been said, it is probably best at this stage to see sketching as primarily a means of sharpening up your powers of

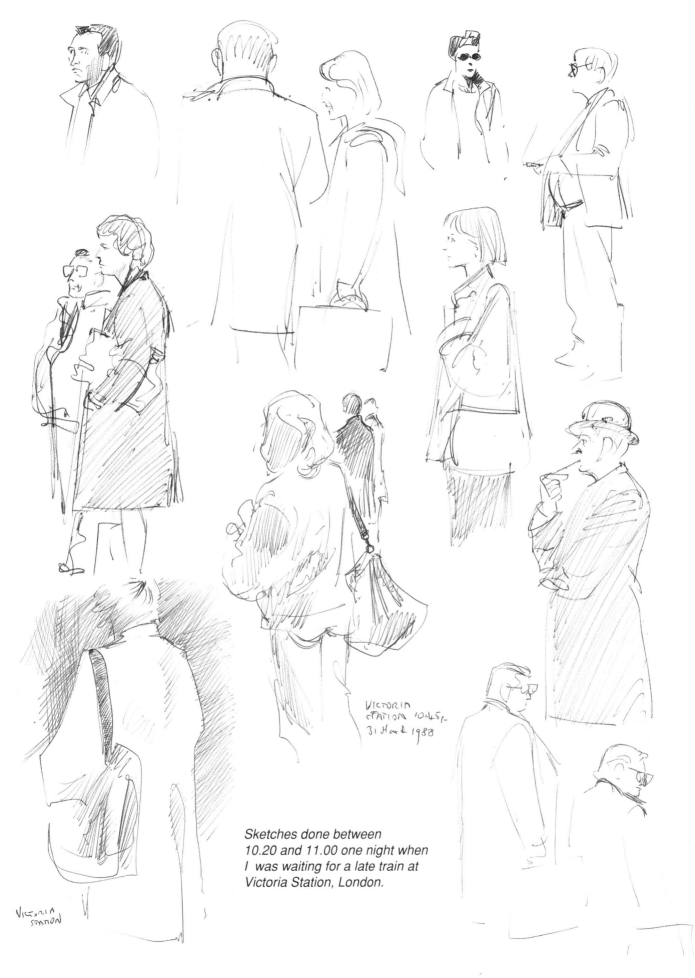

VICTORIA
STATION 10.45p.
31 March 1988

*Sketches done between
10.20 and 11.00 one night when
I was waiting for a late train at
Victoria Station, London.*

VICTORIA
STATION

*Saloon-bar sketches. If you use
your sketchbook habitually it can
provide you with an excellent
source for picture composition and
character reference.*

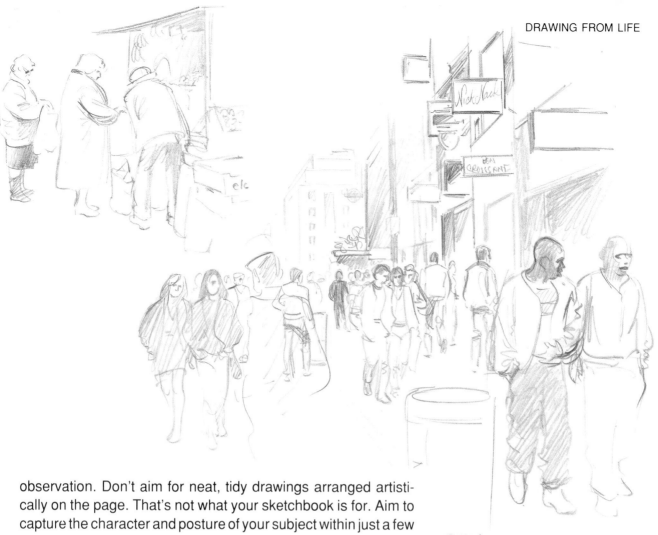

observation. Don't aim for neat, tidy drawings arranged artisti-cally on the page. That's not what your sketchbook is for. Aim to capture the character and posture of your subject within just a few moments. Choose someone who is likely to remain still for a while, and get started. Don't hesitate. Don't try for attractive line quality or arty tricks. This is an exercise in recording facts quickly. Your sketches are for your benefit alone – to give you the sheer pleasure of seeing and recording the life around you and to help you develop a sharp eye and a sure touch.

If you've never tried this you may think that it sounds like hard work. It isn't. It is a most pleasurable and most rewarding occupation. It is relaxing and invigorating, and as a means of improving your drawing skills it can't be beaten.

Take your sketchbook with you wherever you go. This is so important that I make no apology for repeating it. Draw people as they wait on a railway platform or sit on a park bench, or members of your family at home as they watch television. In bars, in restaurants and cafés, and in the street you can see all shapes and sizes of people. Note them down in your sketchbook and you'll never regret it. Sketching, it should be stressed, is not only a pleasurable occupation in its own right: there is no better way to increase your knowledge and ability. If you make it a habit your life will be enriched by your clearer perception of your fellow human beings, and you'll develop a sureness of touch that will enliven your work and increase your ability to draw just what you want.

The circumstances under which figure sketching is done are

*More leaves from my sketchbook – street scenes in London and Exeter.*

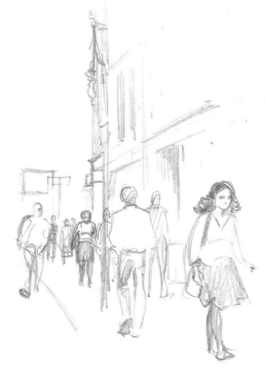

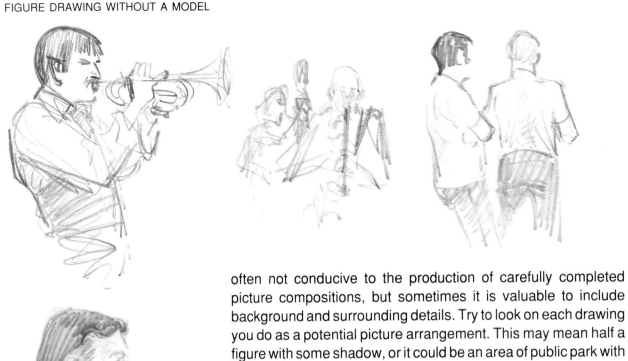

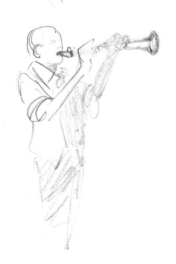

*Sketchbook pages showing drawings done at Ottery Jazz Festival, Devon, England.*

often not conducive to the production of carefully completed picture compositions, but sometimes it is valuable to include background and surrounding details. Try to look on each drawing you do as a potential picture arrangement. This may mean half a figure with some shadow, or it could be an area of public park with figures distributed around it; the random patterns the figures make are often surprisingly pleasing. When you progress to composing original pictures of your own the experience will prove extremely valuable.

If you take a larger sketchbook along to concerts, jazz clubs or auction rooms, or perhaps to the public gallery of the town hall when a council meeting is in progress, you will have time to make more considered drawings of figure groups, as the performers remain reasonably still.

Throughout this book I shall return again and again to this theme of drawing and sketching from life. It is a process of reaching out for raw material to provide a pool of resources for your imagination to call upon. Without this exercise of your powers of observation, your drawings from memory are in danger of gradually deteriorating until they become little more than a series of clichés.

In selecting the illustrations to accompany this section I have used pages from my own sketchbooks. Many of them are reproduced here about the same size as the original drawings, which were done in either ballpoint pen or 2B pencil. I deliberately looked out some old sketchbooks dating back to a time when I, too, was a virtual beginner in order to remind myself of the problems and difficulties I encountered. As I sifted through them I was struck by how quickly skill in precise observation can be developed and also by how many were executed purely for the pleasure of doing them. Old friends I hadn't seen for many years were brought back clearly to my mind by the small drawings made in cafés and bars and on the beach. Memories of places visited were brought into sharp focus. A sketchbook well used is not only a storehouse of pictorial knowledge and a training ground where the artist's skills are refined, it can also be a fascinating visual diary.

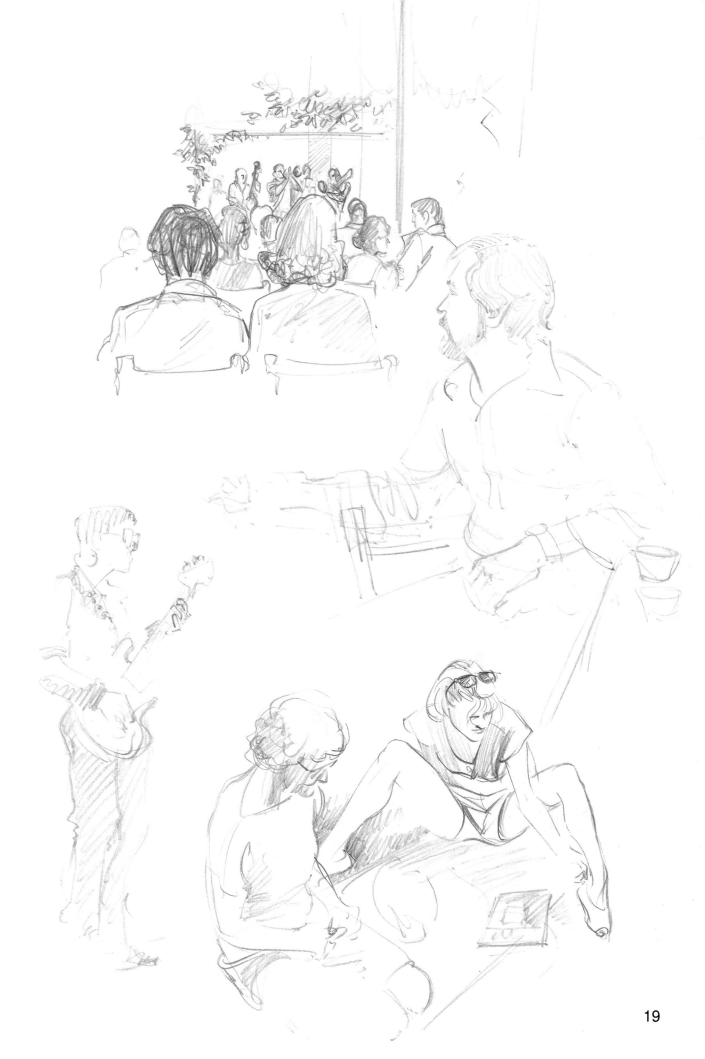

*Rapid observation drawings*
*– gesture drawings –*
*done using a posed model.*

# Using a Model

Gaining sufficient knowledge and experience to produce authentic and convincing drawings from memory or imagination is impossible without an understanding of the unclothed human figure, so you will need to make studies from the nude. Although you will probably choose to draw more clothed than naked figures later on, they will not be successful unless you are very sure of the shape of the body beneath the clothing. In Chapter 2 I'll discuss physical anatomy, but that knowledge will be much more readily assimilated if you have done some life drawing first, so at this stage I recommend you make numerous quick 'action' drawings from a posed model.

It may seem to you that I keep suggesting that all your drawing practice should be carried out at high speed. What I am really implying is that you should develop the ability to both observe and draw simultaneously. Of course, in an absolute sense, this is not physically possible. You can't focus on both model and drawing at the same time: if you are looking at one you can't be looking at the other. But the more directly linked the two activities of seeing

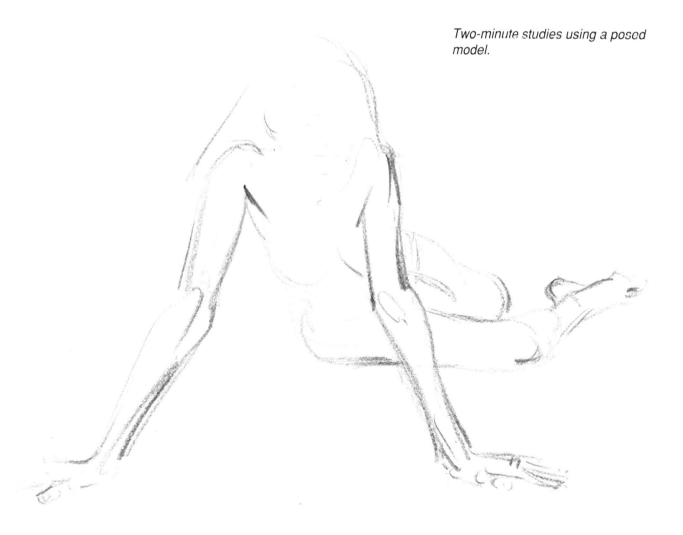

*Two-minute studies using a posed model.*

and drawing become, the more lively and expressive your drawings will be and the more quickly you will develop the ability to create figures from your imagination. You will have the means to draw actions and postures which no model could hold long enough for you to be able to make studied drawings. Note that I'm not trying to suggest that a time will come when you will know everything about the human figure and never need to look at one again: just as professional footballers don't give up their training sessions when they reach a peak of performance, so artists must keep themselves 'match-fit'.

For studio work you will probably want to work on a slightly larger scale than when sketching out of doors, so an A3 or even A2 cartridge pad or sheaf of papers clipped to a board may be appropriate. There are no rules about this: work on whatever makes you feel most comfortable and at whatever size you like. I know some artists who always prefer to work on a very small scale indeed, while others like to be able to make big, sweeping strokes from the shoulder to produce drawings that are almost life-sized.

Have your sketchpad or drawing board in such a position that you need move your head as little as possible. Hold it so that, as you face the model, you need only look over the top or round the side of it to see the whole pose clearly.

Your purpose at this stage is to jot down the pose of the whole figure. Of course, everything can be seen in a single glance but, until you have learned to take in the curve of the spine, the distribution of the limbs, the angle of the head and neck – indeed, the whole pose – you'll need to keep looking up at the model as you work. Sit far enough away from the model to enable you to see the whole figure all at once, and allow yourself no more than about four minutes for each pose.

Try to get down the shape of the spine and the positions of arms, legs and head, glancing rapidly back and forth at the model and at your drawing, checking relative proportions and angles as you draw. Such drawings are often referred to as 'gesture drawings', which is a very good description, because the pose must be felt as well as seen. When you see the position your model has adopted you should try to mentally experience this posture yourself. You, too, have a spine, shoulders, arms and knees that move in the same way as the model's. Because of this, you can know what the model's pose feels like. As soon as you make yourself aware of this you'll begin to make more effective drawings.

As you draw an arm, think *arm* and feel your own arm. This kind of identification with the subject of your drawing is the secret of success. Try it and you will find that good drawing is an attitude of mind – and as natural as thought.

Each of these gesture drawings should take only a few minutes, so it is a good idea to instruct your model to adopt a new pose

every four minutes (say) without any directive from you. As soon as the model changes position begin a new drawing, even if you do not feel you have finished the previous one. This is a work-out and you won't gain as much as you could unless you feel a little pressured. So don't use an eraser: if you do something wrong, redraw right over it. Several drawings can be done on the same page, and it doesn't matter if they overlap. We're not aiming for slick, polished pictures at this stage. What are valuable here are the exercise and the right attitude of mind.

Quite soon you'll find you have time to give more shape to the torso and limbs, allowing your pencil to flow over and round the muscle and flesh shapes, feeling their solidity and roundness as you do it. I know a number of artists who never use any other approach: when they create imaginative figures from memory they adopt the same searching and delineating style.

# Longer Studies

There are any number of different ways of carrying out longer, more detailed studies using a model, and I'm reluctant to recommend any one approach above another. My own approach varies depending on nothing more profound than how I feel at the time! You might take your inspiration from the way light and shadow form patterns near the eye, the chin, the armpits or the fingers, or from the fluid rhythm of the shapes.

Browsing through the illustrations in this chapter, you'll have seen that the drawings have been executed in a great many different ways. Some seem to stress weight and solidity, while others are loose and relaxed and still others are simply patterns of light and shade. Few were done specifically for this book: most are working drawings from my sketchbooks.

Every drawing is a new experience, and almost any natural method of approach is valid if it seems right to you. However, if you are fairly new to this activity, it is probably a good plan to begin in the same way as you did for the gesture drawings: search out the larger forms and put them down in simple line, and then add more detailed information afterwards.

Life drawings by beginners very often have the problem of appearing flat and insubstantial, so do all you can to emphasize the form of the figure – its bulk, weight and solidity. Form can be accentuated by the quality of line you use, or by paying particular attention to the light and shadow areas. The different styles used in the drawings shown here that have been done using a posed model each represent the search for a solution to the problem of giving form and weight to the figure, either by judicious use of areas of light and shadow or by the quality and shape of the lines used.

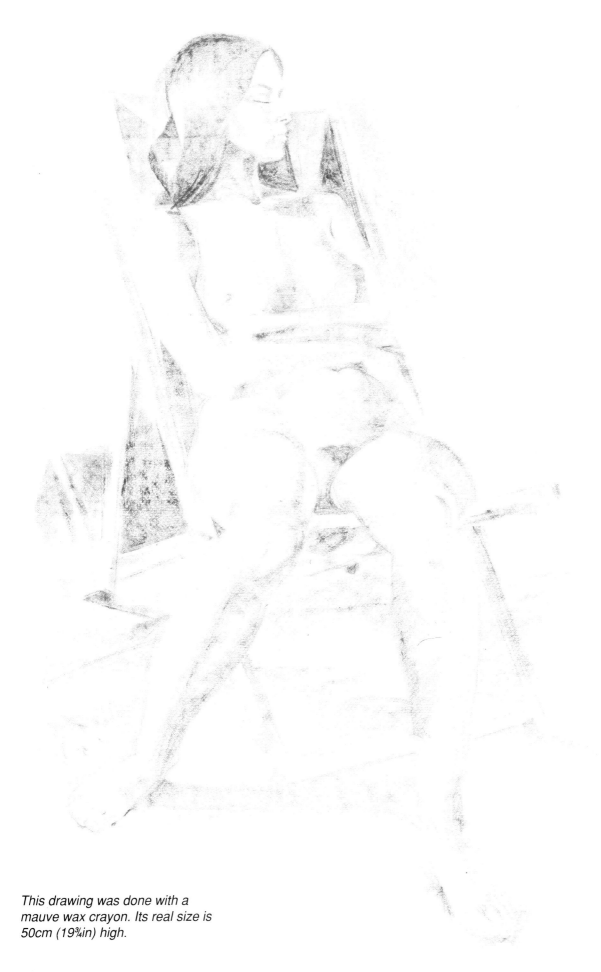

*This drawing was done with a mauve wax crayon. Its real size is 50cm (19¾in) high.*

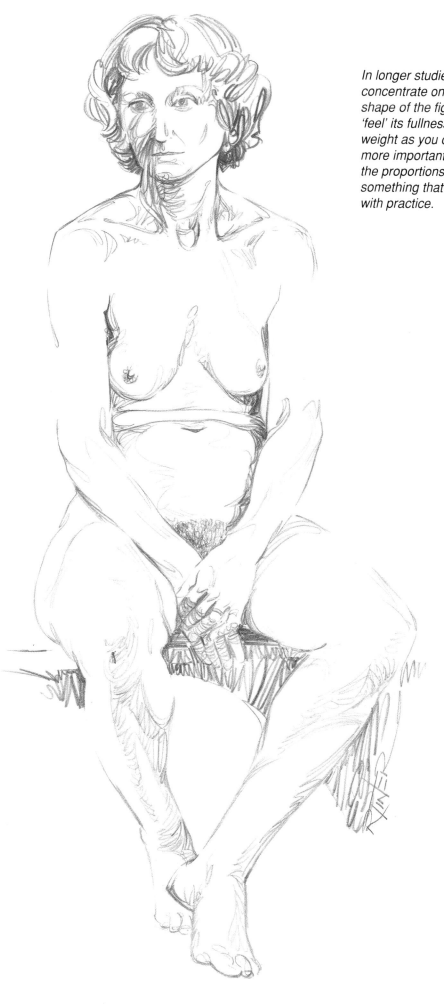

In longer studies you should concentrate on the solid, round, full shape of the figure: you should 'feel' its fullness of shape and its weight as you draw. This is even more important than representing the proportions accurately – something that will come naturally with practice.

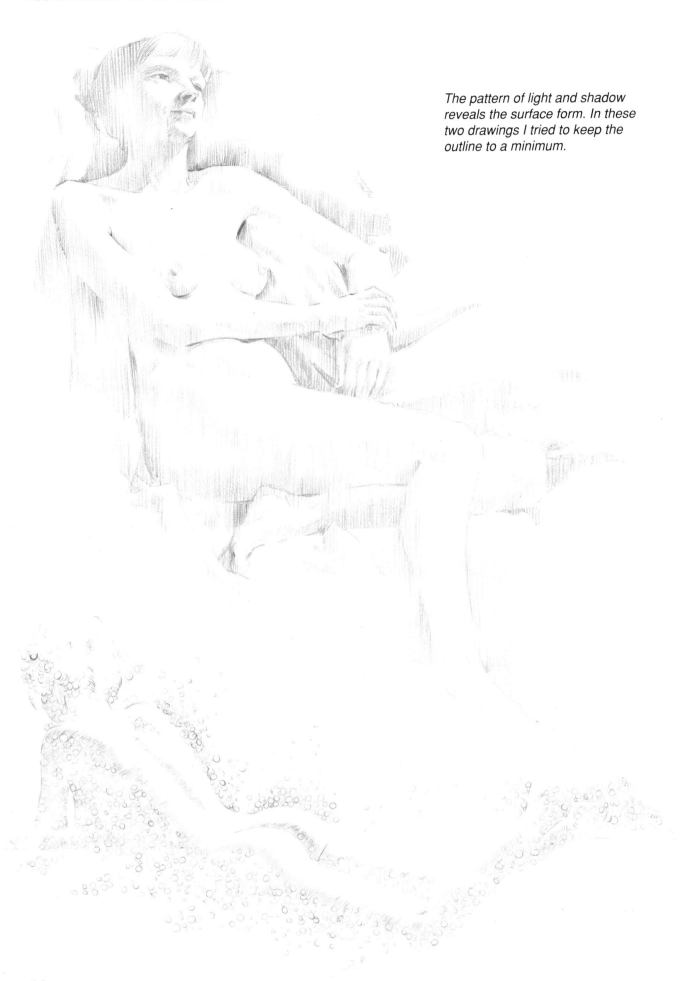

*The pattern of light and shadow reveals the surface form. In these two drawings I tried to keep the outline to a minimum.*

Another quite different method is to begin with any part that interests you, drawing the pattern of darks and lights. Then draw round or across the figure to another interesting area and work on that. A delightful pattern can emerge, and often you find that the drawing seems complete enough when there are still some parts that you haven't even started. By its very nature, this approach can easily lead you to draw some parts out of proportion to others, but this is not too much of a problem under most circumstances, and can sometimes add charm to the finished study in a quite unexpected fashion; besides, no drawing is so precious that you can't discard it and begin again – you will always have learned something, and that, after all, is at this stage the sole purpose of the drawing. The most expressive drawings produced without reference to a model are often created in this way, for it allows the imagination the freedom to improvize and modify the image during the drawing process: the drawing 'grows' towards completion.

Quite often your best and most readily available model is going to be yourself – a model you can guarantee will not become bored with posing before you are ready to stop drawing! A full-length mirror will give you plenty of scope, but you can arrange two of these in such a way as to be able to draw your own body from almost any angle. Mirror studies are ideal for building an understanding of the shape and structure of the hand, wrist, elbow and knee: all may be quite quickly understood through a few sessions of close study.

It would be impossible within the covers of this book to introduce you to all the possible ways of drawing: they are far too numerous for such an enterprise to be practicable. Here our concern is the basic knowledge you need and the opening of a few doors to show you something of the endless range of fascinating possibilities available to you. There are many good books devoted entirely to this aspect of drawing, some of which you will find listed in the Bibliography. I strongly recommend them as back-up study material.

*A good life drawing conveys the weight and three-dimensional 'presence' of the living figure as well as its vitality – its 'life'.*

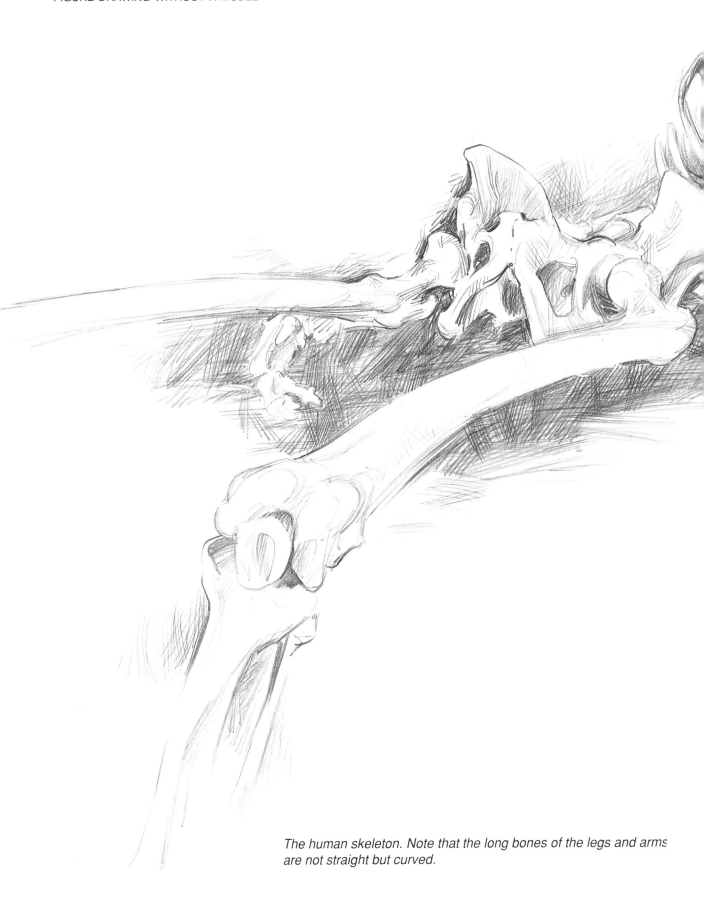

*The human skeleton. Note that the long bones of the legs and arms are not straight but curved.*

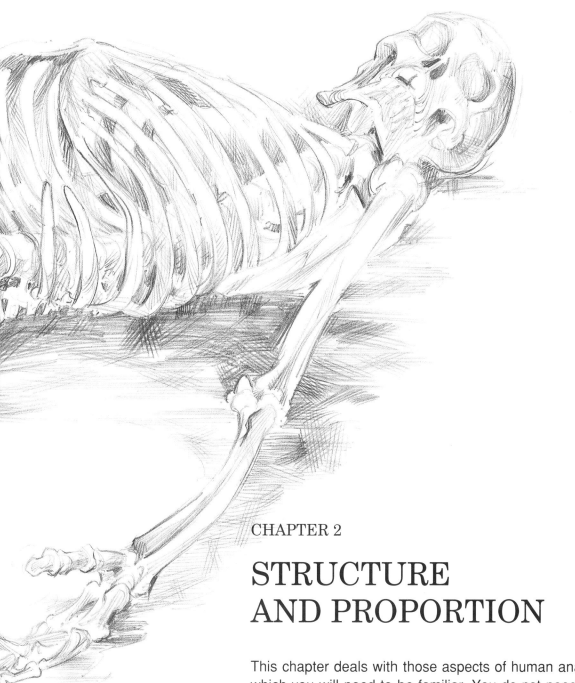

# CHAPTER 2

# STRUCTURE
# AND PROPORTION

This chapter deals with those aspects of human anatomy with which you will need to be familiar. You do not need to have a surgeon's knowledge of each individual muscle and internal organ, but you will have to know everything that affects the shape of the body and its surface form. This includes the skeletal structure, the principal muscle groups which hold it erect and activate it, and the distribution of fat deposits under the skin.

Should you wish to study the subject further, there are many good anatomy books available that will give you a greater insight into this absorbing subject. But all the artists I know have found that a small fund of basic anatomical knowledge is quite adequate for their drawing needs, so here we shall look only at the essentials of the body's structure and the simple mechanics of its operation.

It should be stressed that a good figure drawing has little in common with an anatomical diagram. However, if you don't know the basic machinery, your drawings will be unconvincing.

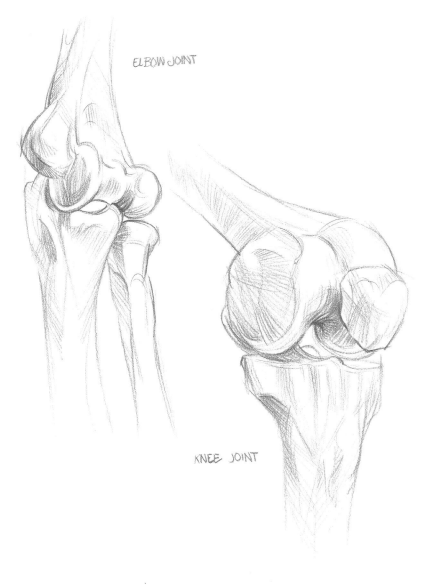

ELBOW JOINT

KNEE JOINT

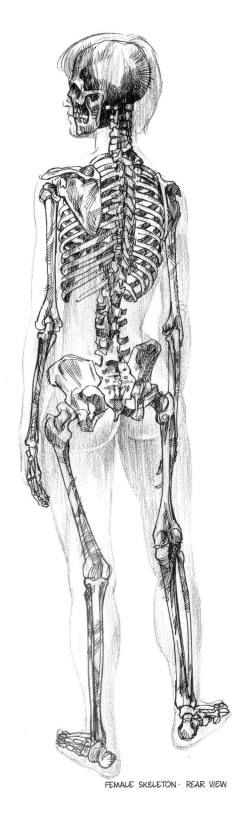

FEMALE SKELETON · REAR VIEW

# Bones

The normal human skeleton consists of 206 bones, providing a mobile supporting framework for the body and a protective carapace for the vital organs. (There are also the sesamoid bones, which are formed in tendons and do not directly connect with the others. These are not counted in the total of 206, and are not germane to our discussion here.) The bones are bound to one another by tough, flexible ligaments. At the joints, each articulating bone surface is covered by a thin layer of cartilage, which bears the brunt of the wear and tear and needs constantly to be replaced. The whole joint is enclosed by a capsule of connective tissue, which secretes sinovial fluid to provide lubricant.

Central to the human skeletal system is the spine, a flexible column of 33 vertebrae supporting the skull, pectoral girdle (or shoulder framework), rib-cage and pelvis. The arms are connected to the shoulder girdle, the legs to the pelvis.

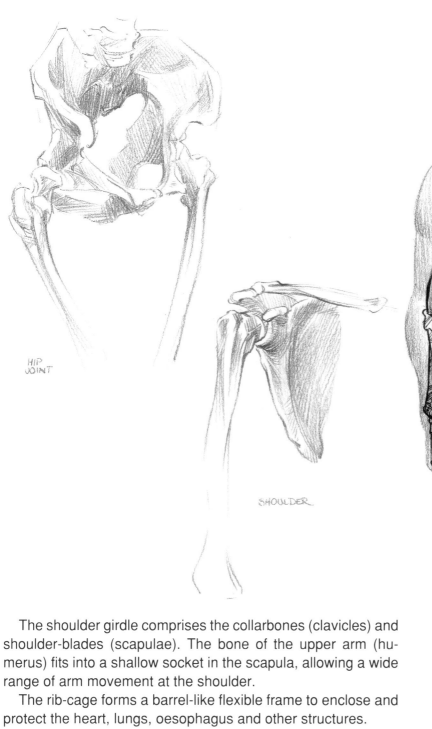

HIP
JOINT

SHOULDER

MALE SKELETON
FRONT VIEW

The shoulder girdle comprises the collarbones (clavicles) and shoulder-blades (scapulae). The bone of the upper arm (humerus) fits into a shallow socket in the scapula, allowing a wide range of arm movement at the shoulder.

The rib-cage forms a barrel-like flexible frame to enclose and protect the heart, lungs, oesophagus and other structures.

The pelvis is firmly attached to the lower spine and forms a basin which supports the intestines and other internal organs and transmits the weight of the upper body to the legs. The thigh-bone (femur) is bound firmly into a cup-shaped cavity in the pelvis. Although individuals vary widely, the bones of the average female skeleton are smaller and lighter than those of the male. The rib-cage tends to be narrower and the pelvis broader and shallower, so that the trunk appears longer and the hips relatively wider than in the male. Also, the female pelvis is tipped forward slightly, the spine having a more accentuated curve outwards from the small of the back.

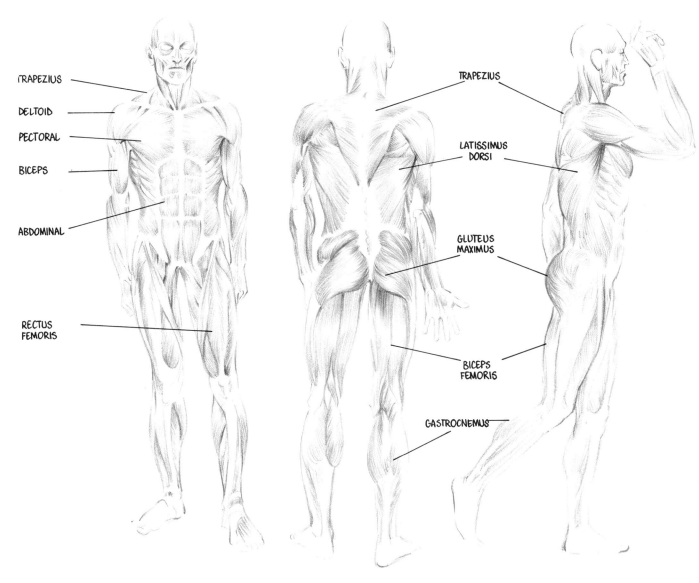

TRAPEZIUS

DELTOID

PECTORAL

BICEPS

ABDOMINAL

RECTUS
FEMORIS

TRAPEZIUS

LATISSIMUS
DORSI

GLUTEUS
MAXIMUS

BICEPS
FEMORIS

GASTROCNEMIUS

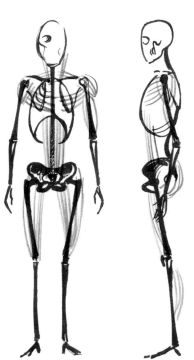

# Muscles

There are just over 600 voluntary muscles in the human body, but for our purposes here it is necessary to discuss only

- the larger superficial muscle groups which affect the shape of the body and are responsible for the movement of the limbs, and
- the rather more complex muscles which effect facial movement

All these are referred to as skeletal muscles. Most skeletal muscles are attached at both ends to bones (via tendons) and act rather like tension springs, in that they are able to contract; in doing so they cause the bones to pivot against one another like a lever on a fulcrum. The muscles that give expression to the face link bone to skin.

A muscle is made up of thousands of fibres, each of which is controlled by a nerve ending. These nerve endings respond to signals from the brain by releasing minute amounts of acetylcho-

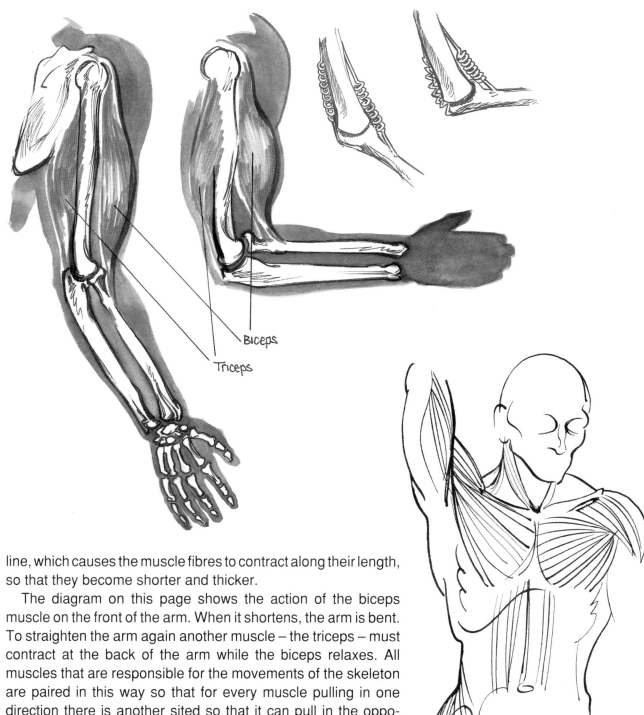

Biceps

Triceps

line, which causes the muscle fibres to contract along their length, so that they become shorter and thicker.

The diagram on this page shows the action of the biceps muscle on the front of the arm. When it shortens, the arm is bent. To straighten the arm again another muscle – the triceps – must contract at the back of the arm while the biceps relaxes. All muscles that are responsible for the movements of the skeleton are paired in this way so that for every muscle pulling in one direction there is another sited so that it can pull in the opposite direction.

Generally a whole complex of muscles is brought into play for each movement of the body; bending the arm involves many more muscles than just the biceps and triceps. One set of muscles provides the primary moving force, while the muscles opposing it relax and lengthen in unison with it. Meanwhile, others immobilize joints not needed in the action and still others adjust to stabilize the body's equilibrium.

The muscle pattern is the same in the male and female figures, but differential fat deposits on breast and hip cause sex-specific differences in body-shape (see page 50).

*Simplified diagram of the major muscle groups of the torso.*

33

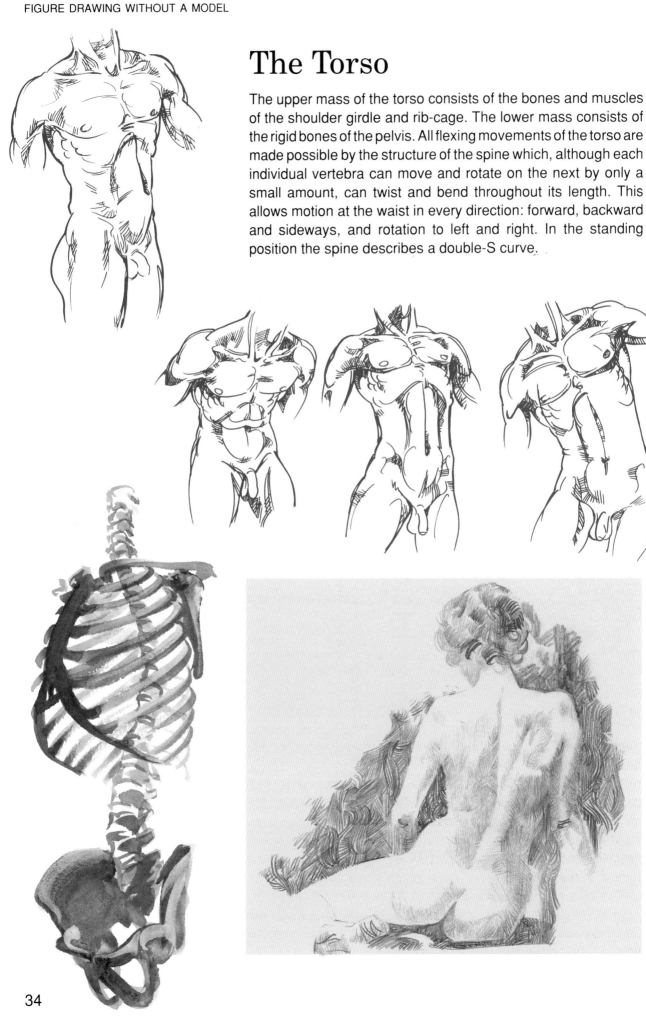

# The Torso

The upper mass of the torso consists of the bones and muscles of the shoulder girdle and rib-cage. The lower mass consists of the rigid bones of the pelvis. All flexing movements of the torso are made possible by the structure of the spine which, although each individual vertebra can move and rotate on the next by only a small amount, can twist and bend throughout its length. This allows motion at the waist in every direction: forward, backward and sideways, and rotation to left and right. In the standing position the spine describes a double-S curve.

34

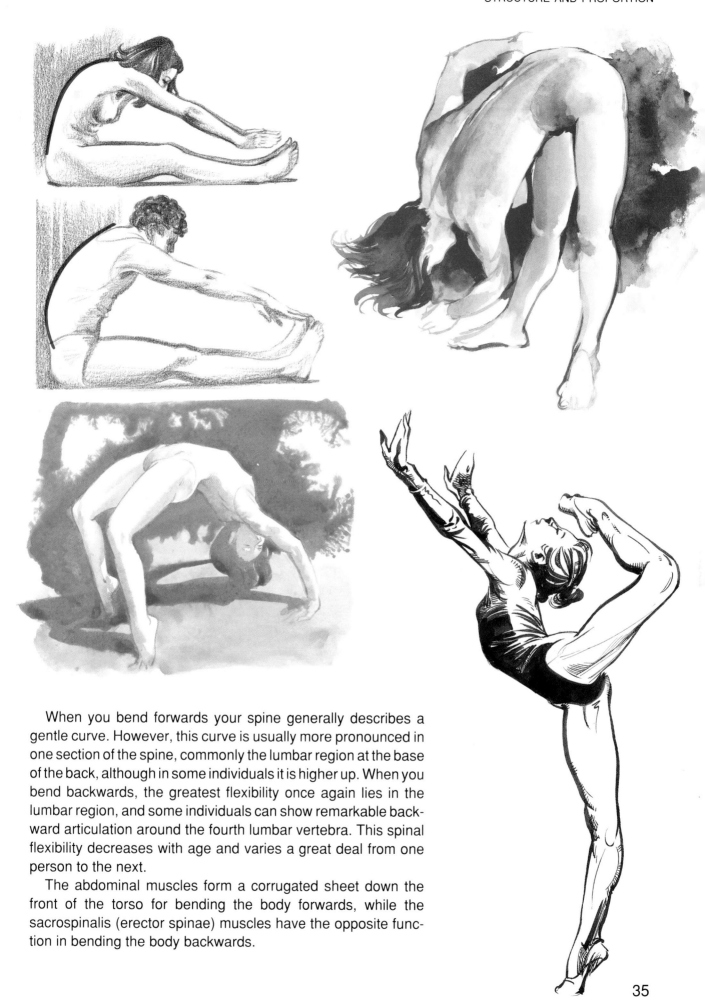

When you bend forwards your spine generally describes a gentle curve. However, this curve is usually more pronounced in one section of the spine, commonly the lumbar region at the base of the back, although in some individuals it is higher up. When you bend backwards, the greatest flexibility once again lies in the lumbar region, and some individuals can show remarkable backward articulation around the fourth lumbar vertebra. This spinal flexibility decreases with age and varies a great deal from one person to the next.

The abdominal muscles form a corrugated sheet down the front of the torso for bending the body forwards, while the sacrospinalis (erector spinae) muscles have the opposite function in bending the body backwards.

35

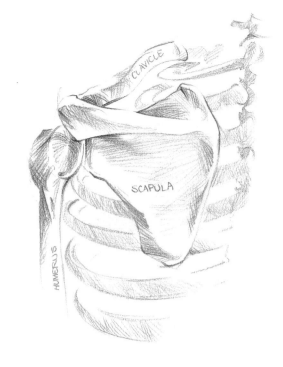

# The Shoulder

The very wide range of movement of the arms and shoulders is made possible by the arrangement of the clavicles and scapulae in what is referred to as the shoulder girdle. The scapulae are not held static, but are able to move laterally against the back of the rib-cage.

The deltoids or shoulder muscles add width to the shoulders. Along with the pectorals (the slabs of muscle on the chest) and the latissimus dorsi (which gives breadth to the back), their function is the movement of the upper arm.

The female breast is a gland superimposed on top of the pectorals and surrounded by fat, which gives it its distinctive shape.

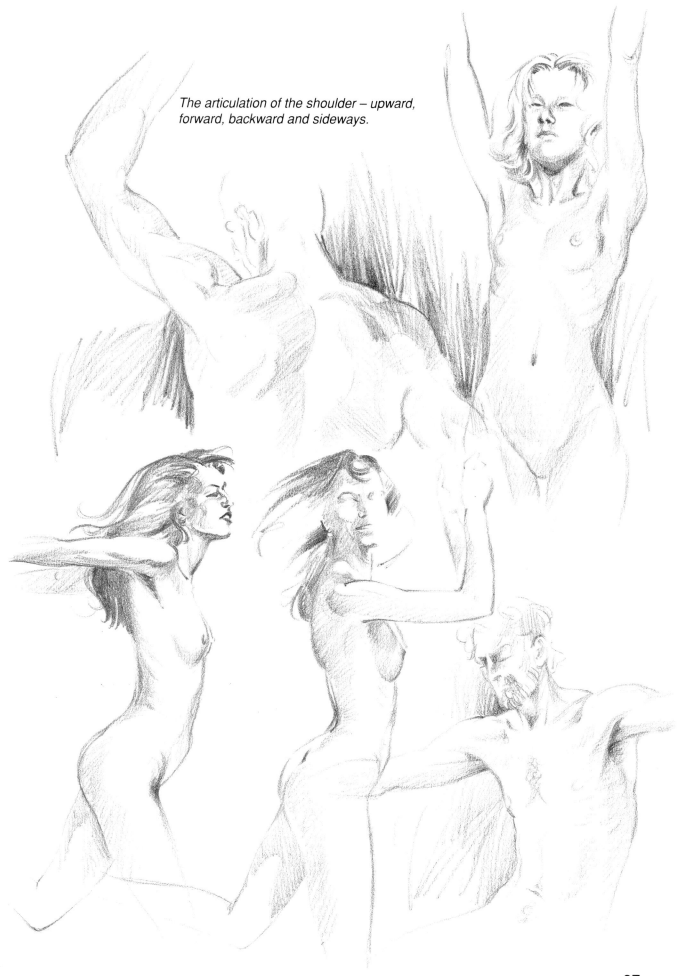

*The articulation of the shoulder – upward, forward, backward and sideways.*

# The Arm and Hand

The bone of the upper arm is the humerus. The bones of the forearm are the ulna and the radius. The bones of upper and forearm are connected at the elbow by a hinge-type joint.

Both ends of the ulna are evident just under the skin at the elbow and at the outer edge of the wrist. The radius, which like the ulna is hinged to the humerus at the elbow, is able to rotate around the ulna, giving an almost 360 degree rotation of the hand. This rotation is not, therefore, a function of either the elbow or wrist joints, but occurs within the forearm itself.

The main muscles of the upper arm are the biceps on the front and the triceps at the rear. They control the bending of the arm at the elbow.

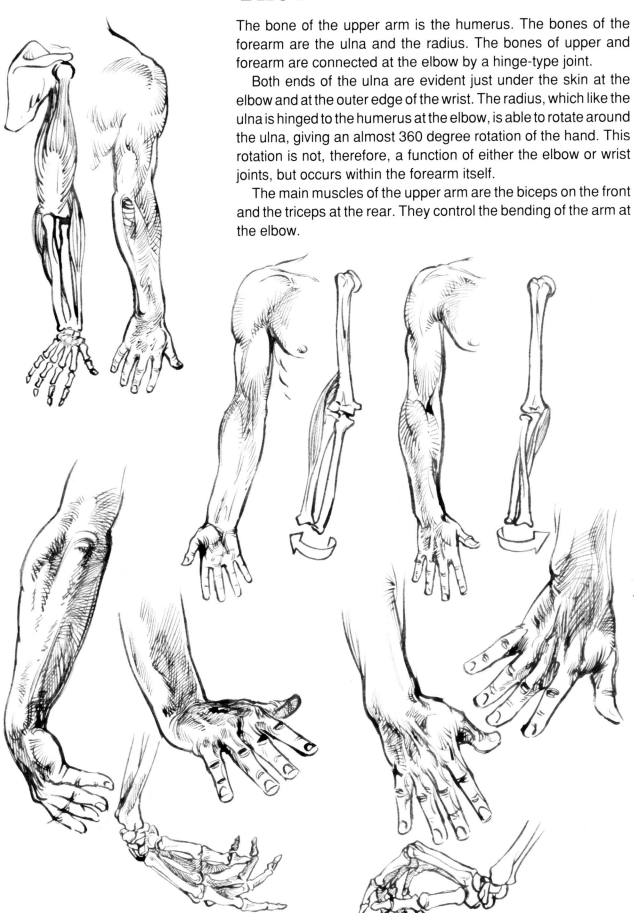

The wrist permits all movements except rotation – that is, forward-and-back and side-to-side. It consists of eight small bones, known as the carpal bones, arranged in two transverse rows.

The bones of the hand are the metacarpals and the phalanges. At the back of the hand the bone and muscle structure is just under the skin. On the palm there is a thick layer of protective tissue which acts as padding.

# Drawing Hands

Whole books have been written on the subject of drawing hands. Being made up of such a large number of small bones, with attendant muscles, ligaments and tendons, the human hand is surprisingly flexible and versatile. To understand and draw it well you will need to do a lot of studies from life. A good way to start is by making drawings of your own hands using a mirror in the way we described on page 27.

Think of the palm as a flat square shape with a curved outer edge from which the four fingers radiate; to the basic square is added, on one side, a fleshy and very flexible wedge shape in which the thumb is rooted.

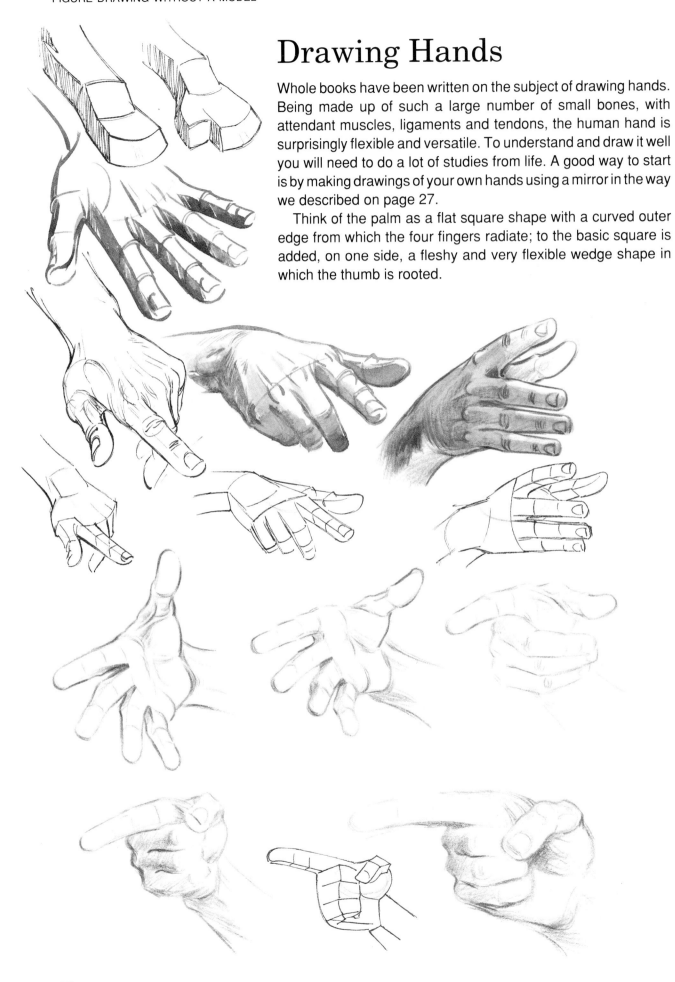

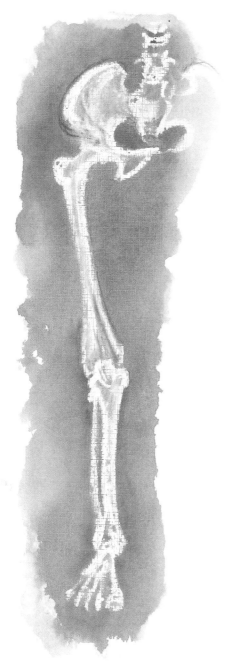

# The Leg and Foot

The most prominent muscles giving the leg its distinctive shape are on the front of the thigh and the back of the calf.

The femur, or thigh-bone, is fitted into the pelvis at a ball-and-socket joint which offers free movement in a forward direction with some lateral and rotary articulation; backward movement is prevented by ligaments across the front of the joint. Slight backward movement of the thigh is made possible by the pelvis tilting.

The knee is a hinge joint allowing backward motion only, forward motion being prevented by strong ligaments across the back of the knee. The patella, or kneecap, is a small plate-shaped bone in front of the joint which serves to protect it and which also, by virtue of its position and the tendons that connect it to the other bones of the leg, increases the leverage of the thigh muscles.

The lower leg has two bones: the tibia and fibula. These work together to allow rotation of the foot in much the same way as the ulna and radius allow rotation of the hand.

The shape of the foot is best understood if you think of it as a piece of flexible load-bearing architecture, with an arch at the instep. Its skeletal structure consists of a number of small bones (12, excluding the toes), with cushions of cartilage between, so that the shocks of the considerable jolting the foot receives in walking and running can be absorbed.

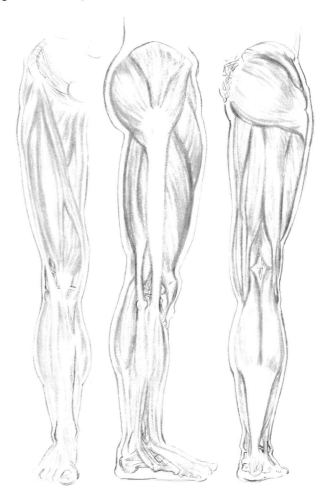

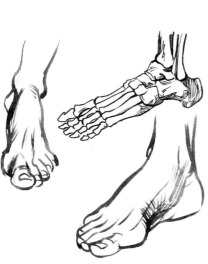

42

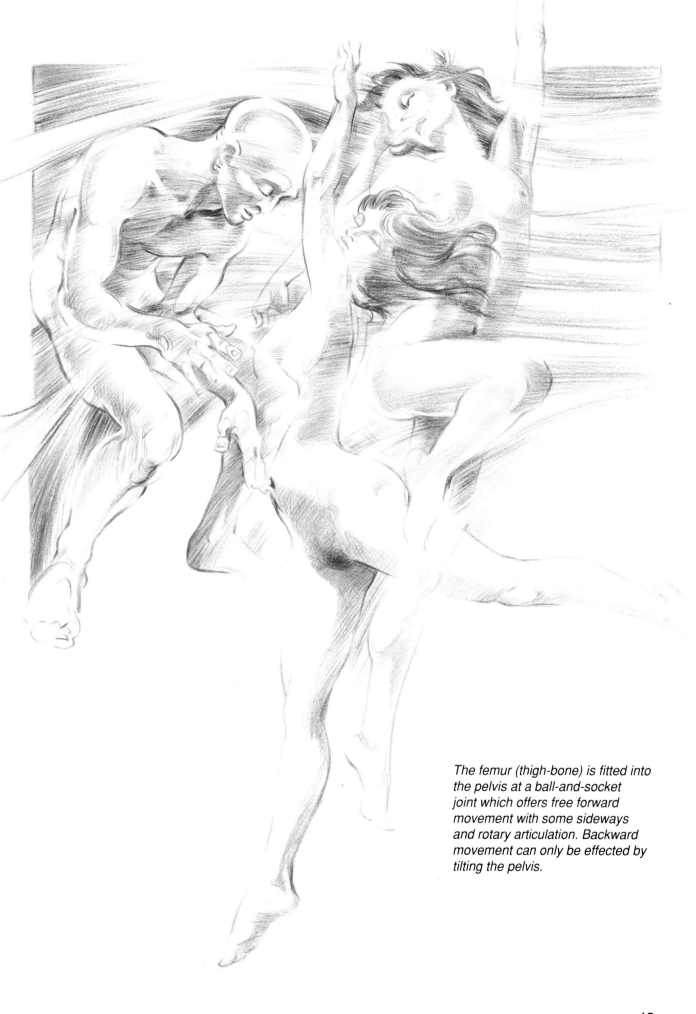

The femur (thigh-bone) is fitted into the pelvis at a ball-and-socket joint which offers free forward movement with some sideways and rotary articulation. Backward movement can only be effected by tilting the pelvis.

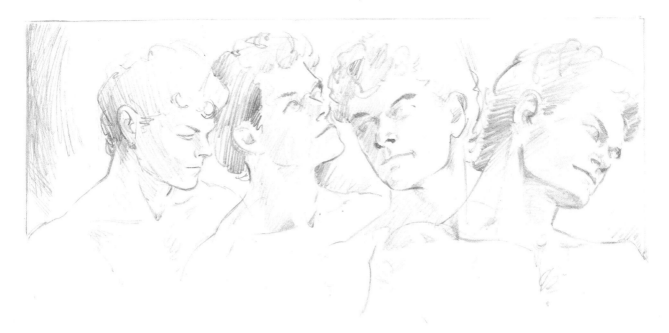

# The Head and Neck

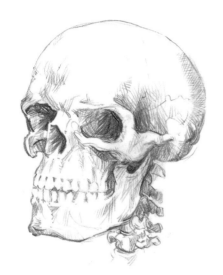

The bones of the neck are the seven cervical vertebrae that comprise the upper portion of the spine. The large muscles which affect the shape of the neck are the trapezius at the back and, at the front, the sternomastoids, which run from the back of the ear down towards the inner ends of the clavicles.

The neck is capable of motion in all directions: inclining the head forward and back, laterally towards either shoulder, and rotating it from side to side through 180 degrees.

Apart from the sound-conducting structures in the ears, the only moving joint in the head is the jaw. All the rest of the bones of the skull are rigidly interlocked and immovable.

The muscles of the face are of two types:

- the sphincter-type muscles around the eyes and mouth
- the muscles – studied and analysed in depth in Chapter 6 – that attach parts of the skull to the skin and so allow a very wide range of facial expression

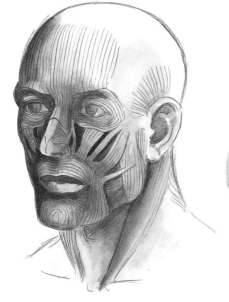

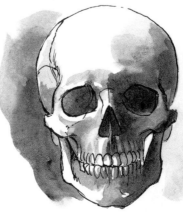

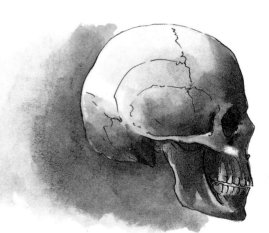

# Drawing Heads

The face is, of course, the most expressive part of the body. Here is a simple construction method which will help you to see, in simplified form, the shapes involved. The average proportions of the human head are shown at right. The head is about as deep as it is high, and so in profile it fits approximately into a square. Seen from the front, the head's width is rather less than its height.

Start by drawing profiles. Begin with a circle for the cranium and then add a line for the front of the face and another for the jaw, as shown in the first two pictures. The commonest fault in drawings by beginners is that the head appears flat so, as soon as you can, try a three-quarter view, striving always for an appearance of roundness and solidity. Use faint guide-lines to establish the centre line of the face and the position of the eyes.

This is a rather characterless face, of course, but at this stage the important thing is to understand the basic forms involved. Individuals vary from the average in many ways, as discussed along with expression and facial movement in Chapter 6. The drawings on these two pages represent a first step. If you draw hundreds of these simplified heads you will come to understand the subtle topography of the human face and be able to imbue your drawings with life and character.

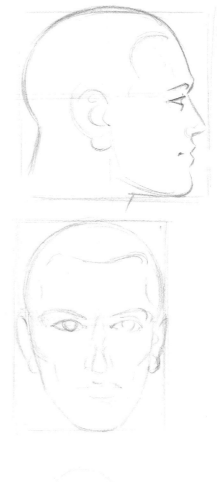

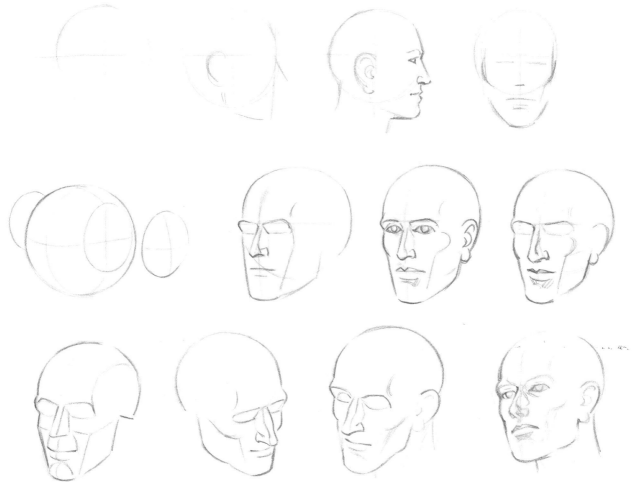

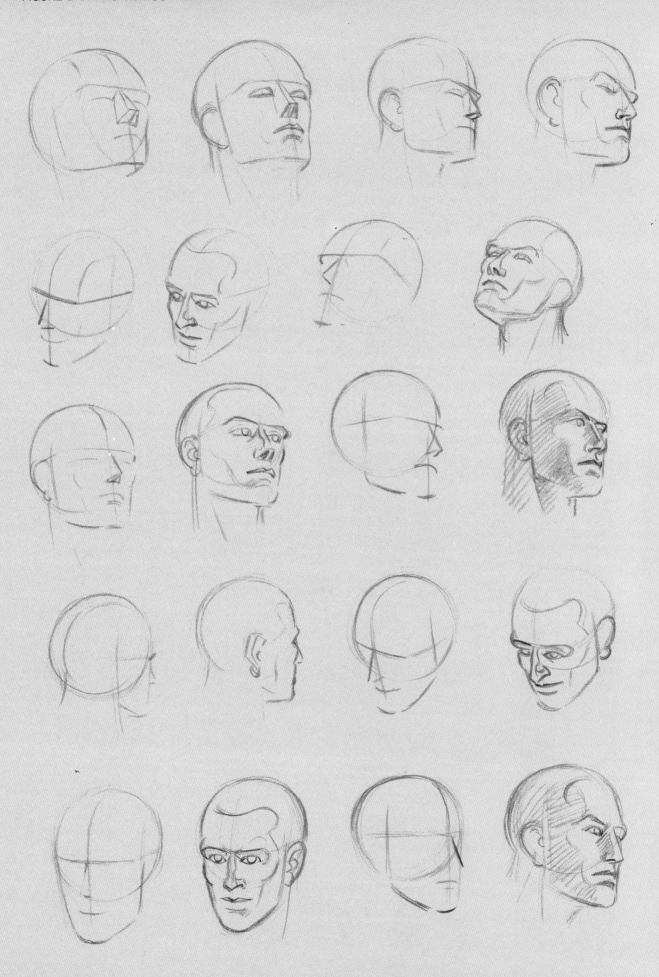

It is most important to realize that the face is not simply a flat surface with features superimposed. To draw faces successfully you must understand the three-dimensional form of the surface – that's why we began with a characterless 'average' face which could have been either male or female.

If you look at the foggy newspaper photograph of a crowd reproduced on this page you'll see that each face is distinct from the rest simply by the pattern of light and shadow on it, rather than by the shapes of the eyes or lips. If you can conceive of the face as a pattern in this way you will avoid the common pitfall of creating lifeless arrangements of eyes, noses and mouths, indistinguishable from one another.

So practise drawing the basic face with the addition of light and shade until you thoroughly understand its surface form and the way that the light and shadow areas reveal its contours.

On these two pages are several views of basic faces from various angles. Once again, it is imperative that you understand the actual surface form, not merely the outline.

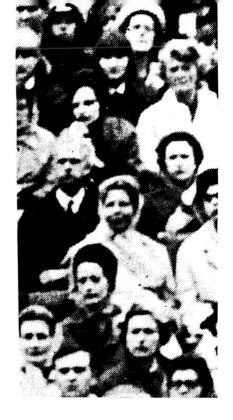

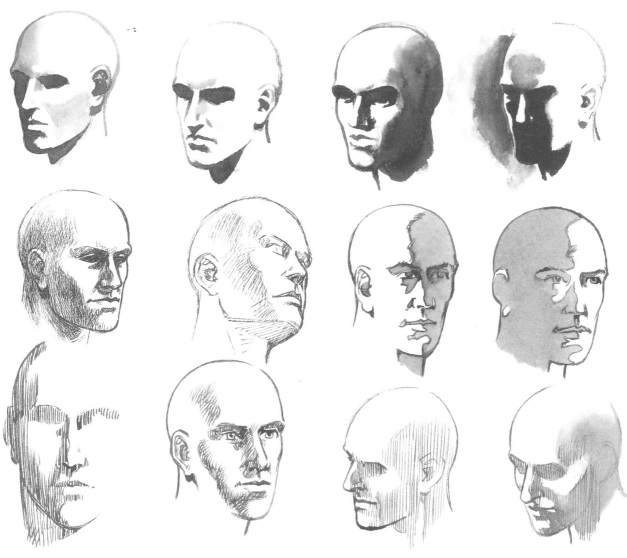

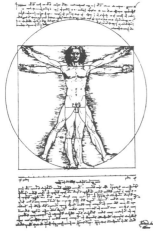

# Proportion

The proportions of the human figure have interested artists, philosophers and teachers throughout the past 20 centuries or more. The Roman architect Vitruvius wrote early in the 1st century AD: 'Nature has so fashioned the well formed human figure that the face, from the chin to the roots of the hair, is a tenth part of the whole body.' He asserted also that the navel was the centre of the body, so that a circle drawn around this point would touch the outstretched toes and fingers of a man lying on his back. It is this theory that is shown in Leonardo da Vinci's famous illustration at top left. Unfortunately the theory works in practice only if the arms are held out at a very specific angle. We can see, nevertheless, that when the arms are stretched out to the sides the distance between the fingertips is roughly the same as that between the crown of the head and the soles of the feet, and this is a useful rule-of-thumb guide to arm length.

During the Renaissance, human anatomy became the subject of detailed investigation, and artists became involved in a search for significant mathematical relationships between the sizes of various parts of the body. Complex systems were invented to define what was considered an 'ideal' figure. Since then, hundreds of such systems have been devised using various parts of the body as units of measurement, including the head, face, foot, forearm, index finger, nose, spinal column and so on, but, because no account was taken of the simple, obvious fact that individuals vary very considerably, these systems are really of interest only to the classicist. Ideals vary considerably, too, and the accepted view of what constitutes perfection in bodily proportions changes from one generation to the next. We must therefore in general resort to observation of the wide range of sizes and shapes displayed by the people we see around us.

For our purposes, however, it is useful to study a figure of average proportions, as this gives us a basis upon which to build.

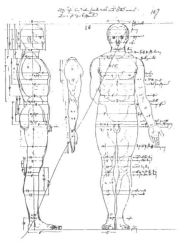

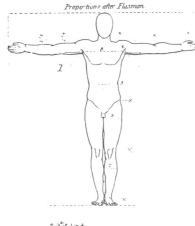

*Proportions after Flaxman*

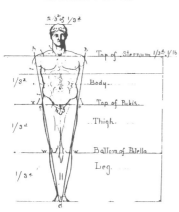

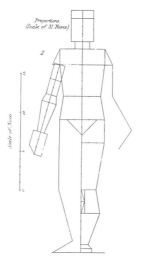

*Left-hand column, from top: Leonardo's drawing based on Vitruvius; Albrecht Dürer's measured drawing of a stocky man; diagram by John Flaxman RA, who remarked in his* Lectures *(1812) that 'Greek sculpture did not rise to excellence until anatomy, geometry and numbers had enabled the artist to determine the drawing, proportions and motion . . .'; William Rimmer's diagram to show that torso length = thigh length = shin length.*
*Left: Anonymous scheme depicting the proportions of the body in terms of 31 noses!*

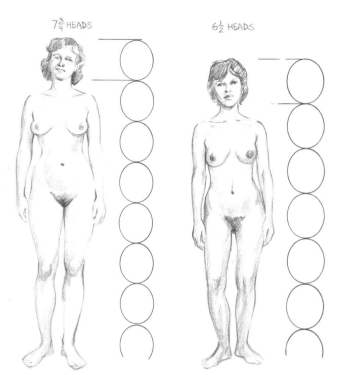

7¾ HEADS    6½ HEADS

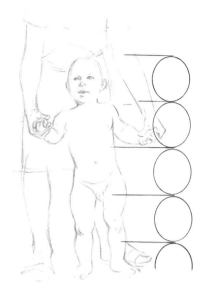

Individuals vary from this average in quite specific ways, which we'll investigate in Chapter 6. Nevertheless, many of the rules set down in this chapter apply to most normal figures, and they provide a useful means of checking the proportions of a drawing when we need to – which is, after all, the only practical purpose they can serve.

The usual method of ensuring that the relative sizes of the various parts of the body are in proportion is to use the vertical length of the head as a unit of measurement. An average figure is about seven heads high, but anything between six and eight heads is well within the normal range. Indeed, the 'ideal' figure of eight heads' height has persisted in books of drawing instruction right up to the present day – largely, I suspect, because then it is possible to divide the body vertically into eight convenient parts at chin, nipples, navel, crotch, mid-thigh, knee, calf and foot, making life simple for the instructor!

To be pedantic about the rule is to miss its point. Much as we may admire the remarkable achievements of Roman architects and Renaissance artist/mathematicians, all they have to offer us practically in this instance is a handy, rule-of-thumb checking device, and it would be foolish to allow ourselves to be restricted by it.

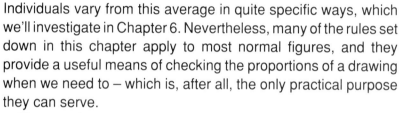

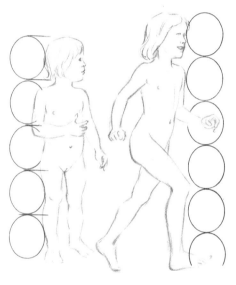

# Children

When drawing children you will find that the head contributes a much larger proportion of the height. A newborn baby's head is about a quarter of its total height and the length of the legs very little more. As the child grows, the legs increase in length far more than the other parts in relation to the total height of the body, so that the head becomes proportionately smaller.

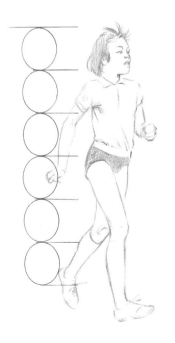

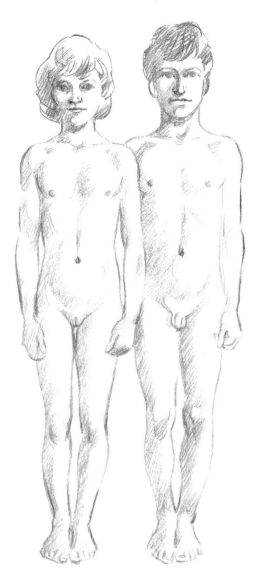

# Fat Distribution

In childhood, male and female body shapes are very similar. The shape of the average adult male body is largely dictated by the size of the muscle masses, while that of the average female depends mainly on the size of the fat masses. When girls attain puberty there is an increase in body fat, which is laid down in very specific places to give the distinctive roundness of breast and hip of the adult woman.

The shaded areas in the drawings at the foot of this page show where excess fat is stored. Both sexes have a storage area high on the back between the shoulderblades, which gives obese people of both sexes that distinctive hunched-shouldered, short-necked appearance. However, other storage sites give rise to sex-specific differences in shape. In overweight men the waist is characteristically larger than the hips, the excess fat being stored above the hip-bone at the back on either side of the spine, and on the upper abdomen. Overweight women, by contrast, are typically bigger at the hips than at the waist, the main sites of fat storage being the lower abdomen, buttocks and thighs, as well as on the breasts, at the back of the upper arms and, as for men, between and above the shoulderblades.

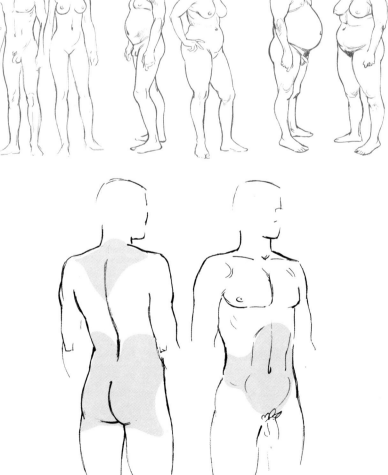

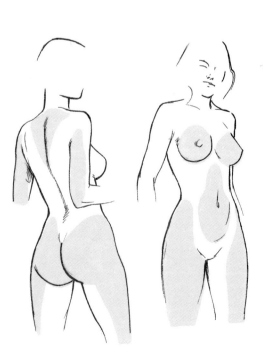

# Ageing

In old age the flexor muscles tend to shorten. This causes the body, when it is in a normal standing posture, to have a general 'bowed' shape, with rounding of the shoulders as the upper back (the dorsal spine) increases its natural curvature and the neck thrusts the face forward. Even when the body is relaxed, the arms and legs remain slightly flexed.

The skin and the subcutaneous fat layers become thinner, and the muscles shrink. The elbow and wrist joints and the knuckles seem larger, and the veins may become visible as ridges just under the skin. All the fat deposits on the body and face become softer and tend to sag, as does the skin at the elbows and under the chin.

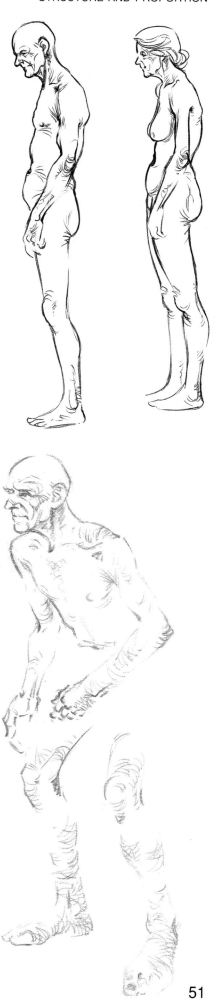

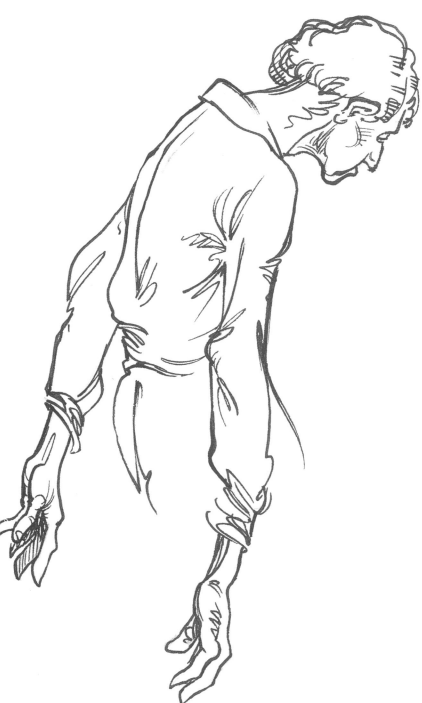

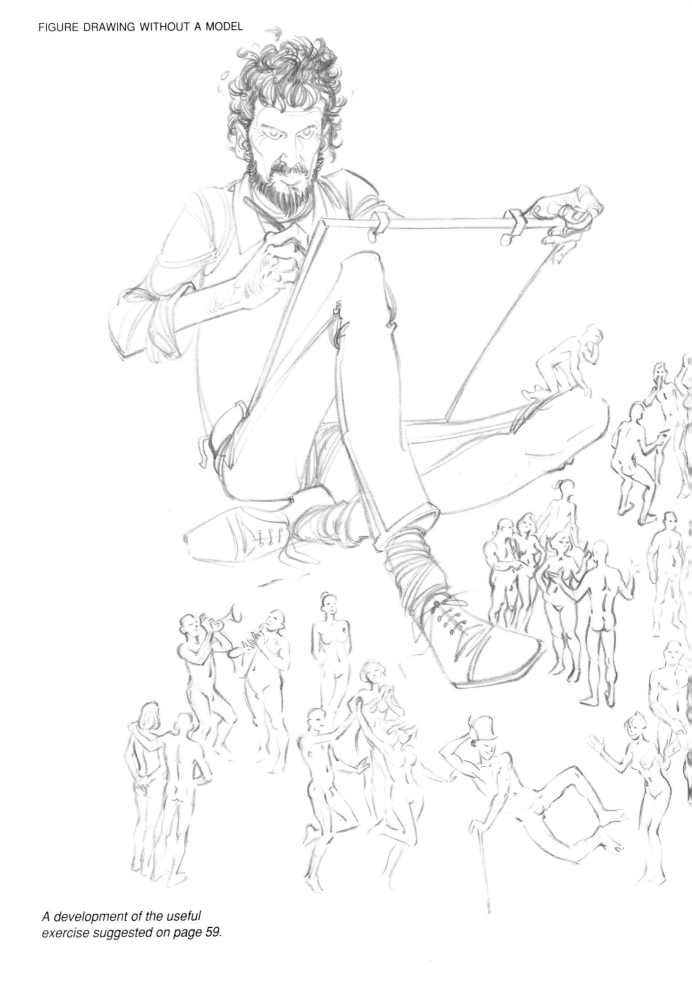

A development of the useful
exercise suggested on page 59.

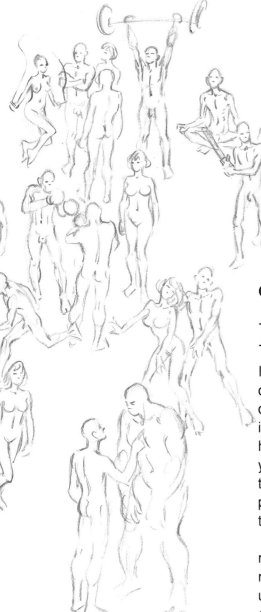

CHAPTER 3

# Practice

In this chapter we shall look at a number of drawing exercises devised to help you towards your goal of good imaginative figure drawing from memory. They are aimed at consolidating the information so far presented and building on the familiarity you have gained with the human figure through your frequent use of your sketchbook. Each exercise contributes in a significant way to the development of the drawing skills you will need, and in the process will help you avoid the commoner pitfalls and weaknesses to which drawings from memory are prone.

The exercises outlined on the following pages should be regarded as steps in your learning process. Knowledge memorized as a list of facts is generally of little use in practical terms unless backed up by activities that put it to work. (That's why the contents of the chapters in this book alternate between practical and theoretical.) Carrying out these exercises will help you build a fund of knowledge and experience which you can easily and naturally call upon later.

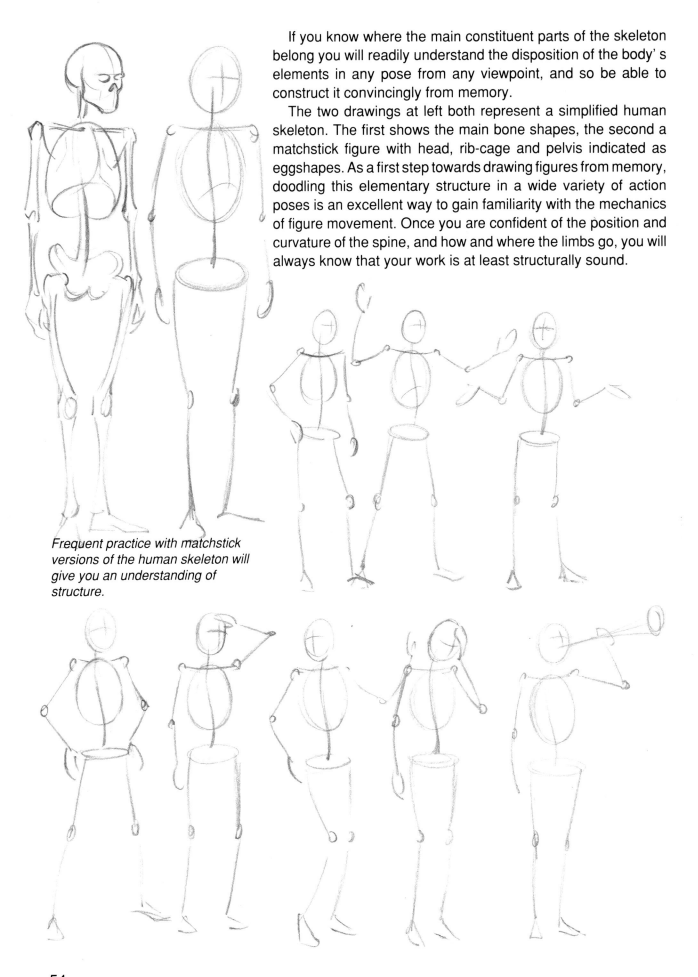

If you know where the main constituent parts of the skeleton belong you will readily understand the disposition of the body's elements in any pose from any viewpoint, and so be able to construct it convincingly from memory.

The two drawings at left both represent a simplified human skeleton. The first shows the main bone shapes, the second a matchstick figure with head, rib-cage and pelvis indicated as eggshapes. As a first step towards drawing figures from memory, doodling this elementary structure in a wide variety of action poses is an excellent way to gain familiarity with the mechanics of figure movement. Once you are confident of the position and curvature of the spine, and how and where the limbs go, you will always know that your work is at least structurally sound.

*Frequent practice with matchstick versions of the human skeleton will give you an understanding of structure.*

Remember that the spine is flexible, and that in a normal upright posture it describes a shallow double-S curve. Remember, too, that the legs account for half the total height of the figure.

Try the static, standing poses first, then go on to draw more and more active poses in which the spine is bent or twisted in various ways and the limbs are flung wide.

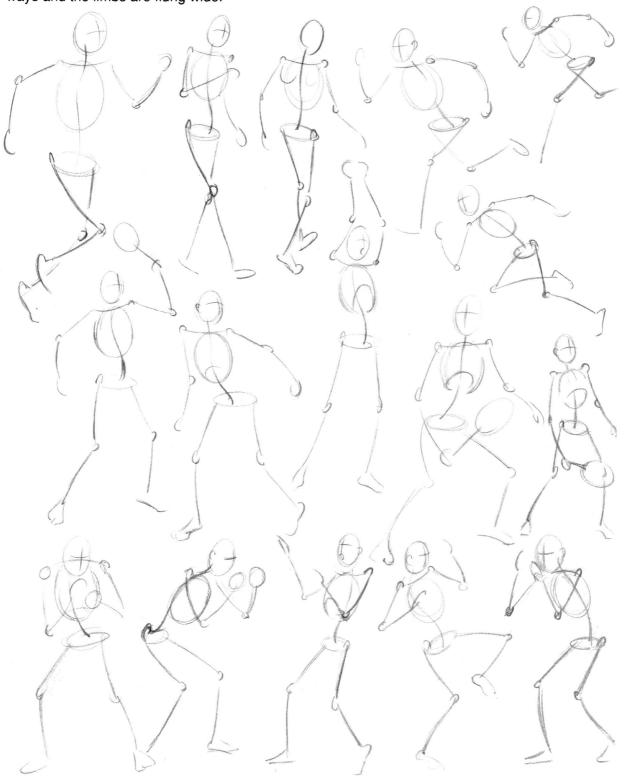

*By simplifying the figure into blocks and cylinders you build up in your mind a conception of the figure as a three-dimensional object in space.*

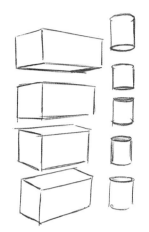

This practice session involves your simplifying the figure into blocks and cylinders so that you build up in your mind a conception of the body as a solid object.

If you can understand these simple shapes as solid, three-dimensional cylinders and boxes, you have a means by which the very much more complex shapes that comprise the human figure can be analysed and understood. This kind of analysis can make an apparently complicated and difficult pose easy to understand. Understanding it, you will be better able to draw it.

The sketchbooks of many great artists contain analytical drawings like these. The technique provides a simple means of establishing the way the forms of limbs and torso relate to one another in space. In creating figures from your imagination, this grasp of three-dimensional form is something you will need to call upon constantly as you draw: your practice with these simplified forms will help to increase the stock of knowledge you bring to bear on the task.

Never forget that your drawing is a two-dimensional representation of a solid, three-dimensional subject, and not merely a line around the outer edges of a flat shape.

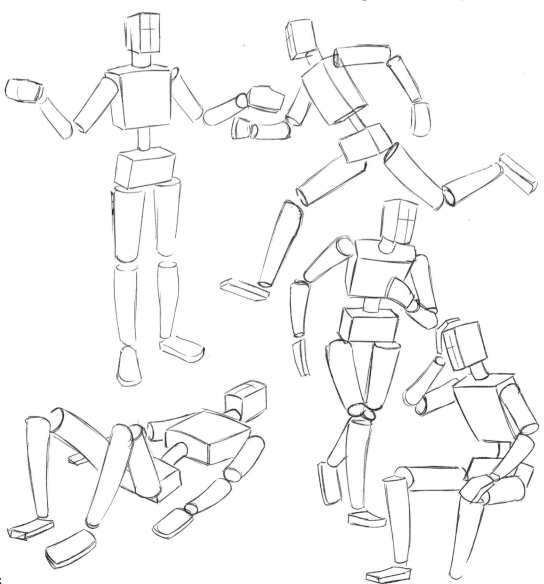

This exercise, derived from one used by the tutors of the famous Bauhaus School in Germany in the 1920s, is an excellent means of gaining an understanding of how a three-dimensional object is represented on a two-dimensional surface.

Find a photographic reproduction of a human figure. The most freely available nowadays are the pictures of fashion models in magazines and mail-order catalogues. Draw lines on the picture as though they were drawn on the skin of the model. Imagine that the lines are actually a part of the original photograph – in other words, drawn onto the model's real body. Cut out the figure and then along the lines you have drawn. Separate the parts and paste them down; then add finishing touches to make it appear that the model has actually been dismembered.

You can have a lot of rather macabre fun doing this! In the process you will become familiar with the intimate shapes of the body and its surface form.

*This rather gruesome-seeming exercise helps you gain an understanding of surface form.*

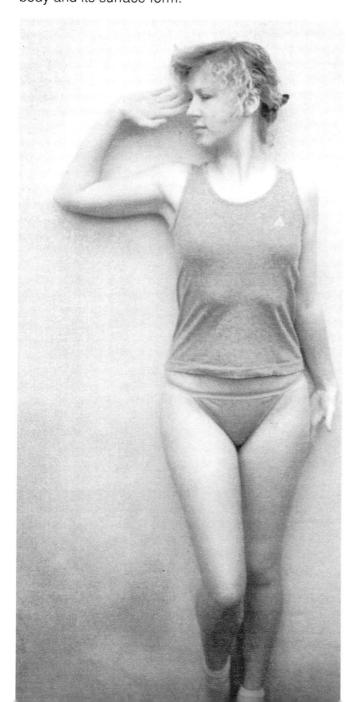

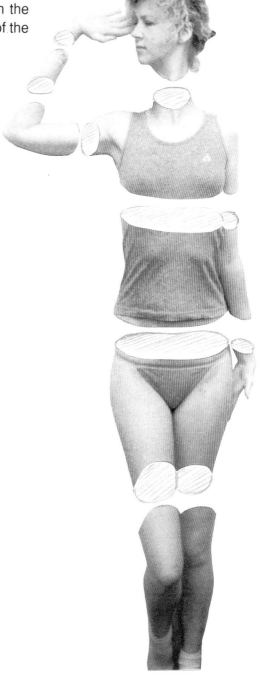

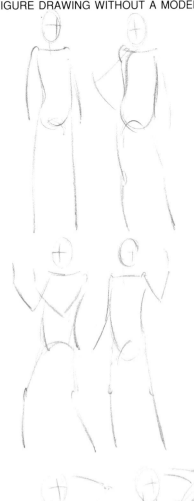

# Fleshing out the Figure

It is a short step from drawing the simplified skeletal figures described on pages 54-5 to drawing a manikin which may serve as a basis for a fully fleshed-out human figure.

If we view the torso as a flexible tube or sausage-shape, remembering that it is capable of twists and bends in any direction – forward, sideways, and to a lesser extent backward – the exercises on pages 54-5 can now be taken further using something very similar to the gesture drawings discussed in Chapter 1 (see page 22). Although they are drawn from memory and imagination rather than from life, the approach should be the same: to establish a complete pose in a few choice lines.

Begin as before with simple standing figures and progress to active running, dancing and sports-playing poses.

Once the basic gesture is jotted down, further refinements can be made: the arms and legs can be fleshed out and the sex differences made evident. The purpose of this type of gesture drawing is to train yourself to establish the complete figure in your mind's eye: to develop the ability to visualize clearly what you want to draw.

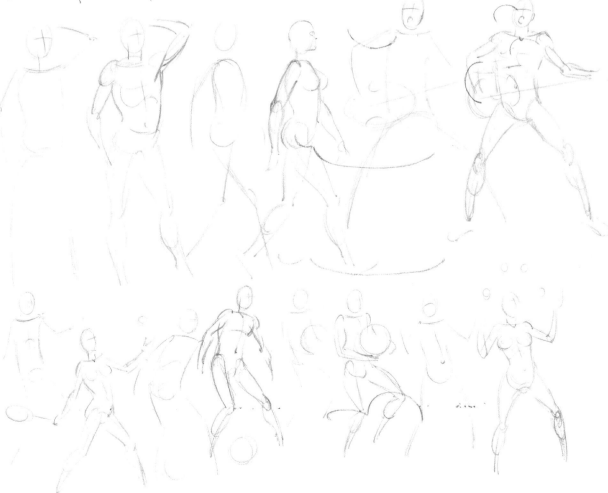

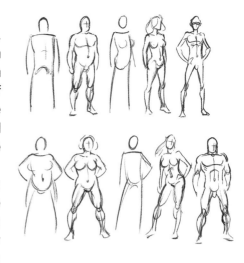

Good drawing is a frame of mind as well as an exercise in line.

For good figure drawing from memory, the artist's identification with his or her subject is of paramount importance. By this I mean that you must feel that you're dealing with an aspect of yourself as you draw. As you draw a hand, you should be acutely aware of your own hand – its structure and proportions, the knuckles and the fingertips, etc. This state of mind will transmit itself into the drawing and so give it life.

Draw a small naked figure – as small as you like, maybe even only a couple of centimetres tall. Your first effort may well look like a rag doll, but this is quite adequate to begin with so long as you bear it in mind as you draw that this little figure is you, yourself. Try to experience the pose while you draw it. Think of your own shoulders, spine, knees and elbows as you draw them. Try to make this figure physically similar to yourself, too: if you are a bit overweight, then this little manikin should be likewise. If you are tall and lean, so should your drawn image be. All this will help you to feel more intimately involved with the figure you are drawing.

Don't be too ambitious in the early stages. Initially just try drawing your figure standing upright, then go on to show the arms raised or the knees bent. Then try depicting the manikin leaning on a stick or sitting down – always remembering as you draw what it's like to do these things yourself. If the pose you have selected is a tense one, feel the tension of it in yourself. If it is relaxed, feel the looseness and calmness of it.

Do this as often as you can – whenever you have a spare moment. It can be quite therapeutic to draw your figure doing something energetic or aggressive on the corner of the telephone directory while you're waiting for a call to be answered. But wherever you draw him or her – *you* –make this little figure a part of your everyday life for a while. He or she will give you a very effective and light-hearted way of gaining skill in imaginative figure drawing.

*Create a little figure representing yourself. Draw it running, jumping, screaming with rage . . . or even hitting someone you're annoyed with. As you draw, bear in mind that the little figure is you. Constant practice of this exercise in spare moments will rapidly increase your skill in drawing from imagination.*

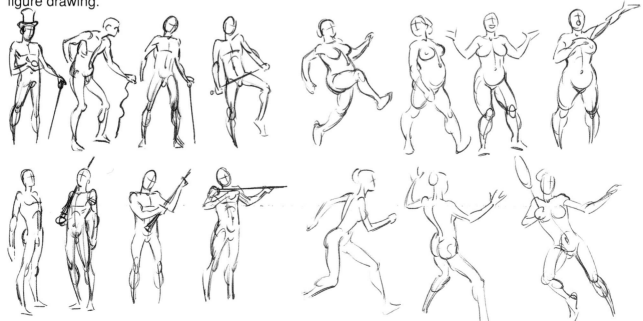

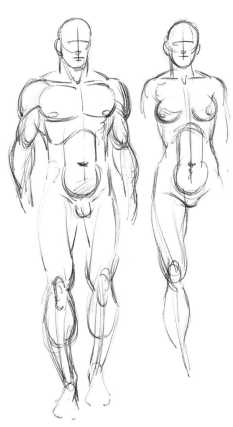

# Exploratory Doodling

Since the shaping of the outer surface of the body is largely a result of the configurations of the muscles, time spent consolidating information about the position and function of the major muscle groups, and the subtle changes in shape they display when a limb is moved, is never wasted.

The lengths of the limbs and the sizes of the muscles and fat masses account for almost all of the differences in shape between one person and another. Of course, not all bodies have large, well rounded muscles, and individual variations can be very pronounced, but all bodies have the same number of muscles in the same places.

Your first drawings might be simply loose diagrams of a limb or joint. Even this preliminary exploration should serve to engage your imagination, and you will gain an insight that will continue to grow. Once you've grasped the basic principles, you can improvize, invent and exaggerate the shapes and structures you draw, and thereby start to explore the cross-fertilizations and insights that are the roots of creativity.

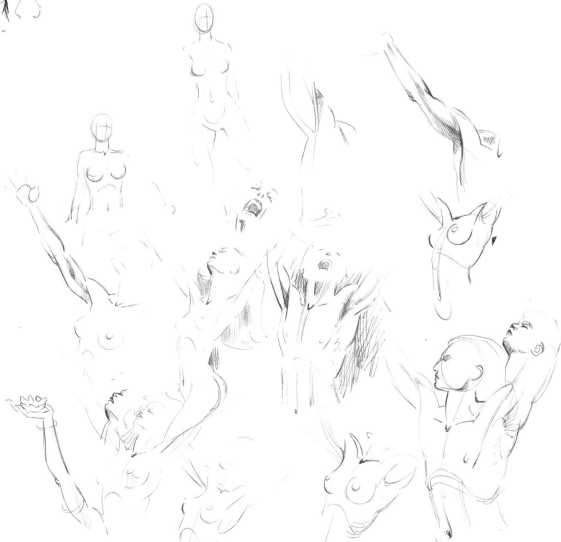

As always, remember that it is in your sketchbooks and notebooks and on odd scraps of paper and practice sheets that your growing knowledge and experience are processed, your imagination is indulged and you generate new ideas. Of all drawing activities, this can be one of the most satisfying and most rewarding. Never underestimate the value of doodling – of 'thinking with a pencil'.

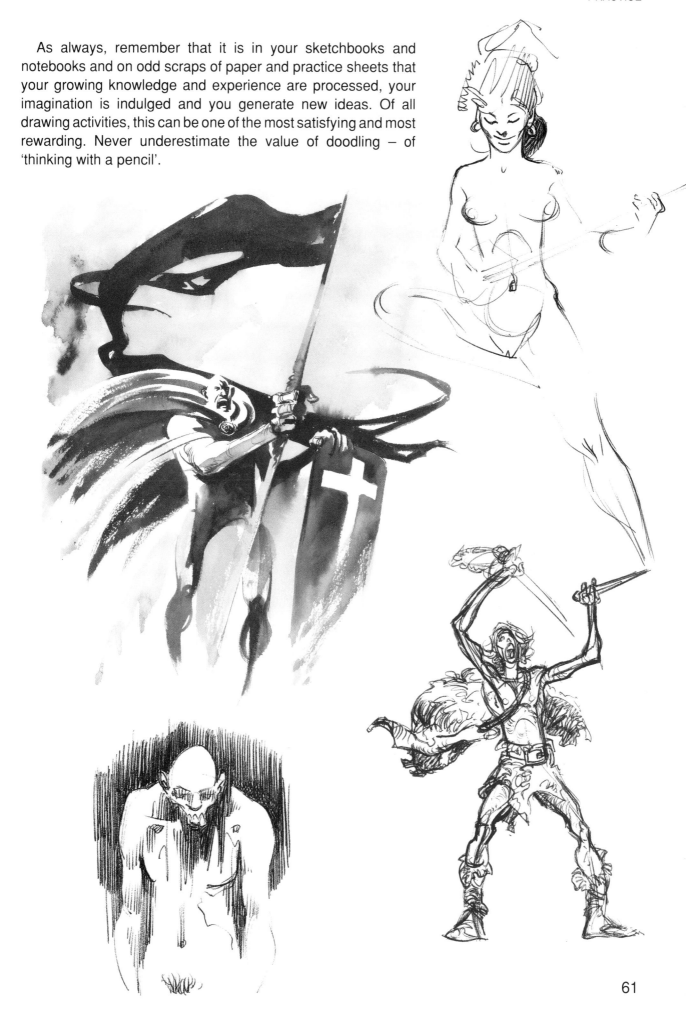

CHAPTER 4

# THE FIGURE IN ACTION

The human body is perhaps the most versatile living structure in nature. *Homo sapiens* is alone among mammals in having adopted a fully upright posture as its customary stance, and has evolved a number of unique physical characteristics as a result.

The head, chest and vital organs are supported on a vertical spine, not hung below a horizontal one. As the front limbs no longer perform a supporting function, the shoulders have evolved to become wider apart, thus offering Man a far greater range of movement of the arms than is possible for the forelegs of, say, a horse or a cow. The suppleness of the spine makes twisting and bending motions possible. The broadened pelvis and modified

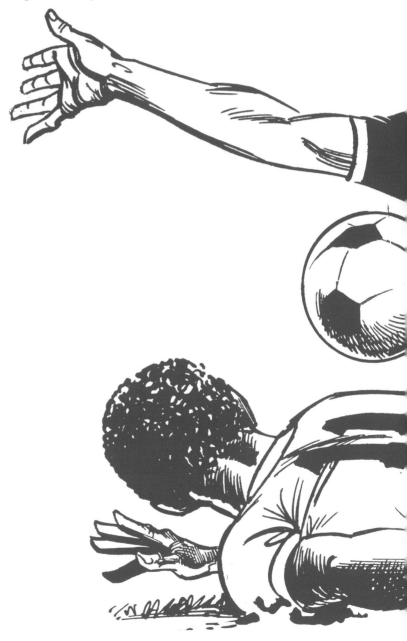

hip-joint expand the range of uses to which the legs and feet can be applied in such activities as kicking and swimming; indeed, the spine and joints of some individuals – 'double-jointed' people – are so flexible that their bodies can be contorted into almost any conceivable position, with the limbs held at almost any angle relative to one another.

But the tremendous versatility of the human body, while offering artists infinite possibilities in terms of stance and action postures, also presents us with a number of specific difficulties, not least of which is balance.

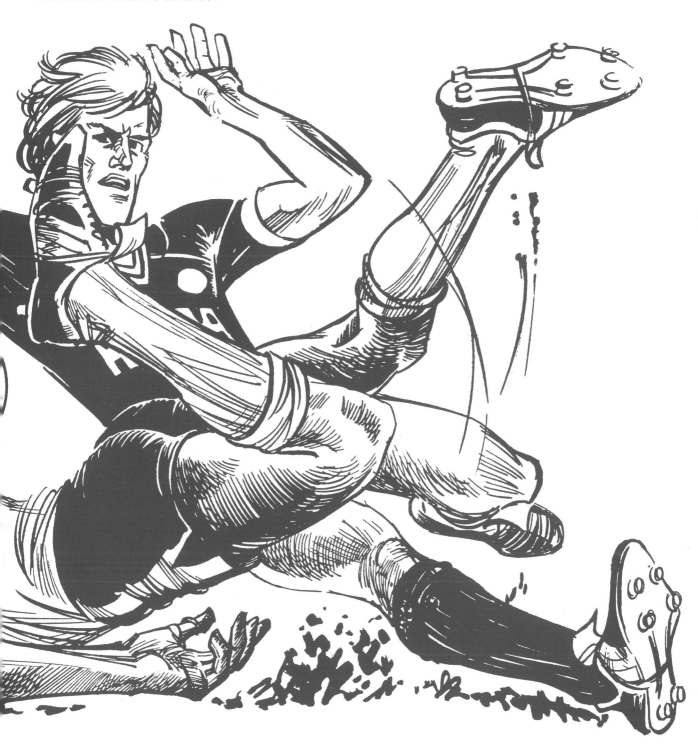

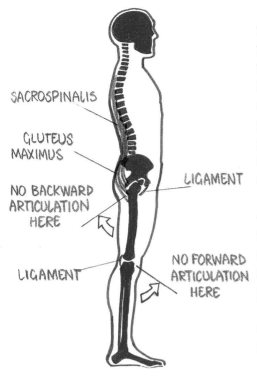

SACROSPINALIS

GLUTEUS MAXIMUS

NO BACKWARD ARTICULATION HERE

LIGAMENT

LIGAMENT

NO FORWARD ARTICULATION HERE

Upright posture is maintained by the sacrospinalis muscles in the back, which bind the spine tightly to the pelvis and hold the torso erect, and by the gluteus maximus muscle of the buttock, which holds the trunk upright on the legs. As we noted in Chapter 2, strong ligaments at the front of the groin prevent backward articulation of the thigh, while others at the back of the knee prevent forward articulation of the knee joint. In a normal standing posture, the hip is slightly forward of the body's centre of gravity and the knee is slightly behind. These two joints are locked in opposition to each other, providing a perfect supporting structure.

To remain upright, the body must maintain balance at all times – whether standing, bending, twisting or stretching – or it will topple over. This means that in any standing figure the body's centre of gravity must be directly over the supporting foot or feet, and this you should always bear in mind when drawing a balanced pose.

Balance is of paramount importance in all physical activity: every movement of one limb requires opposite and complementary movement of other parts if the body is to retain that equilibrium. In the elementary example shown below, the figure on the left is standing upright on both legs, and the line of the shoulders, seen from the front, roughly parallels a line drawn through the hips. If the figure adopts a relaxed stance (below right), in which most of the body's weight is supported by one leg, the hip on that side will be higher than the other. The line of the shoulders automatically adopts a complementary slope in the opposite direction so that the body remains upright and stable.

Readjustments of this kind take place every time we change our posture. We retain our equilibrium by constantly redistributing our body-weight. This is not a conscious process, of course – it is something we never really think about. If you do plenty of sketches from observation of people standing chatting in city streets or waiting for buses, your understanding and perception of such things will soon become just as automatic, and the benefits will be evident in your drawings.

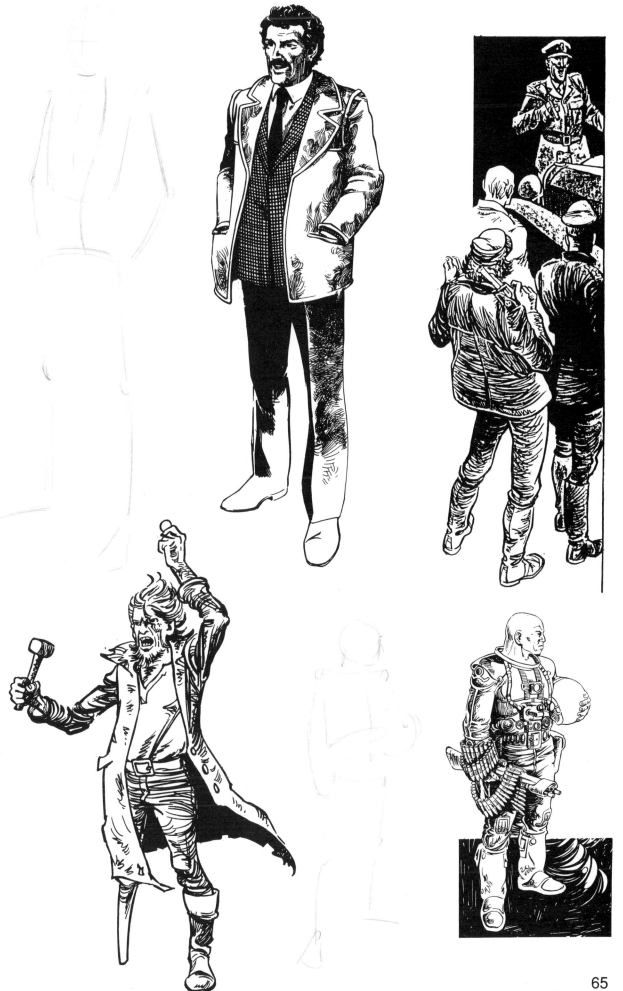

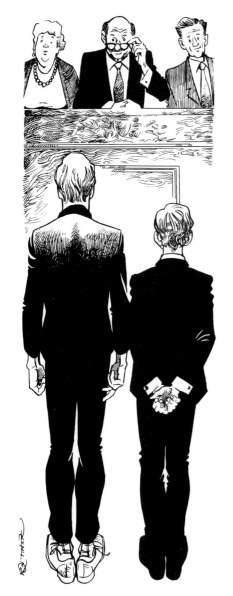

**Above:** *Two illustrations from* Gumboot Practice, *written by John Francis. [Copyright © Smith Settle Ltd.]*
**Below:** *Sketchbook jotting of a group in conversation.*

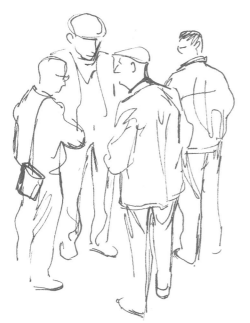

Individuals stand in diverse ways as a consequence of subtle differences in body-structure, limb-length and spinal flexibility. Age, too, has an influence on normal body stance, as may clothing. Physical tiredness will show, and so to some extent will the person's mental and emotional state. The way individuals stand can say a very great deal about them.

Looking at the group illustrations reproduced on this page, you should be able to deduce something about each of the individuals portrayed from their posture – something about their character and also a little about their feelings.

The quick sketch of a small group of raincoated figures was drawn at a racecourse. When people relate to each other in this way, they quite naturally adopt similar postures, so it is easy to tell from posture alone which of the men here was not really involved in the conversation.

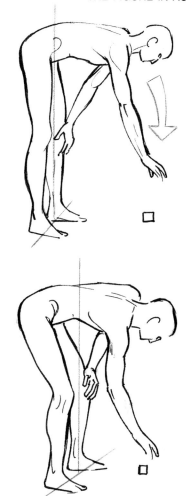

If you've ever tried making an articulated doll or lay figure stand upright and discovered what a delicate and careful operation this needs to be, you'll know what a remarkable feat of balance the same task is for a living, moving organism. Each time a person moves a limb, bends the back, or lifts a weight, adjustments and compensations have to be made with other parts of the body to maintain that fine balance and avoid falling over.

Take the simple example shown at left. The act of picking something up from the ground appears to be a simple matter of bending at the hip and extending the arm downwards in order to grasp the object. However, for the person to remain standing, the position of the pelvis relative to the supporting feet has to be changed to counterbalance the weight of the torso leaning forward. Of course, normal individuals are doing this all the time. We are all permanently in the process of making compensatory movements to counterbalance every weight we lift and counteract the effect of every movement of a limb, every bend and twist of our body.

This is clearly a relatively simple process when we are bending to pick something up, but in a high-speed activity such as disco dancing such adjustments may need to be made a hundred times in a few seconds. Despite the fact that we never really think about them, any drawing of a figure will look odd if it doesn't show these compensatory movements taking place and balance being maintained.

*All day and every day we perform the small compensatory adjustments required to stay on our feet and avoid falling over.*

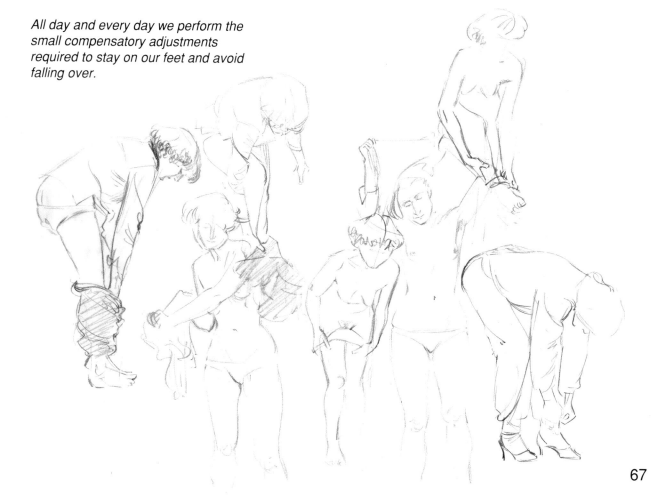

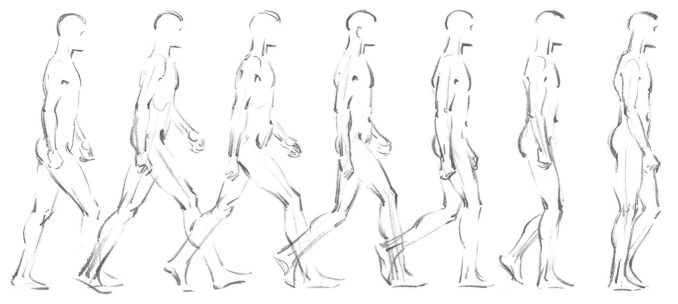

# Walking

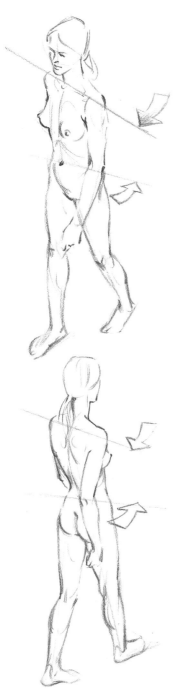

During physical activities like walking and running and kicking, the body is in a state of controlled imbalance and the centre of gravity is only rarely vertically over the supporting foot, as it must be when we are standing still. The act of walking is an example of an action in which a rhythmic sequence of limb movements is repeated again and again. And it doesn't involve only the legs. The need constantly to restore and adjust equilibrium involves the arms and torso in a series of compensating movements in which most of the voluntary muscles of the body are involved.

The series of drawings along the top of these two pages shows the complete sequence of limb movements involved in two strides. The sequence begins with the body being impelled forward by the left leg as the right leg is lifted and brought forward so that it can receive the weight of the body in its turn. When the right foot is firmly in contact with the ground, it begins to take over the weight-bearing role and, as forward movement continues, the left leg is lifted and brought past the right until at last it is placed in front to take over support once again.

These leg movements are in themselves fairly simple but, because the body is continually moving forward, the arms and torso must perpetually be making a number of fine adjustments to retain stability. The left arm swings forward with the right leg and the right arm with the left leg, so that the figure does not have to take on a rolling motion as the weight shifts alternately from one leg to the other. Hip and shoulder movements likewise take place, and the upper body may lean slightly ahead to aid forward movement.

As each leg comes forward the hip on that side likewise swings forward slightly. This is counterbalanced by a backward swing of the shoulder on the same side. The net result is that the body twists at the waist, adding the strength of the abdominal and oblique muscles to the movement of the legs.

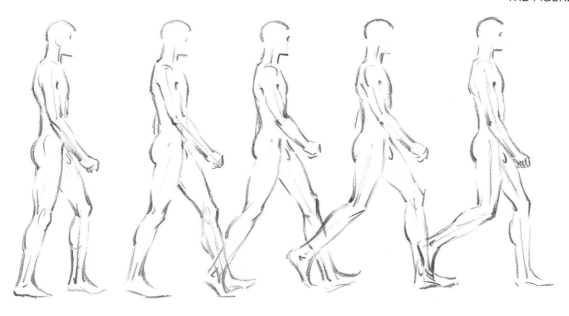

We can see that in this way the whole body is involved in the action, maintaining balance and the control of the forward movement. The rhythmic movements, as well as the additional rocking motion of the pelvis, are shown in the other drawings on this page.

These adjusting and compensating actions are a very important consideration when you are drawing moving figures. They become more pronounced in speedy or violent action. In the drawing of the race-walker on this page, the hip and shoulder movements and the forward lean of the body are very much more evident, and the swing of the arms is more vigorous. It is these differences, rather than the length of stride, that show us that this is a much more energetic activity than ordinary walking.

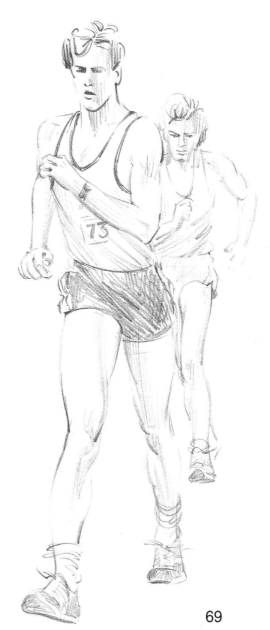

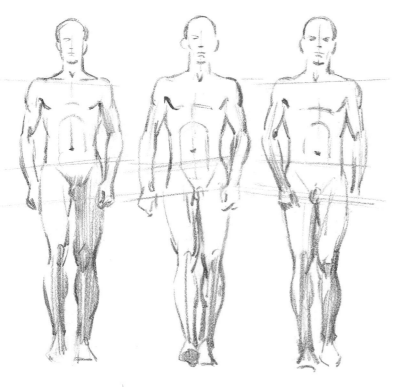

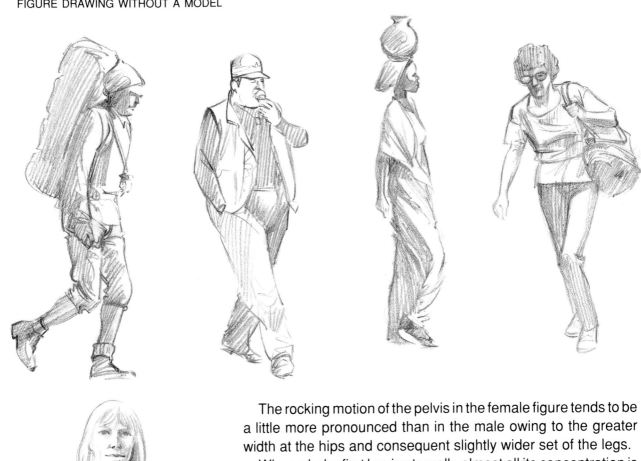

The rocking motion of the pelvis in the female figure tends to be a little more pronounced than in the male owing to the greater width at the hips and consequent slightly wider set of the legs.

When a baby first begins to walk, almost all its concentration is focused on maintaining balance, because the head and torso account for so much of the total body-weight. So the arms are held out and up, and the child 'toddles' precariously along. But later, as the legs lengthen and strengthen, balance becomes less difficult and the action is more fluid.

Weight distribution has a marked effect on the way in which walking – or, indeed, any other activity – is carried out. A fat man

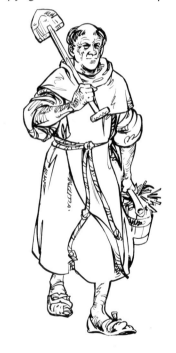

**Left:** *Unpublished illustration for* Gumboot Practice, *written by John Francis.*
**Below:** *Illustration from* In a Monastery Garden, *written by E. and R. Peplow.*
*[Copyright © David & Charles plc.]*

with a heavy abdomen will tend to lean back as he walks, while a hiker carrying a heavy rucksack strapped to his or her back will lean forward to keep the centre of gravity of the hiker-rucksack combination over the legs, adopting a rolling gait as left and right feet alternately come in contact with the ground.

Carrying a heavy weight in one or both hands may cause the shoulders to be pulled forward and down. If the weight is slung over one shoulder, the figure will lean over towards the opposite side to achieve the same result.

A *very* erect posture is necessary for someone carrying an object on their head.

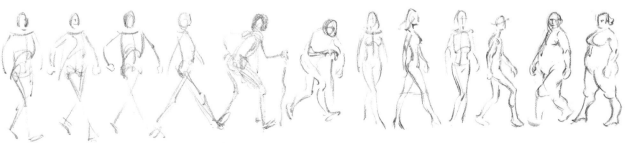

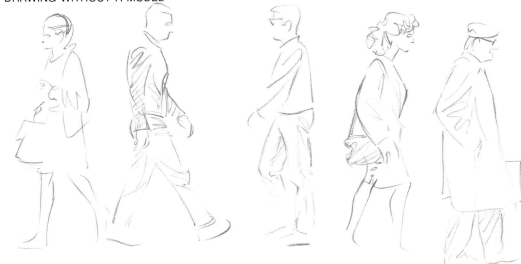

# Drawing Walking Figures from Life

In this, as in all other aspects of figure drawing, the most important source of knowledge and understanding is your sketchbook. Through informal studies made in real-life situations you gain an intimate perception of such things and, in the process, develop increasing drawing skills.

To catch the action of walking figures you need to choose your vantage point carefully, so that the people walking past you are a sufficient distance away. If you are looking across a wide street, the people on the other side will repeat their steps several times while your viewpoint remains almost unchanged, so that you have time to decide upon the person you wish to draw and glance up at them several times as you quickly jot down the movement. As I said in Chapter 1, this kind of exercise should be treated as a work-out. It helps you develop a sureness of touch that you cannot achieve in any other way, and your drawings will have added vitality as a result.

Catching the character of a continuing, fluid sequence of movements in activities like walking is by no means an easy task, and only a few worthwhile jottings may result from your first efforts, but the learning process is greatly enhanced by this exercise. There is a subtle yet profound difference between a drawing made from life of a walking figure and a drawing of a model posed as though walking. If you do draw from life frequently, the drawings you create at other times from memory and imagination will be more authentic and convincing. You will become immediately aware of character in the different proportions of individuals, their postures and the way they move. Some walk in an apologetic way, others aggressively; some with pride, others as though burdened with life's problems. All this can be convincingly recorded in your sketchbook and the experience you gain will later enrich your work. I cannot recommend the practice too highly. It will prove invaluable to you as a developing artist.

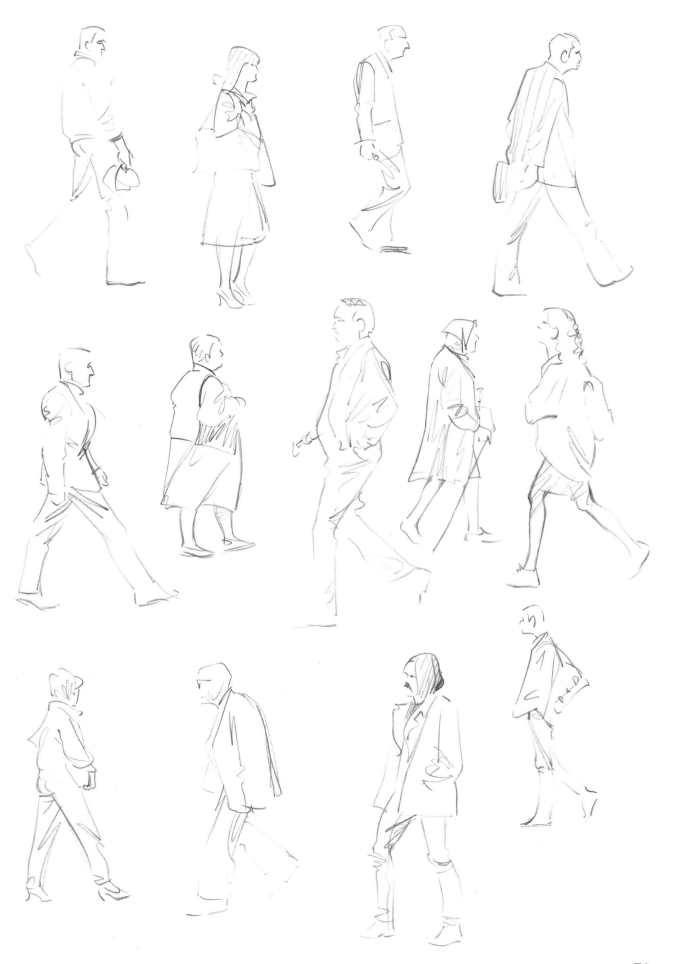

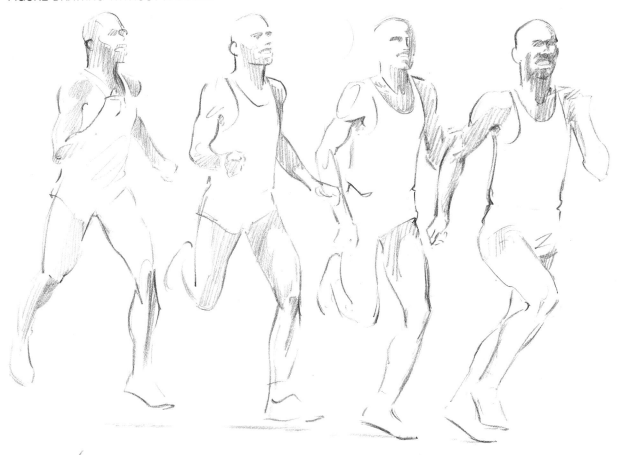

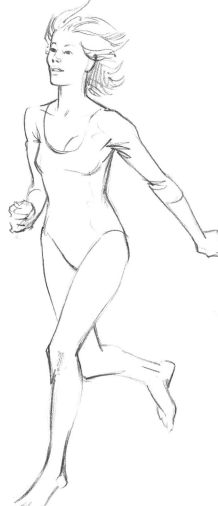

# Running

During the action of walking, at all times there is at least one foot in contact with the ground. But running involves a leap from one foot to the other, and so there is a moment during every stride when there is no contact with the ground at all.

The first two drawings in the sequence above show this part of the process. The right foot has thrust the body forward and has left the ground, while the left foot has been brought forward in order to receive the body's weight and carry on the action. The upper body continues its forward movement. The right leg is lifted high and brought forward, past the supporting left. As it reaches out in front for the next stride, the left leg springs the body forward once again, to land on the right foot so that the cycle is repeated.

Movement of the pelvis is minimal. The massive swing of the top half of the body is, by contrast, very pronounced, aided by strong movement of the arms. This serves two purposes: it keeps the majority of the body's weight over the load-bearing foot, so maintaining lateral balance, and it also allows full use to be made of the muscles of the waist and back, so that strength and speed are added to the movements of the legs.

The differences in posture between the runners in the other drawings on these two pages reflect the different degrees of force and energy being used.

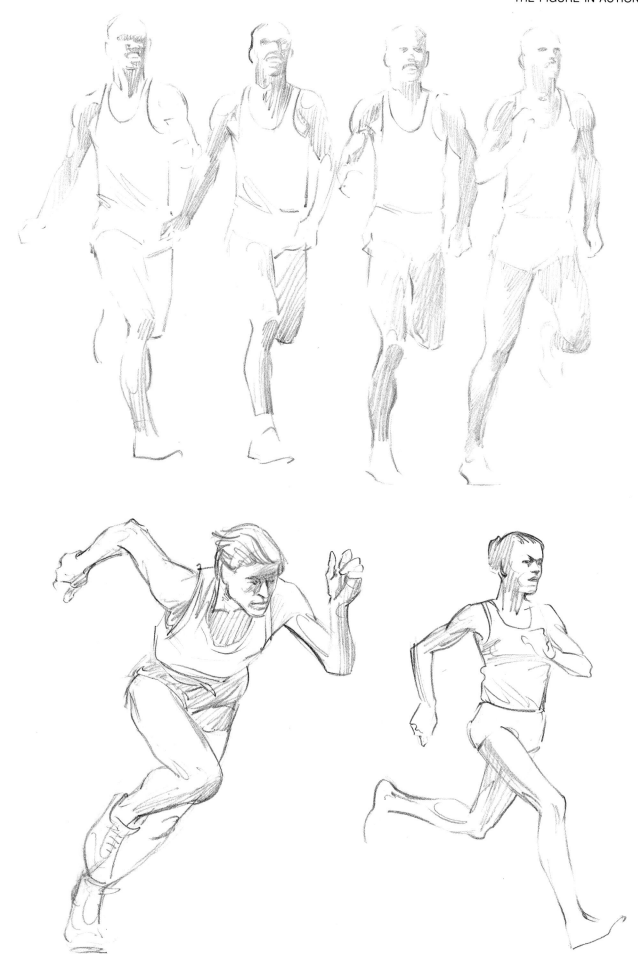

**Right:** *Illustration from* Lorna Doone, *written by* R. D. Blackmore.
**Below:** *Illustration from* Canon, *written by* Melvyn Bagnall.
**Opposite, top left:** *Illustration from* Timequake, *written by John Wagner.* [Copyright © Fleetway 1991.]
**Opposite, top right:** *Illustration from* Spring-Heeled Jack. [Copyright © D. C. Thompson.]

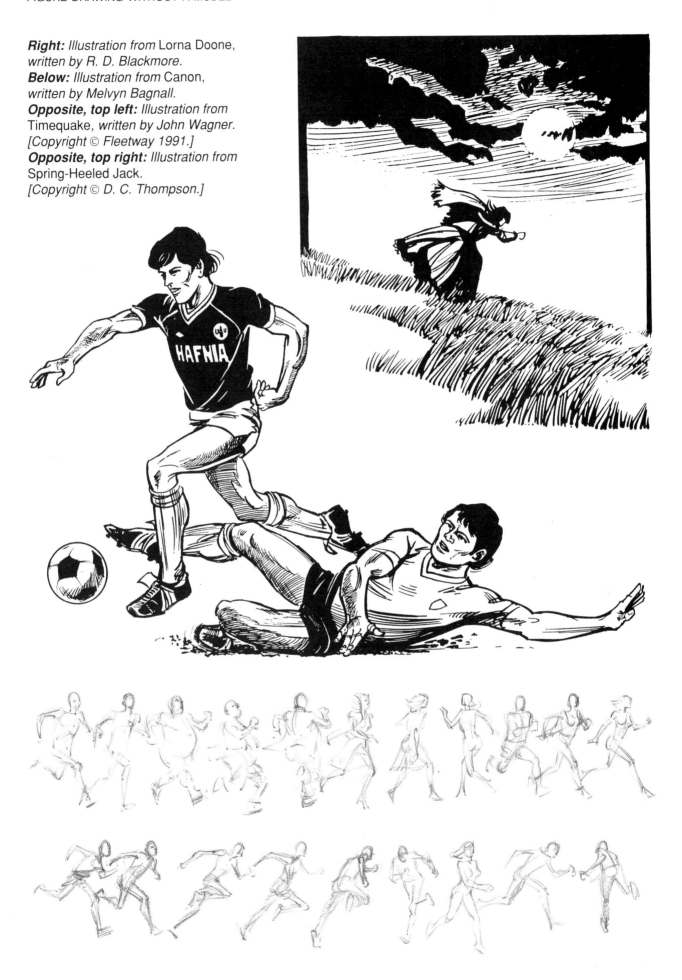

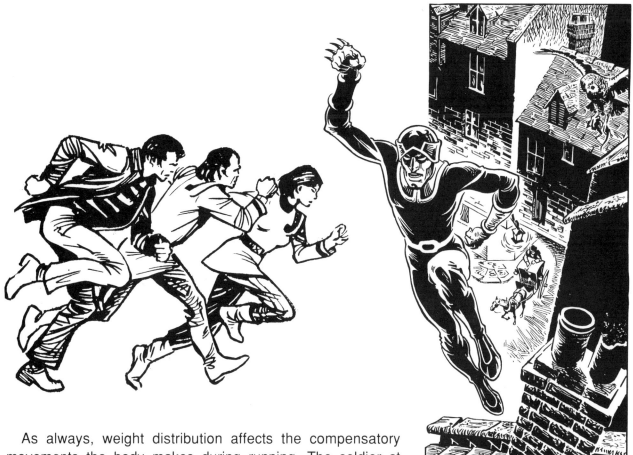

As always, weight distribution affects the compensatory movements the body makes during running. The soldier at bottom right swings the heavy gun he is carrying to left and right to keep his lateral balance over whichever foot is in, or about to be in, contact with the ground; this ensures that he doesn't fall over sideways. His centre of gravity is not, however, vertically above the supporting foot at any moment, as it would be if he were standing still and lifting alternate legs; his whole body is leaning forward so that the strength of the legs is used effectively to impel him forwards.

A visual analysis of any single moment in the action can be readily undertaken using the simplified skeletal, matchstick-figure and gesture drawings discussed in Chapter 1. As you draw, try to feel the action in your own limbs, and use the pencil to search out the movements and tensions of the body: if you *experience* the action yourself your drawing will reflect and communicate it effectively.

Photographs from sports magazines can be useful at this stage – not, let it be stressed, as pictures to copy, for a good drawing of a running figure must be more than a frozen moment in the whole action. However, by drawing the positions of torso, limbs and so on in a simplified analytical way, you can firmly grasp and understand the complete cycle of limb movements and counter-movements.

Just reading about all this will not improve your ability to draw it. You need to search out the information in visual terms for yourself, and practise drawing the essentials, so that the essence of the action becomes a part of your drawing experience.

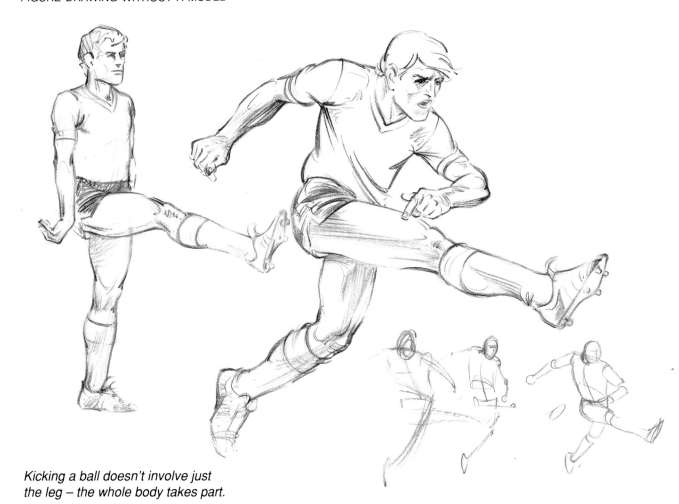

*Kicking a ball doesn't involve just the leg – the whole body takes part.*

All that I have said in the preceding few pages about the drawing of walking and running figures is relevant when you attempt to capture any other figure movement. The entire manoeuvre must be thoroughly understood if you're to make a convincing drawing.

If you have any difficulty, go through the whole movement yourself, noticing how your body quite naturally adopts the balancing and compensating positions which your drawing will need to show in order to be convincing. The two drawings at the top of this page are attempts to draw a man kicking a football. The first figure could be kicking, but if the player is to do it properly his whole body needs to be involved, with compensatory movements of trunk and arms being made to allow the application of maximum force without loss of balance or control. Once you are thoroughly familiar with these movements, it should be possible for you to draw the figure in action from any angle using the gesture-drawing technique described earlier. This is the key to your complete understanding of what's happening in the action.

These principles may sound enormously complicated when described in words, but they are really quite simple. Since you are making compensatory balancing adjustments instinctively almost every minute of your waking life, you will, once you have come to understand the principles involved, find yourself able to reflect them just as naturally in your drawings.

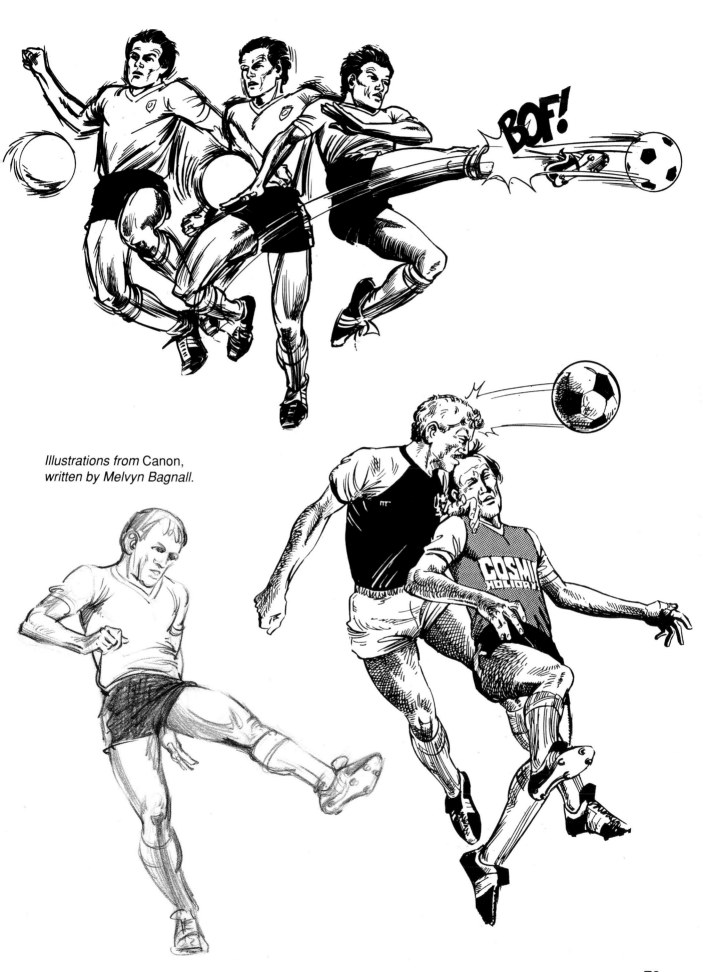

*Illustrations from* Canon,
*written by Melvyn Bagnall.*

BOF!

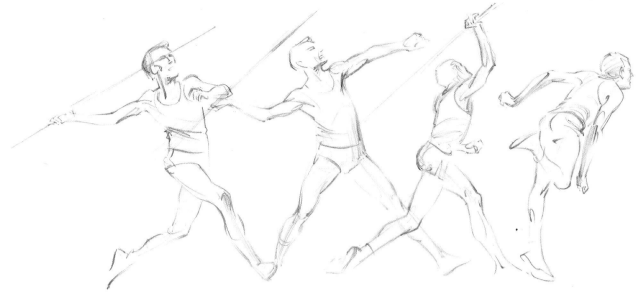

# The Definitive Moment

Generally you will want – or be asked to produce – only one drawing of any complete action, and so you have to choose which part of the action to draw. Your single drawing must represent the whole of the action from start to finish. In a good action figure drawing, it should be evident what has just happened and what is just about to happen. If the point in the action which you choose to depict epitomizes the entire manoeuvre your drawing will be perceived and understood as a *moving* figure.

In the sequence above, the javelin-thrower has run up towards the scratch-line and is shown taking the last stride of his run with his body arched back and his throwing arm extended behind him in readiness for the big forward thrust. The other three drawings in this sequence show how the right leg is straightened as the muscles of the torso, shoulder and arm are all brought into play to throw the javelin forward and upward. At the instant of the throw the entire length of the body, with arm extended, is like a long lever pivoted on the left foot.

Perhaps surprisingly, the drawing in the sequence which least represents the dynamic nature of the whole manoeuvre is the one

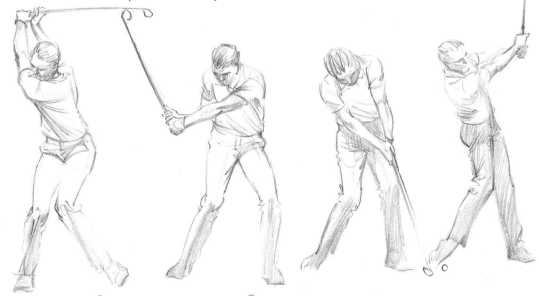

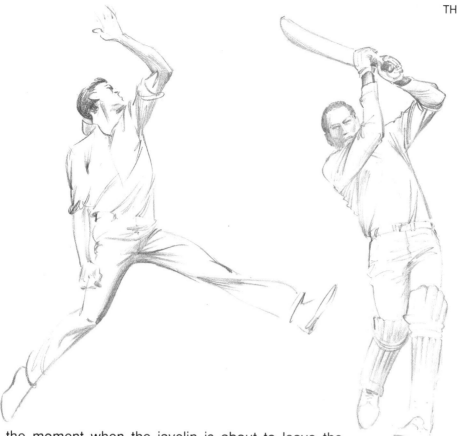

showing the moment when the javelin is about to leave the athlete's hand. At this point all the force he can muster is concentrated into the throw, and yet his body position as seen in the drawing is very ambiguous. The same is evident in the sequence showing the golfer: at the moment of impact, the posture of the body and the positioning of the limbs give us no indication of what is going on.

For this reason it is often best to draw your figure at a stage before or after the definitive moment. This principle holds true for all throwing and striking actions. In all the other drawings on these two pages the figures are shown just before or just after that definitive moment. The cricketer above is caught immediately before bowling the ball down towards the wicket, and in the other drawings we see the action at a point immediately after the point of impact.

*In a good action figure drawing it should be evident what has just happened and/or what is just about to happen.*

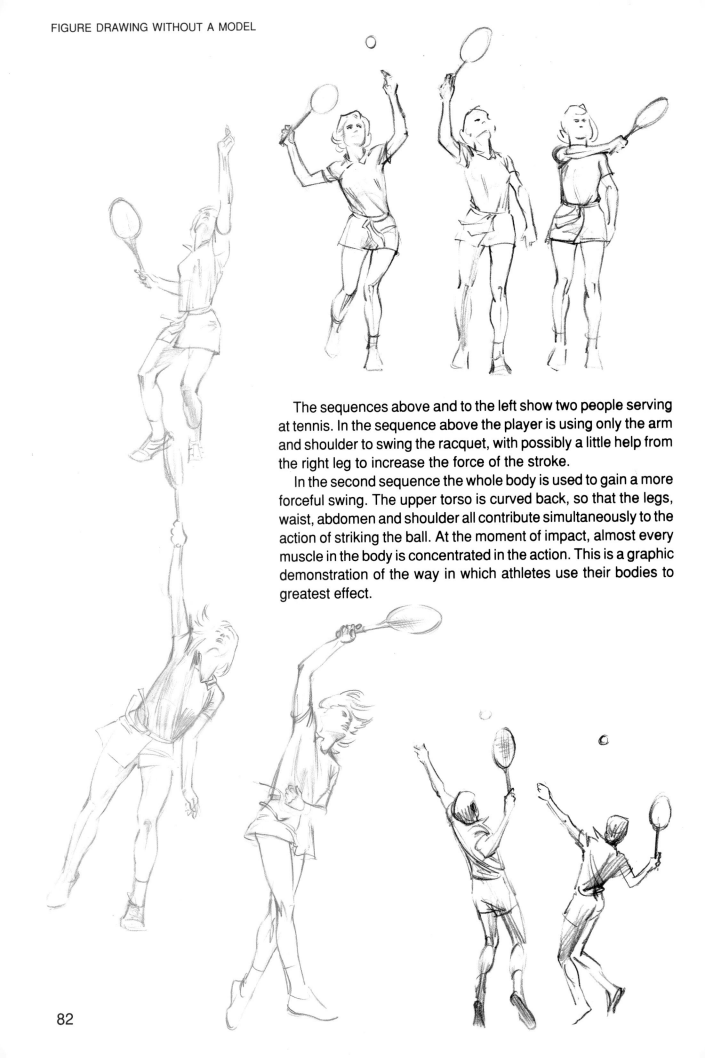

The sequences above and to the left show two people serving at tennis. In the sequence above the player is using only the arm and shoulder to swing the racquet, with possibly a little help from the right leg to increase the force of the stroke.

In the second sequence the whole body is used to gain a more forceful swing. The upper torso is curved back, so that the legs, waist, abdomen and shoulder all contribute simultaneously to the action of striking the ball. At the moment of impact, almost every muscle in the body is concentrated in the action. This is a graphic demonstration of the way in which athletes use their bodies to greatest effect.

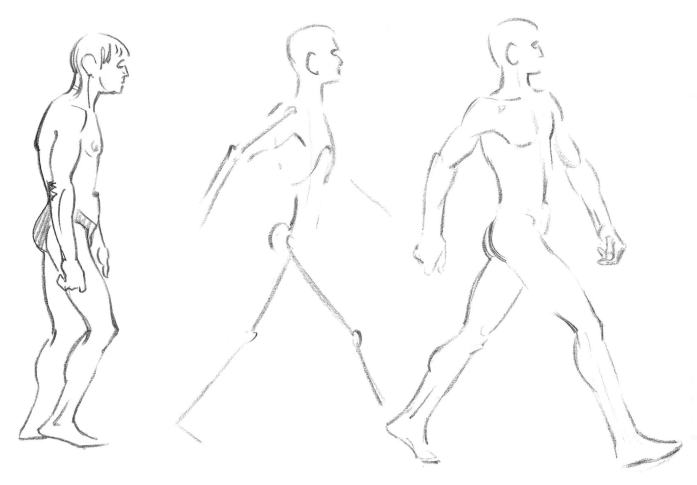

Although we shall not always have athletes as our subjects, it is useful to understand how they achieve greater speed and power in their movements through more completely coordinated action. In less effective action, fewer muscles are brought into use and they are less well coordinated: the movement looks clumsy and ineffectual because not all the limbs are involved together.

The body conserves energy by using fewer muscles. A person walking in a tired or lazy way, as shown in the drawing above left, makes almost exclusively leg movements, the other muscles barely coming into play. The more vigorous walker on the right is using the muscles of the waist, shoulders and arms as well, and as a consequence the picture of him is more expressive of movement and purpose.

The remaining two drawings on this page show the whole body concentrated in the action, so that all the muscles are brought into use for maximum force and efficiency. In these gesture drawings the dynamics of the movement are shown, and you can see how the tension runs through the whole length of the figure.

In setting down the thrust of the action in this way, we are drawing the anatomy of the *movement* first and that of the *figure* afterwards. Your finished drawing must still retain the essence of these vital lines, for they are the heart of the action: the drawing will look posed and unconvincing if they are not allowed to influence the finished work.

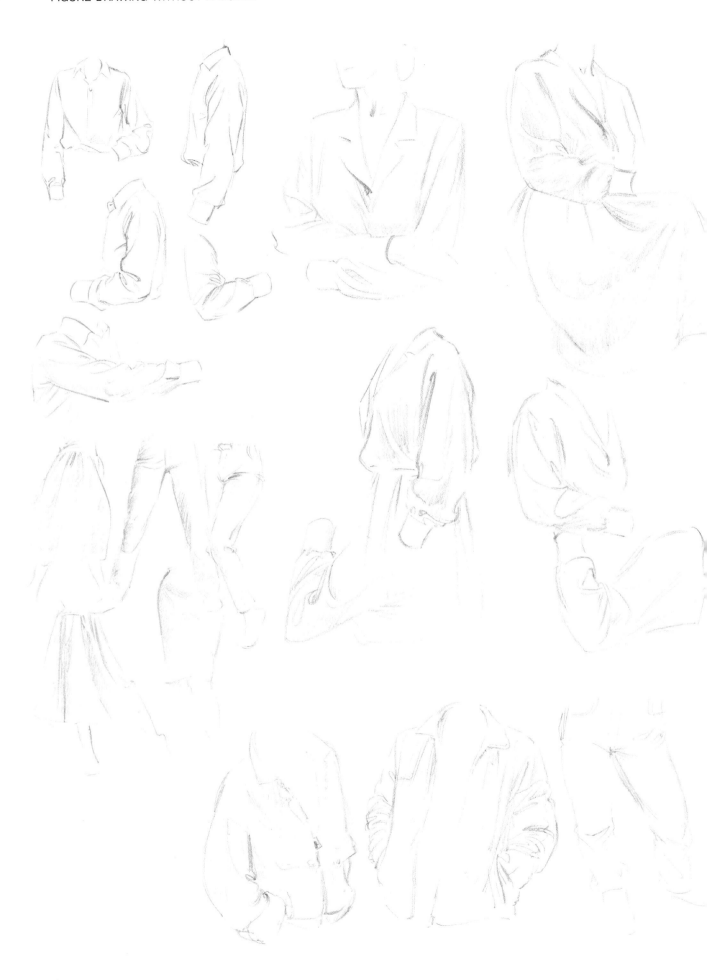

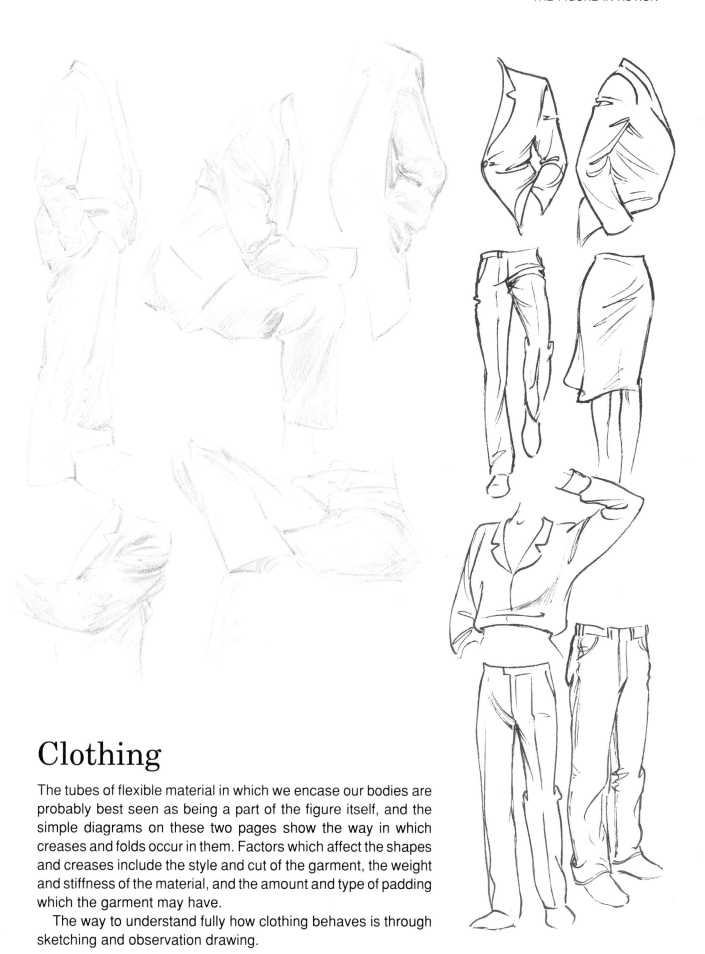

# Clothing

The tubes of flexible material in which we encase our bodies are probably best seen as being a part of the figure itself, and the simple diagrams on these two pages show the way in which creases and folds occur in them. Factors which affect the shapes and creases include the style and cut of the garment, the weight and stiffness of the material, and the amount and type of padding which the garment may have.

The way to understand fully how clothing behaves is through sketching and observation drawing.

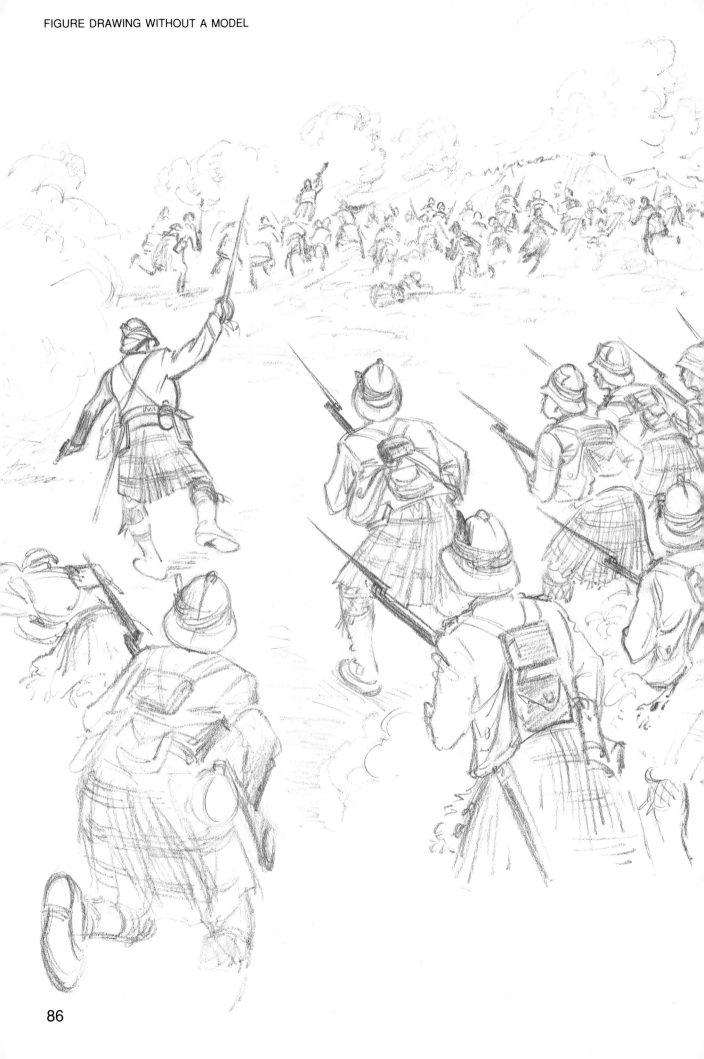

*This drawing is based on a field sketch by Melton Prior, war reporter for* The Illustrated London News, *at the battle of Tel-el-Kebir.*

CHAPTER 5

# DRAWING ON THE IMAGINATION

When you have had some experience in drawing the human figure from life and have assimilated the basic information about the body's structure and operation, the prospect of creating imaginative figure drawings without a model becomes far less daunting. A great amount of information about human anatomy and movement is learned in the process of drawing the posed studio model and from sketching people as they go about their daily lives, but this is not the sole purpose of such exercises. Knowledge gained in this way is absorbed at an intuitive level, and as such contributes to the stock of experience available to feed your imagination and give scope to the expressive possibilities of your work. The human form is so subtle, its range of movement so wide and its expressiveness so profound that no artist can claim to have explored all its vast potential. Drawing from life keeps your mind open and liberates your imagination. If your work is to remain honest and alive and free from slick clichés, you must return constantly to observed studies and sketches.

That having been said, it is now time to look at approaches to drawing from memory and imagination.

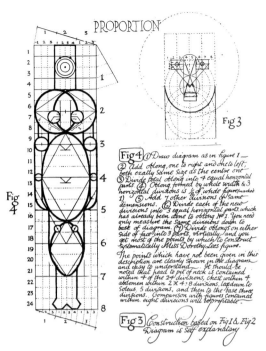

PROPORTION

Fig 3

Fig 4 (1) Draw diagram as in figure 1
(2) Add oblong, one to right and one to left,
both exactly same size as the centre one
(3) Divide total oblong into 4 equal horizontal
parts (4) Oblong formed by whole width & 3
horizontal divisions is ⅔ of whole figure (marked
1) (5) Add 7 other divisions of same
dimensions. (6) Divide each of the new
divisions into 3 equal horizontal parts which
has already been done to oblong No. 1. You need
only measure the same divisions down to
base of diagram. (7) Divide oblongs on either
side of face into 3 parts, vertically, and you
get most of the points by which to construct
systematically Miss Dorothy Lees figure.

The points which have not been given in this
description are clearly shown in the diagram
and easy to understand. It should be
noted that head to pit of neck is contained
within 4 of the 24 divisions, chest within 4
abdomen within 2 × 4 = 8 divisions, leg down to
Soleus, 5 divisions, and then to the base three
divisions. Comparison with figures contained
within eight divisions will be profitable.

Fig 3 Construction based on Fig 1 & Fig 2
Diagram is self explanatory

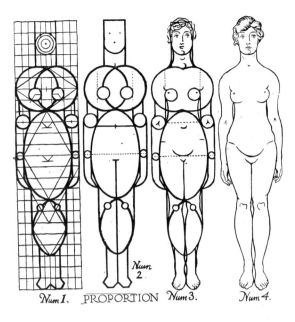

Num 1. PROPORTION Num 3. Num 4.

Num 2

**Above:** *It's difficult to believe that this crass nonsense was ever seriously put forward as a drawing method, but put forward it was! Reproduced from A. A. Braun's* The Hieroglypic Method of Life Drawing *(1916).*
**Below:** *Arthur Zaidenberg's method of figure drawing involved flat geometric shapes for the torso, with no conception of the figure as a solid, three-dimensional form in space.*

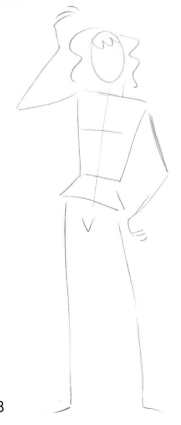

Experienced artists are not generally conscious of working in stages from first concept to finished picture. It is only when faced with the problem of teaching their craft that the question of procedure comes up. You have an image in mind, and a number of variations on the basic theme may be jotted down in embryo form before one is selected; thereafter, resolution and refinement of the drawn image form a continuous process. Alternatively, the germ of an idea may be put down in graphic terms and then embellished or added to, so that the drawing 'grows' on the page. Experienced artists naturally evolve a personal procedure, but even this probably varies according to the requirements of the finished artwork or the original motivations for it. Certainly, if you create an unvarying routine, in which each new drawing is always tackled according to exactly the same procedure, you place unnecessary constraints upon what you can achieve.

There is no step-by-step method which can be imparted to beginners that will enable them immediately to start producing good imaginative drawings. The quality of your work will be governed by your experience and by the extent to which you involve your imagination and creativity in the process.

Studying the working methods of other artists can of course enrich your work very considerably. Sadly, though, very few of the thousands of creative artists and illustrators who have lived and worked during this century have ever written down anything about the nuts and bolts of their practical procedure. All that vast output, and yet hardly a published word about how it was done!

Before I started writing this chapter I searched through all the sketchbooks and working drawings of artists and illustrators I could find, as well as talking to many working artists, in order to study their approaches to the task of drawing from memory.

Sketchbooks and informal studies by famous artists are often obtainable in the print-rooms of museums and municipal art galleries. Remarkable among them is the work of the artist-

reporters of the l9th century, who travelled on campaigns with the British Army and sent back drawings of manoeuvres, battles and military parades for publication in newspapers and magazines at home. Many of these on-the-spot drawings, along with complete sketchbooks used by the artists, are held in the National Army Museum in Chelsea, London. They provide a fascinating insight into the working methods of these remarkable people and the hazardous lives they led; similar examples are available in Washington DC at the Library of Congress (for the Civil War) and the National Archives (where the files of the War and Navy departments are kept). The scenes the war artists drew were reconstructed from the sketches and brief notes they had made, often at great personal risk in the heat of battle; these were subsequently used as authentic reference material by home-based engravers and painters, who could thereby produce huge panoramic views of the campaigns abroad.

At that time no distinction was drawn between illustration and fine art, and memory drawing was a part of every artist's training. Exercises to develop the visual memory were devised in the life class, such as giving the student a few minutes to study a pose and then dismissing the model before drawing was allowed to start. The pose could be readopted later, once the drawing had been finished, to check accuracy.

This could be taken to extremes. The Victorian artist Joseph Crawhall (1861-1913) is said never to have completed any of his work from observation, but always to have relied on his visual memory. Trained in precise observation by a stern father, he would – it is said – destroy and redraw any work he felt to be inadequate. (I do not suggest you use his practice as a paradigm – far from it! To my mind, such unnecessary reliance upon retention and recall of the visual world has great disadvantages, as it must inevitably lead to rather stereotyped images.)

Creative teachers generated systems of figure construction to aid the process of drawing without a model, and many books were published offering figure drawing 'made easy'. While some of these were based on sound principles, others 'simplified' the figure into circles and hieroglyphs which were so odd and devious that they look as if they were calculated to give their readers a weird and erroneous notion of what human bodies are really like; they offer nothing of practical use to the development of drawing skills.

Any method of drawing which does not have as its basis observation and investigation of the real world is more likely to be a stumbling-block than an aid to success. Always remember that drawing from memory is an adjunct to your other work, giving you wider scope for expressiveness and creativity in your overall figure drawing. Through it you can more freely exploit your imagination in the drawing process to create images that transcend those you can conveniently set up as poses in the studio.

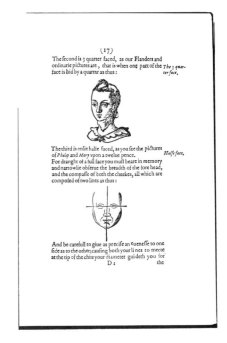

*These pages are from a charming little book by H. Peacham, Gent., published in 1606 and titled* The Art of Drawing with the Pen and Limming in Watercolour more exactlie then heretofore taught, published for the Behefte of all young gentlemen or any els that are desirous for to become practitioners in this excellent and most ingenious Art.

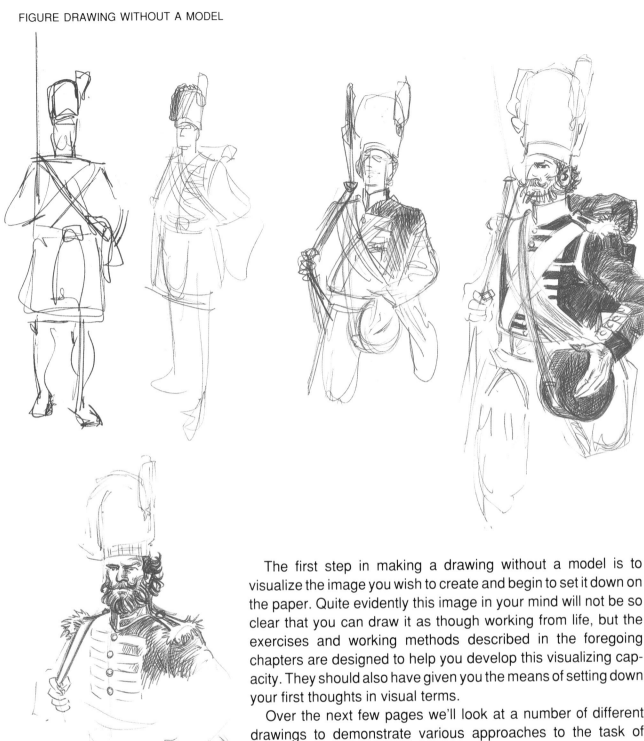

The first step in making a drawing without a model is to visualize the image you wish to create and begin to set it down on the paper. Quite evidently this image in your mind will not be so clear that you can draw it as though working from life, but the exercises and working methods described in the foregoing chapters are designed to help you develop this visualizing capacity. They should also have given you the means of setting down your first thoughts in visual terms.

Over the next few pages we'll look at a number of different drawings to demonstrate various approaches to the task of drawing from memory. The first is a standing figure of a man drawn to illustrate the uniform of a Scottish soldier.

We can begin with a gesture drawing of a standing figure to establish stance and viewpoint – in this instance he is standing upright on both legs and we are viewing him from the front.

From reference material you can find the shape of the headgear and the style of the uniform so, once you have the proportions correctly established, you can make a few drawings of the head and face to decide upon the kind of character you want. I drew the head from different angles to ensure that I fully understood the way the helmet would sit on the head.

You should now be able to visualize quite clearly what the

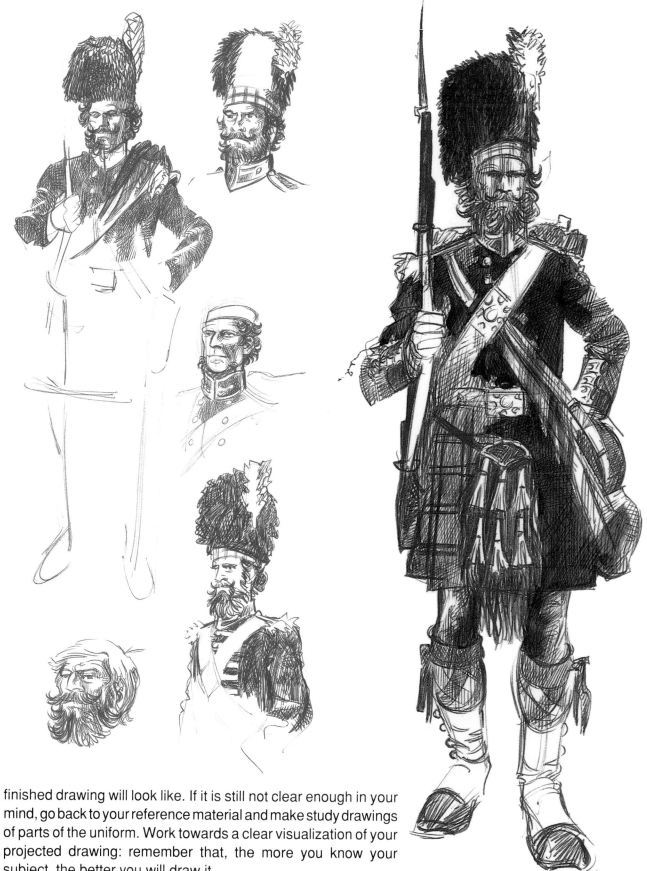

finished drawing will look like. If it is still not clear enough in your mind, go back to your reference material and make study drawings of parts of the uniform. Work towards a clear visualization of your projected drawing: remember that, the more you know your subject, the better you will draw it.

The main shapes and proportions should be established first, then the finer details, and then finally the pattern, texture and shading.

In the drawing here the image I wanted was of a man wearing a raincoat. I imagined his collar turned up against the weather and his coat fluttering in the wind. This was such a clear, simple image that I drew the coat collar and the edge of the coat first. Once I had this image down I could see that the illustration would be most effective if I left out the man's feet. In this way the fluttering movement of the coat would become the main part of the drawing. All that remained for me to do to complete the picture was to draw in the head and indicate the sleeve.

The background building was added as an afterthought — something definitely *not* generally recommended as a picture-composition procedure: figure and background should as a rule be created together. The drawing at bottom left shows how much more successful the result is when the whole composition is borne in mind from the beginning. This topic will be dealt with more thoroughly in Chapter 7.

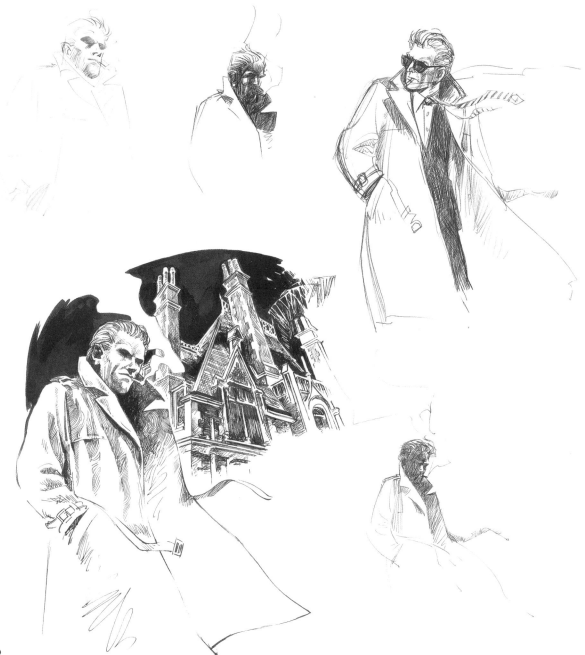

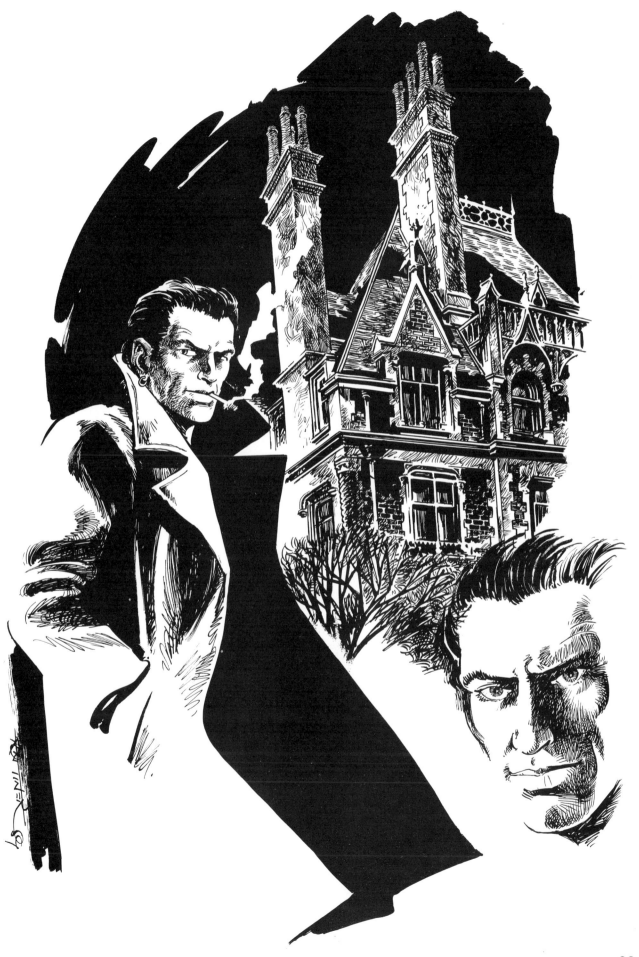

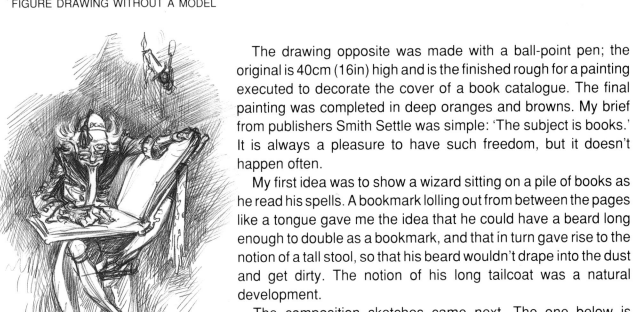

The drawing opposite was made with a ball-point pen; the original is 40cm (16in) high and is the finished rough for a painting executed to decorate the cover of a book catalogue. The final painting was completed in deep oranges and browns. My brief from publishers Smith Settle was simple: 'The subject is books.' It is always a pleasure to have such freedom, but it doesn't happen often.

My first idea was to show a wizard sitting on a pile of books as he read his spells. A bookmark lolling out from between the pages like a tongue gave me the idea that he could have a beard long enough to double as a bookmark, and that in turn gave rise to the notion of a tall stool, so that his beard wouldn't drape into the dust and get dirty. The notion of his long tailcoat was a natural development.

The composition sketches came next. The one below is reproduced about half the size of the original.

After I had sketched in the figure on the stool I drew in the background, starting with the stack of books on the floor to the right and then working my way up and across, adding ever more books as I went.

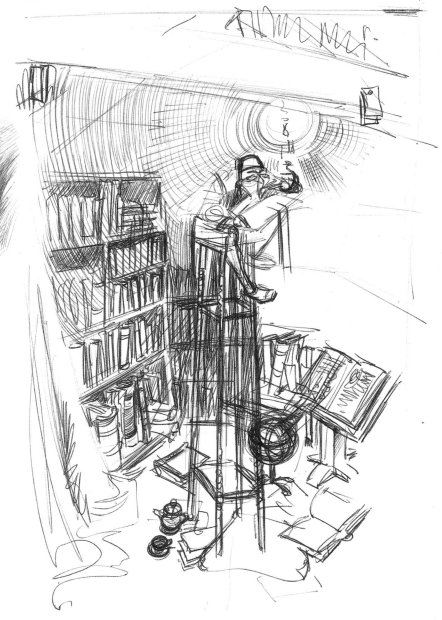

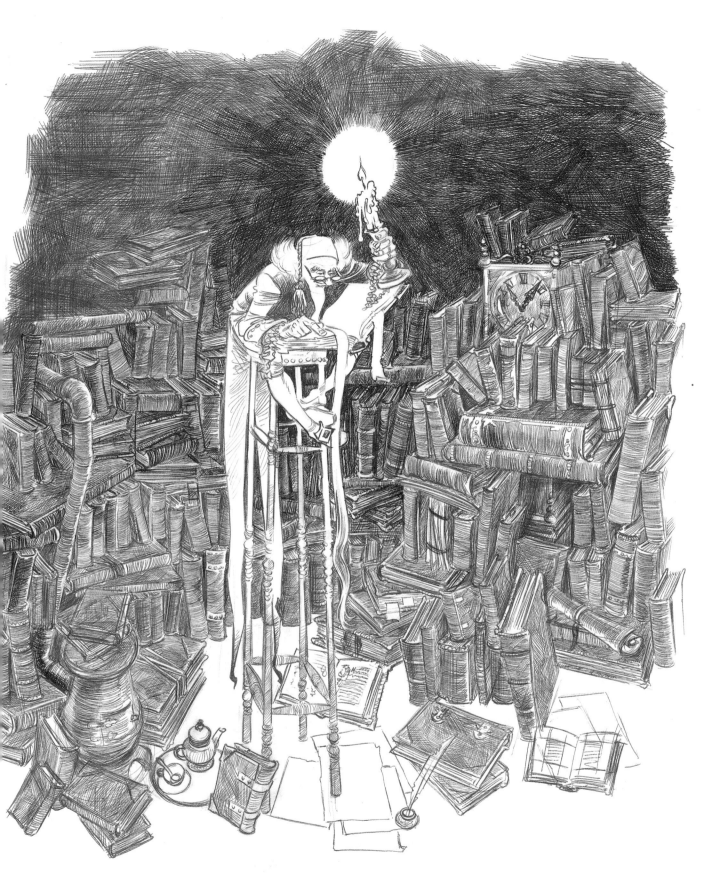

*Working drawing for a full-colour
catalogue cover.
[Copyright © Smith Settle Ltd.]*

This drawing was part of a graphic-narrative page. The story involved two brothers, one of whom was the intended victim of a hit-and-run assassination attempt. The other, seeing the danger, was able to save him. As this was the climax of one part of the story, a dramatic picture was called for.

The sweeping lines of the bodies and limbs had to be established first, so that the overall impression of movement was created. I cannot repeat often enough that, if you want to draw figures in action, the lines of the action must be felt out first. If after that you still find difficulty visualizing clearly, you may find the solution by going back to the basic skeletal figure discussed on pages 54-5. A dozen or more preparatory drawings may be necessary before you can establish the action clearly in your mind.

I posed in front of a mirror in order to study the creases in the clothing. These emphasize the action.

The final result looks as if it was easy – and so of course it should. It is the first steps you take to establish a clear picture in your mind of what you're aiming for that determine the ultimate success of this kind of dynamic figure arrangement.

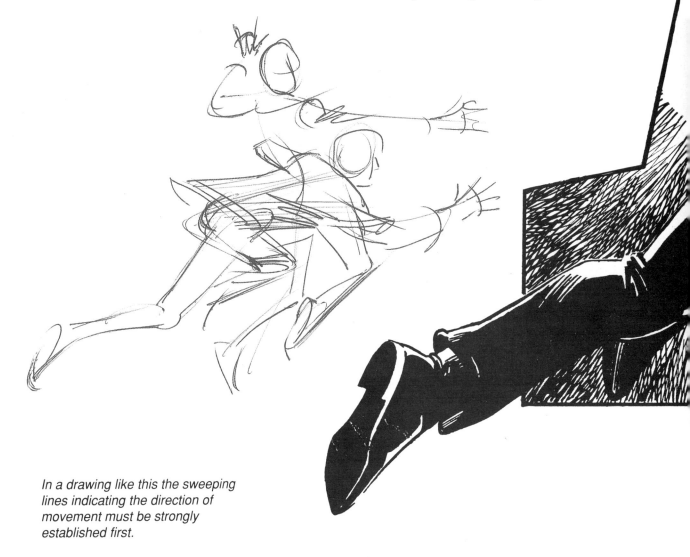

*In a drawing like this the sweeping lines indicating the direction of movement must be strongly established first.*

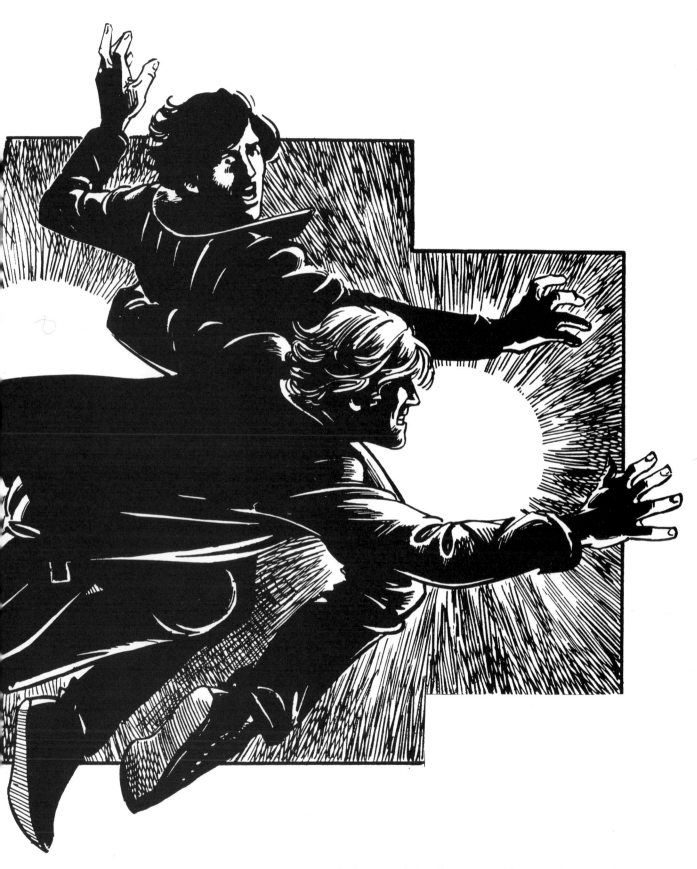

*Single frame taken from a graphic-narrative page:* Canon,
*written by Melvyn Bagnall.*

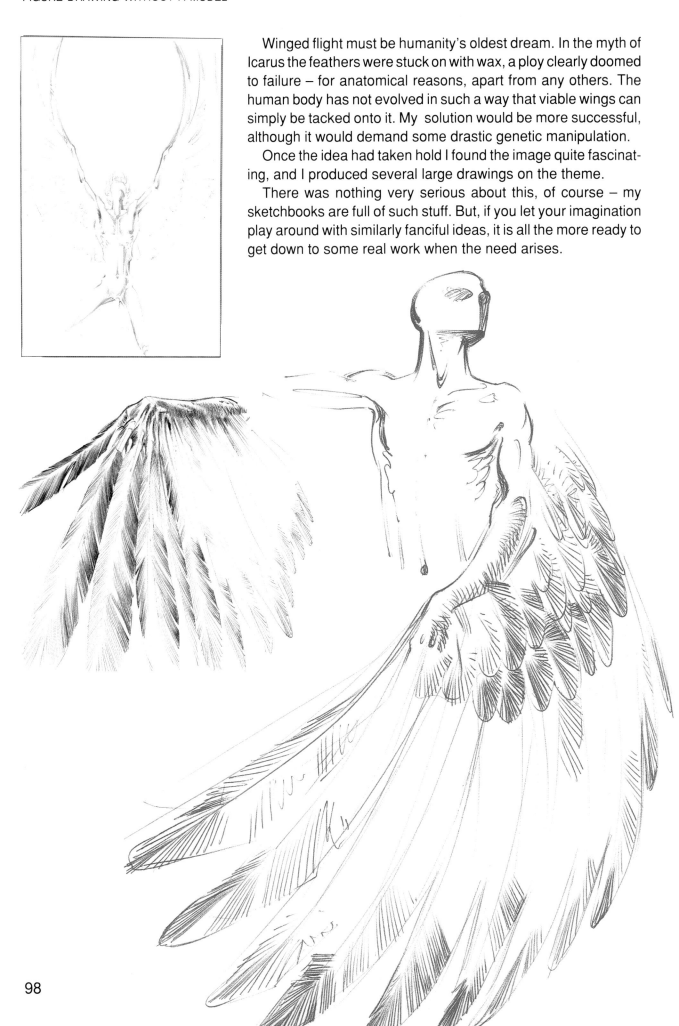

Winged flight must be humanity's oldest dream. In the myth of Icarus the feathers were stuck on with wax, a ploy clearly doomed to failure – for anatomical reasons, apart from any others. The human body has not evolved in such a way that viable wings can simply be tacked onto it. My solution would be more successful, although it would demand some drastic genetic manipulation.

Once the idea had taken hold I found the image quite fascinating, and I produced several large drawings on the theme.

There was nothing very serious about this, of course – my sketchbooks are full of such stuff. But, if you let your imagination play around with similarly fanciful ideas, it is all the more ready to get down to some real work when the need arises.

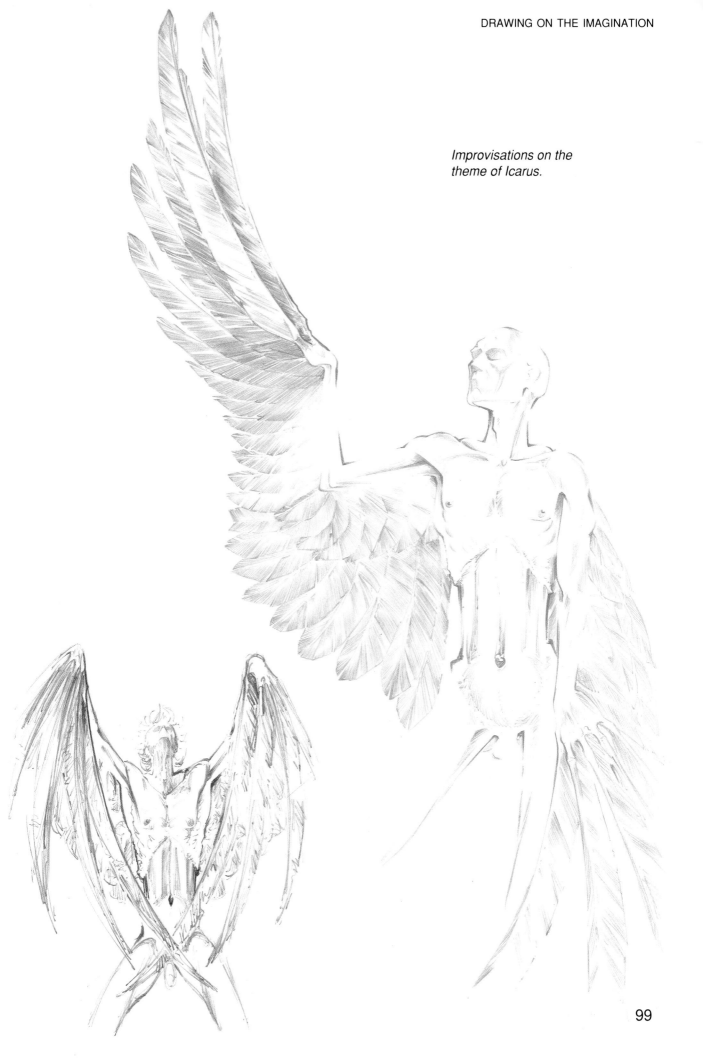

*Improvisations on the theme of Icarus.*

With both the pictures on these two pages I was able to visualize the arrangement of the group fairly clearly even as I read the brief.

The first illustrates the story of a monk who stole the key to the monastery gate in order to go to the annual fair, where he got so drunk that he had to be brought home in a wheelbarrow. The clothing – especially heavy clothing like this - is in effect a part of the figure, and so the first shapes I drew were rather like skittles. As I had a number of drawings of monks to do, I hired a costume locally and got a member of my family to pose in it so that I could familiarize myself with the way that a monk's habit 'behaves'.

The second picture illustrates a short paragraph in another book. The subject was the use of herbal remedies in monasteries to help sore throats. Once again, the arrangement of the figures was decided upon early in the proceedings; studies of hands and faces followed.

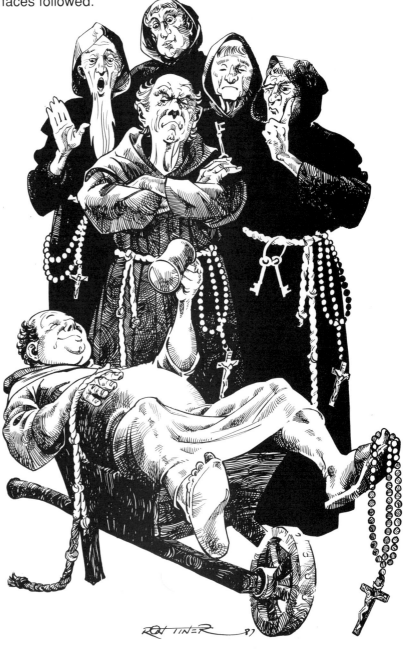

*Illustration from* Yorkshire Oddities,
*written by S Baring-Gould.*
*[Copyright © Smith Settle Ltd.]*

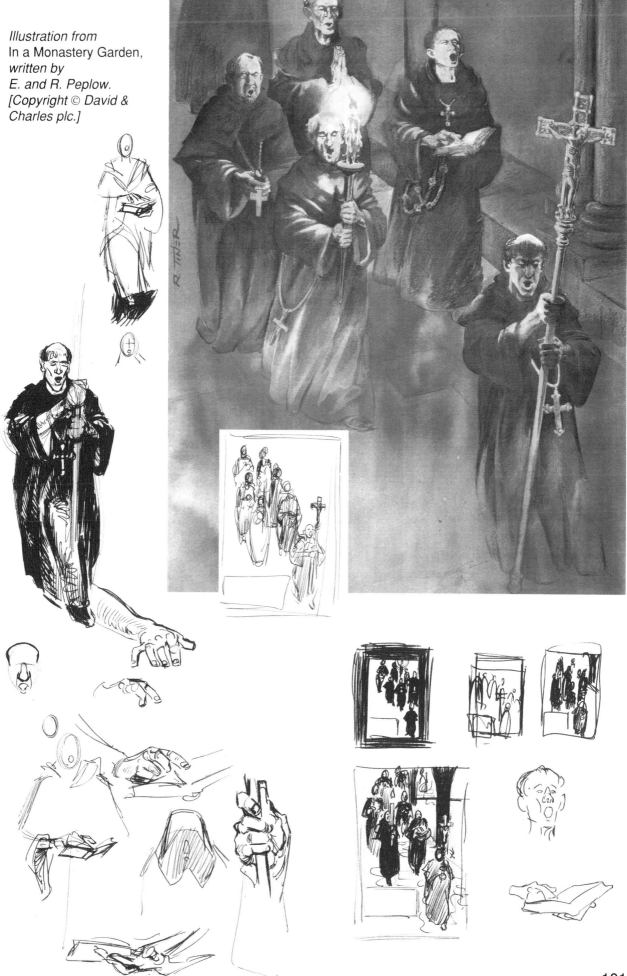

Illustration from
In a Monastery Garden,
*written by*
E. and R. Peplow.
[Copyright © David &
Charles plc.]

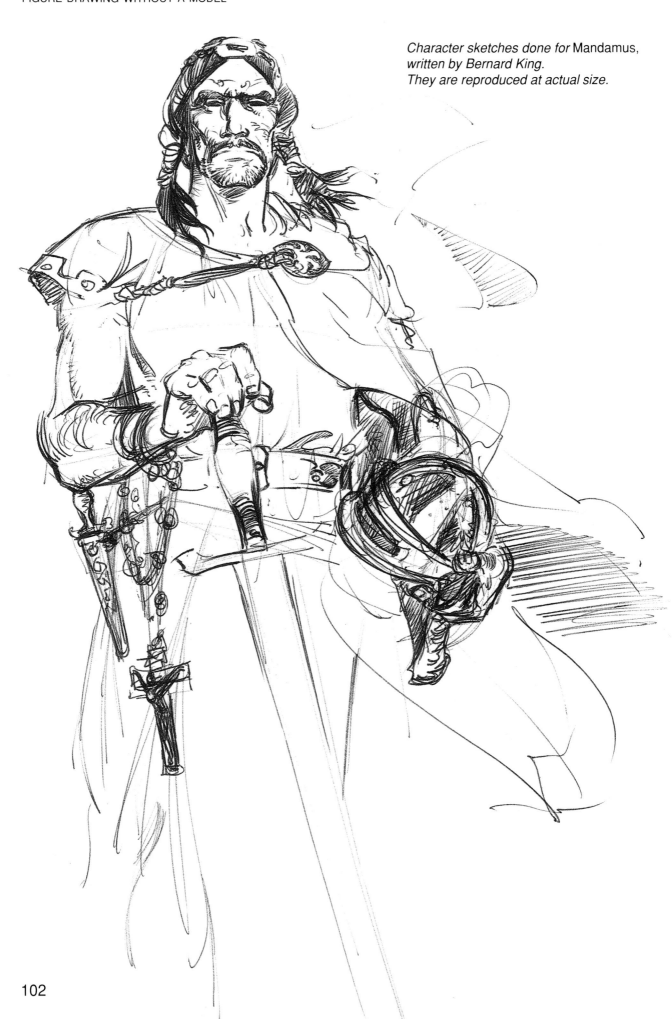

*Character sketches done for* Mandamus,
*written by Bernard King.*
*They are reproduced at actual size.*

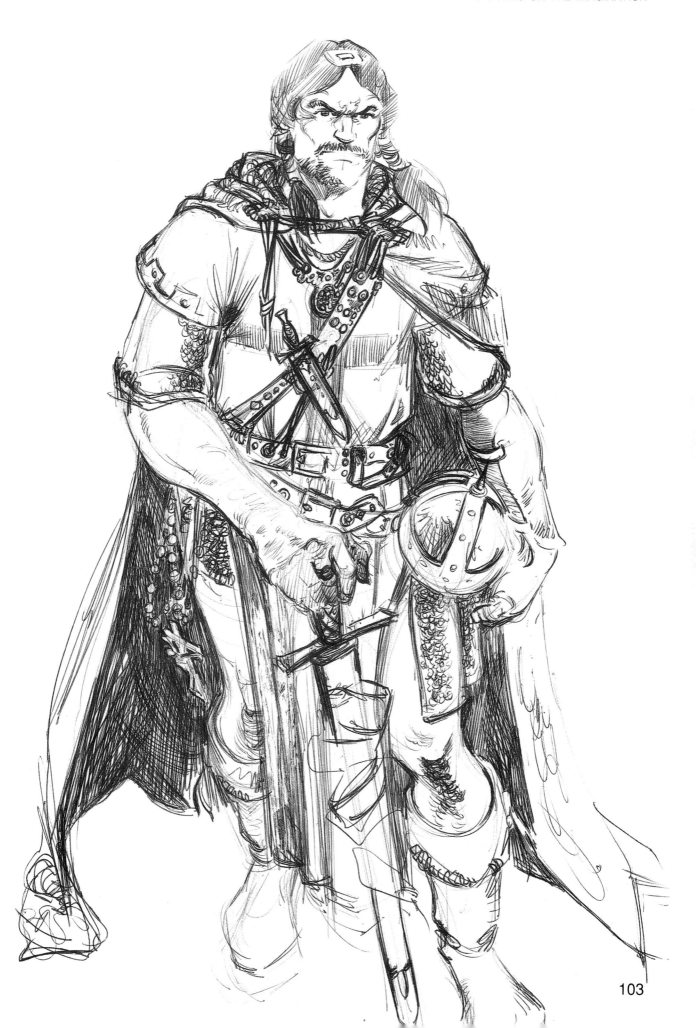

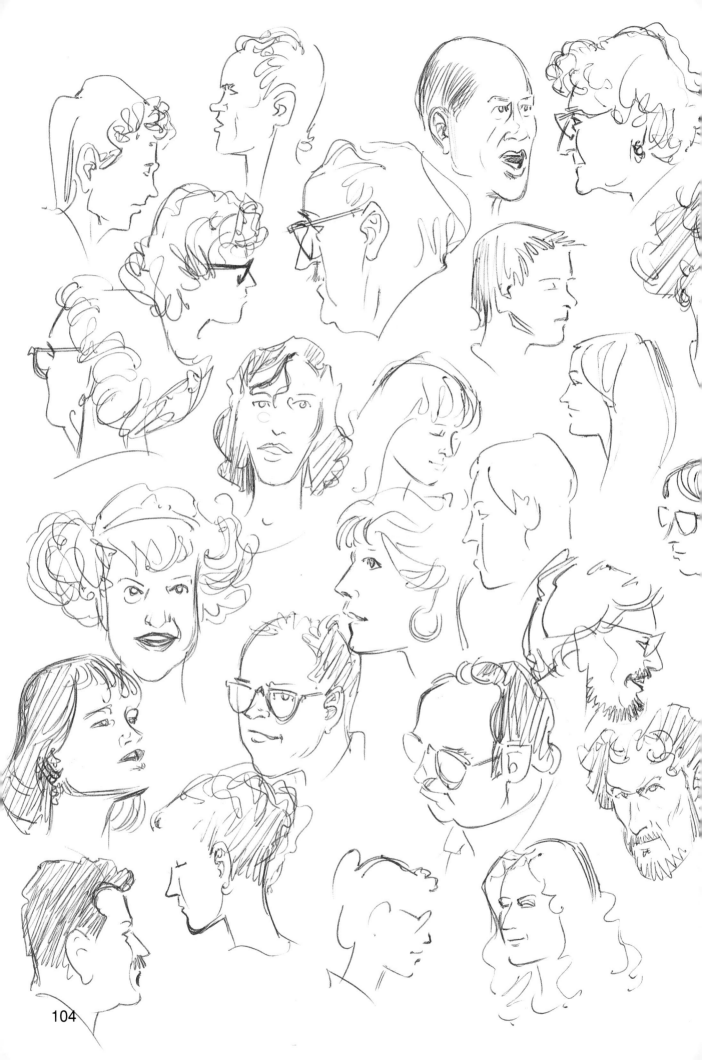

# CHARACTER AND EXPRESSION

So far in this book we have been dealing almost exclusively with a hypothetical 'average' figure. We have studied its structure and proportions, its posture and movement, and only briefly mentioned in passing the very evident differences which occur between one individual and another.

All human populations show a wide variety of physical structure and proportions, and of facial features. But this does not mean that, in drawing the human figure, we can carelessly perpetrate distortions and inaccuracies which can then be conveniently explained away as the unremarkable anatomical peculiarities one should expect to find in any single human being. Variations in physique and facial appearance occur in quite specific ways, and so individuals tend to conform to recognizable physical and facial types – albeit a very wide range of them.

Down the centuries, scores of scientific and (mainly) pseudoscientific treatises have been put forward as rational studies of human types. These have commonly claimed that character and fortune may be divined in the form and features of face or hand, and the lines thereon, or in the specifics of body shape and proportion. Most have now been justifiably forgotten.

In this chapter we shall look at the ways in which individuals differ from one another in appearance, an understanding of which will enable us to imbue our drawings with character.

## The Face

The playwright Christopher Marlowe (1564-1593) attributed the launching of a thousand ships to Helen of Troy's face and, although it seems unlikely that that portion of her anatomy was alone responsible for so much dockyard activity, few would deny the singular importance of the face in distinguishing one person from another.

If presented with a few portrait photographs, almost anyone can be prevailed upon to give an opinion about the personality of each one, and these will show a remarkable consensus if the experiment is repeated a number of times.

Considering that we all make such judgements continually, we might expect that it should be possible to compile a reliable index of facial features and the precise character traits they portray. Since antiquity many theorists have attempted to classify this perceived relationship between the human face and the mind behind it. These varied from pronouncements concerning low

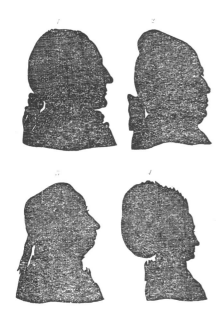

*Above:* From J. C. Lavater's Physiognomische Fragmente: 1, 'Fine Feeling'; 2, 'Circumspection'; 3 and 4, 'I have hitherto seen but few countenances in which so much power, and goodness, fortitude and condescension were combined.'

foreheads and large noses to lists of features and their psychological meaning. The most durable example is to be found in the work of the Swiss physiognomist Johann Caspar Lavater (1741-1801). Following the general trend of 18th-century scientific thinking towards formalized systems of knowledge, he published, in the form of his *Physiognomische Fragmente* (1775-8) an extensive collection of studies of widely varying faces, mainly in silhouette, with measurements of facial slope, forehead height, jaw prominence and so on, prefaced and liberally interspersed with wordy and scornful diatribes against all who questioned the veracity of his 'science'. Ultimately, of course, his conclusions proved to be based on almost entirely subjective criteria, coupled whenever possible with prior knowledge of his subjects' characters, and so even this otherwise creditable attempt to rationalize a fundamental process to which we all sometimes subscribe fell into disrepute.

All jobbing actors will tell you that the range of dramatic character parts they are offered is limited by their physical appearance, and that the roles within that range may have little in common with their own personality.

Everyone, it seems, makes judgements based on appearance, but no proof exists that they have any basis in truth. Indeed, modern studies have shown that the factors on which we base such character judgements are, at best, dubious, and at worst, simply false. Almost anyone will find it surprising that Dr Johnson was described by one contemporary observer as having a face 'with the aspect of an idiot, without the faintest ray of sense gleaming from any feature'; and one of the most capacious intellects of the Northern Renaissance, the scholar Erasmus (1466-1536), had a cranium so tiny that throughout his adult life, to make his head look normal, he wore a specially constructed wig and a large biretta hat which he never took off in public.

And yet what prejudices we have in this regard are continually reinforced by what we see in movies and on television or read about in novels. In the entertainment media, villains continue to be beetle-browed and ugly, heroes square-jawed and handsome, heroines beautiful, despite strikingly convincing proof that this is rarely the case in real life.

*Below:* Facial profiles. - convex, concave and upright - from De Humana Physiognomina *(1847).*

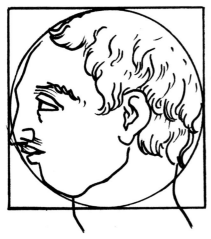 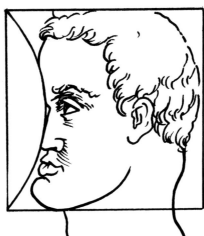 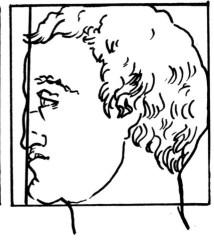

Much has been said and written about psychological insight in portrait painting, and this, I think, provides a key. The sensitivity of your drawings of faces can convey a very great deal. Sadly, though, this is something that cannot be taught. The quality of your own perceptions and artistic skill will determine your success regarding the drawing of character.

What follows is an explanation of the structural factors which determine the uniqueness of every face.

# Race

Of the factors which govern the enormous variety to be found in the human face, most are hereditary. The most obvious hereditary factor is race.

The definitive statement on race – drafted by an international team of scientists, and published by UNICEF in 1963 – states: 'Scientists are generally agreed that all men living today belong to a single species, *Homo sapiens,* and are derived from a common stock.' Widely dispersed and isolated groups developed, over a protracted period, the ethnic characteristics we know today in response to climatic and other environmental conditions.

Opinions differ regarding the number of different major ethnic groups now extant, but according to many classificatory schemes there are seven: Amerindian, Polynesian, Australasian, Oriental, Indian, Caucasian and African. Within each of these groups there are, of course, further subdivisions.

Two groups dominate numerically: Caucasoids and Orientals together account for 92 per cent of the world's population.

But, while ethnic contrasts may be distinctive, the similarities between ethnic groups are far greater than the differences. Two individuals from two separate ethnic groups may be remarkably similar in facial appearance, whereas the contrast in appearance between, say, two Caucasians may be very much more pronounced. Within all ethnic groups a wide variation in appearance is evident.

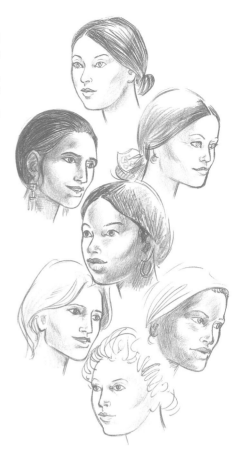

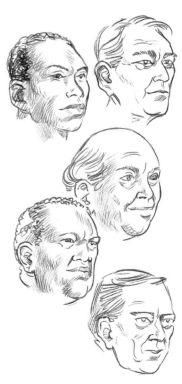

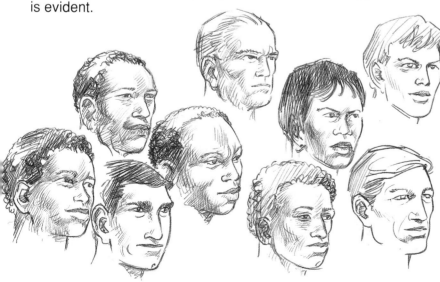

*The illustrations on this page show how remarkably small a factor race is in determining the unique individuality of a face.*

107

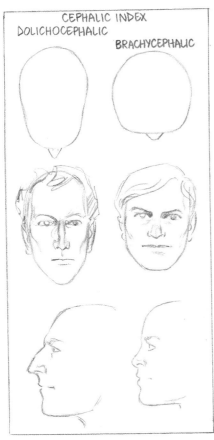

# Facial Structure

According to the Cephalic Index used by anthropologists to categorize head shapes, there are two extremes:

- dolichocephalic, or long and narrow
- brachycephalic, or short and wide

The intermediate type, mesocephalic, shows characteristics of both these extreme types.

If you imagine a face cast onto an inflated balloon, the act of squashing the balloon as shown in the illustration will cause the face to become vertically longer and the features to be thrust forward. As the distance between the eyes becomes narrower, the nose, in order to retain the same airway capacity, must protrude further forward. This gives the distinctive convex profile of the dolichocephalic type. If the balloon is instead stretched widthways, the distinctive flatter profile of the brachycephalic type becomes evident.

To explain facial structure, it is convenient to divide the face into three regions:

- the cranium
- the maxilla, or midface region
- the mandible, or lower jaw

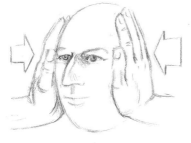

Because the complex of bones which makes up the midfacial region is attached to the base of the cranium, the cranial floor is the template that establishes the dimensions of the face. If the cranium is long and narrow (dolichocephalic) the face beneath it will be correspondingly narrow; by contrast, if the cranium is brachycephalic the face will be short and broad with a flatter profile. We can see, therefore, that the distinctive divergent facial

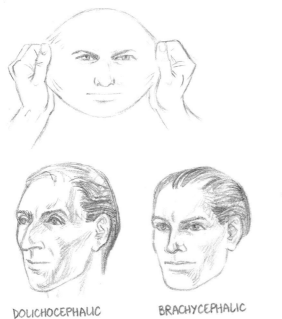

DOLICHOCEPHALIC      BRACHYCEPHALIC      MESOCEPHALIC

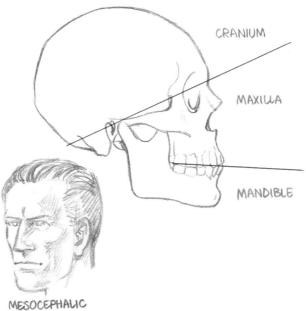

CRANIUM

MAXILLA

MANDIBLE

patterns emerge largely because of the shape of the cranium.

Of course, the shapes of most crania will fall somewhere in between these two extremes, with some (mesocephalic) skulls showing a mixture of characteristics from both extremes.

As forward growth occurs in the cranial and midfacial regions, the mandible, hinged as it is well back near the ear, has to grow downwards (to accommodate the teeth) and outwards to keep pace, so that the upper and lower teeth remain compatible – see diagram 1.

If the mandible does not grow forward enough, the front teeth in the lower jaw will not meet those in the upper for the purpose of biting – see diagram 2. This inadequacy of the lower jaw can cause other problems, too, because there is a need to make an airtight seal with the lips when swallowing. If this can only occur by pressing the lower lip against the inside of the upper front teeth (see diagram 3), the resulting persistent pressure can cause them to protrude outwards.

Excessive forward growth of the mandible can also occur (see diagram 4), resulting in an underslung jaw and a similar difficulty in biting.

*The illustrations on these two pages are derived from the work of D. H. Enlow in* Facial Growth *and B. H. Broadbent Sr, B. H. Broadbent Jr and W. H. Golden in* Bolton Standards of Dentofacial Developmental Growth.

COMPARISON OF BABY'S SKULL WITH ADULT SKULL

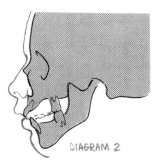

DIAGRAM 1

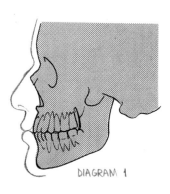

DIAGRAM 2

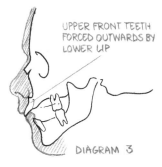

UPPER FRONT TEETH FORCED OUTWARDS BY LOWER LIP

DIAGRAM 3

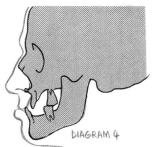

DIAGRAM 4

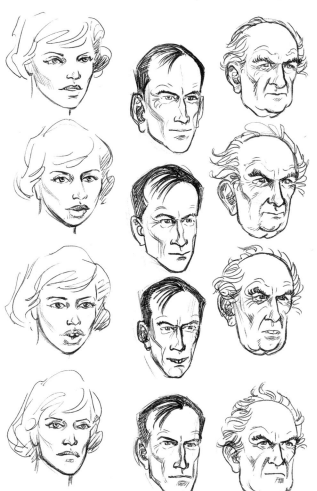

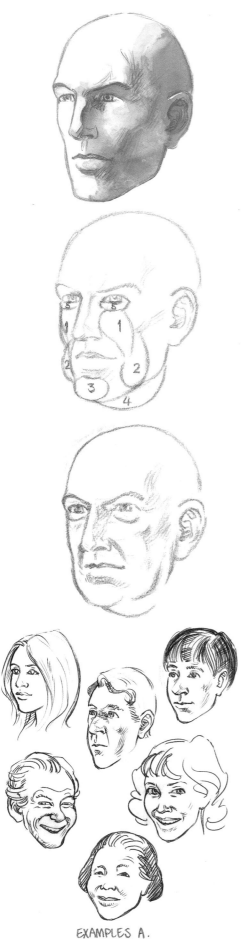

EXAMPLES A.

# Soft Tissue

Underlying the skin and overlying the muscles of the face is a layer of subcutaneous fat. Although this is of fairly even thickness over most of the face, there are a number of important cushions of fat which have a profound effect on its surface form.

In the faces of babies there are always 'sucking pads' situated between the masseter and buccinator muscles of the cheek. These act as an aid to suckling, and give the infant face its typical 'chubbiness' . They vanish in later infancy, and pockets of fat begin to form which modify and augment the bone-and-muscle form of the face.

In youth, all body fat is smooth and firm and these pockets merge subtly into one another and into the overall smooth contours of the cheeks and jaw. By the onset of early middle-age they have begun to soften, and they become progressively more clearly defined as separate individual fat deposits.

In the very few investigations into the peculiarities of the human face that have been published, I have found no mention of these as significant factors in differentiating one face from another, so I shall do the following exposition the dubious honour of calling it the Tiner System of Facial Differentiation.

On most faces, a cushion of adipose tissue forms on the upper lateral edges of the mouth sphincter muscles. This adds a small amount of bulk to the front of the face from the sides of the nose downwards to the sides of the mouth. The area it covers varies a little; its general placing is labelled 1 on the diagram. These cushions soften as one gets older, and contribute to the forming of the familiar 'smile creases' known to beauticians as naso-labial lines. For this reason, I shall designate these fat cushions the *naso-labial* cushions. If large they give an 'apple-cheeked' appearance to the face in youth and, with advancing age, gradually become 'jowls' (examples A) .

These naso-labial fat-pockets sometimes extend far enough to merge with another pair, labelled 2 on the diagram. Although some faces show no sign of these at all, others may show a very definite plumpness here (examples B). Continuing with the Latinized nomenclature, I'll call these the *lateral* cushions. In later middle-age these, too, contribute to 'jowliness' in overweight people.

The third location for a fat-pad is the most common. Almost every face shows some evidence of flesh on the front of the chin (3). This is termed the *mental* cushion (from the Latin *menta*, meaning 'chin'). It sometimes shows a distinct cleft or dimple, which may or may not reflect a small central groove in the jutting lower edge of the jawbone. With the softening and sagging of middle-age, this cushion usually droops down to form the common double-chin.

The fourth fat-cushion is the least common, and tends to be associated mainly – though not exclusively – with obesity . It is situated beneath the jaw, between the throat and the chin, and so I shall call it the *submental* cushion (4). When evident in young people, it contributes a roundness to the face, and in old, overweight people can cause the throat to be entirely obscured; in which case it may show signs of a central groove (examples C).

We may also refer to the 'bags' under the eyes as another pair of fat-cushions. These *suborbital* fat-cushions are, once again, not evident on every face.

All these soft fat deposits are attached firmly to the skin and move when the skin moves. They behave rather like soft, water-filled sacs, and so, when the muscles beneath them shorten, as in, say, smiling, they are squeezed and bulge out. In this way, a face with large fat-cushions is changed quite considerably in shape. Examples D, showing the fleshy-faced old man, illustrate this clearly. At the sides of the face, the cheekbones (zygomatic bones) have no fat-cushions on them, and so remain firm and unmoved, while the jowls not only move but also change shape. In doing so they bulge up under the eyes, which are narrowed into a crescent-like shape as the suborbital cushions are pressed upwards.

In drawing facial movement, you obviously need to understand the ways in which the face's shape changes, and this means that you have to know which parts of the face have firm cartilage or bone just below the surface and which have soft movable tissue. Knowing the location of the fat-cushions on a face is the only way to ensure that you retain a likeness when drawing the same face wearing different expressions.

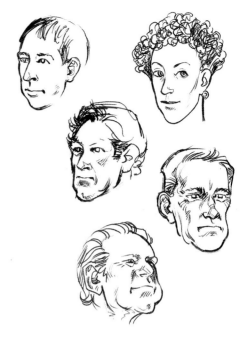

EXAMPLES B.

EXAMPLES C.

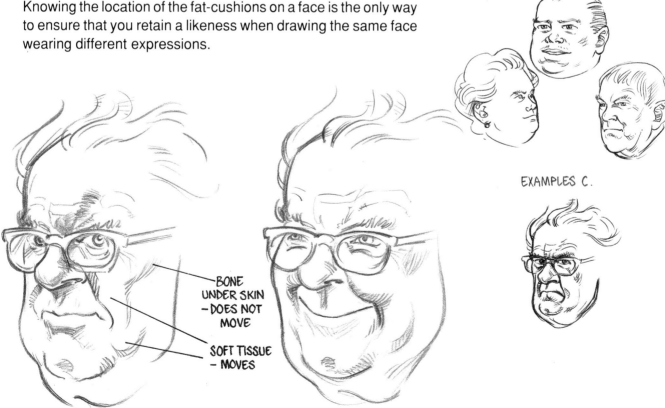

BONE UNDER SKIN – DOES NOT MOVE

SOFT TISSUE – MOVES

EXAMPLES D

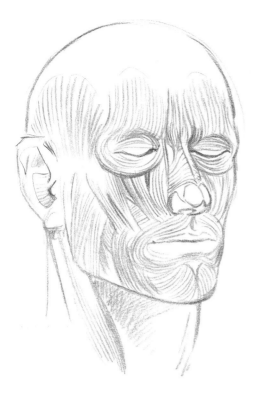

# Facial Expression

The musculature of the face is basically quite simple, although there are several layers of muscles which allow very subtle movements of the facial tissue, and thereby facilitate facial expression. These muscles are attached at one end to bone and at the other to the skin and its concomitant subcutaneous flesh. Pursing and pouting of the lips, opening and closing of the eyelids, etc., are governed by the sphincter-type muscles around the mouth and eyes.

A great many learned works concerning human facial expression have been published during the past 300 years, the most notable being *Expression of Emotions in Man and Animals* (1873) by Charles Darwin (1809-1882), in which he concludes that the manner in which human beings show their emotions is further proof of his theory of evolution. Of a little more interest to the artist is the work of the French anatomist Guillaume Duchenne (1806-1875), who attempted to isolate the expressive function of each of the facial muscles; however, most of the time several muscle groups work in combination to achieve each of the wide range of subtle facial expressions.

Constant observation, coupled with an understanding of bone structure and surface soft tissue, is the key to understanding facial expression.

**Opposite, top:** *Facial expressions are achieved by movements of the soft facial tissue.*

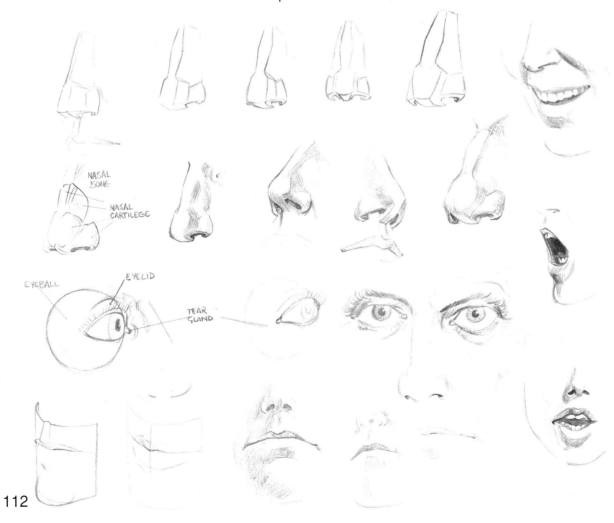

NASAL BONE

NASAL CARTILEGE

EYEBALL

EYELID

TEAR GLAND

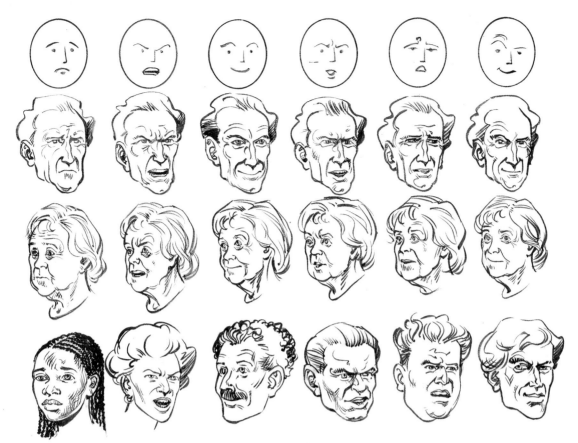

# Ageing

Over the years, the soft, resilient, firm skin of the child becomes replaced by the crinkled, limp and blemished skin of old age. The subcutaneous fat layer immediately beneath the skin becomes thinner and the facial flesh of the cheeks and chin sags over the bottom edge of the mandible, forming the distinctive drooping jowls and double-chin of the elderly. The fat-cushions behave, in later life, like loose, water-filled bags, and become more distinctly separated from one another and from the overall flesh layer under the skin.

The nasolabial furrow deepens as a consequence, and facial lines and wrinkles develop in specific and characteristic locations. These are illustrated here; they include 'crow's feet' at the outer corners of the eyes, horizontal lines on the forehead, vertical corrugations on the bridge of the nose between the eyes, and vertical creases along the upper lip. All the fat-cushions listed earlier become increasingly well defined as separate topographical features by creases at their inner and lower edges.

The skin under the chin and on the front of the throat, with its associated flesh, sags. Two factors cause the tightening of this area: the natural wearing down or loss of the teeth brings the jaws closer together, so that the chin juts forward more, and the increased forward curvature of the spine between the shoulderblades throws the head forward and down, so that the neck vertebrae have to adopt a greater compensating backward curve. These two factors cause a tightening of the skin under the chin.

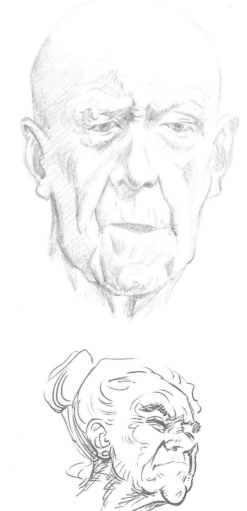

# Body Types

Although Albrecht Dürer (1471-1528) made a number of carefully measured studies of differently proportioned men and women in the early 16th century, he appears to have found no particular pattern to the range of differences he discovered. Long before, the Greek physician Hippocrates (460-377BC) had recognized only two distinct kinds of human body:

- the *phthisic habitus*, or tall, thin physique
- the *apoplectic habitus,* or short, thick physique

It was evident to later investigators that this did not cover the whole range, and so this division was expanded into three, four and more by various authorities in more recent times, with the introduction of the notion of a 'mixed' type by the Italian anatomist Viola. But not until the present century, when investigation of the variety of human body types was undertaken as part of the study of physical anthropology, was a system devised which has anything substantial to offer us here.

It was in the late 1930s that the US psychologist William Sheldon devised the modern system of categorizing body-types known as somatotyping. Sheldon identified three basic types of human physique: endomorphic, mesomorphic and ectomorphic. In simplest terms, they may be thought of as the fat (endomorph), the muscular (mesomorph) and the bony (ectomorph), although the differences are far from being as superficial as these descriptions may suggest: the total body structure is distinctive in each of the three types. The illustrations on the left show definitive examples of each of these three distinct types. Height is not significant in this system; each body type can occur throughout the normal human height range.

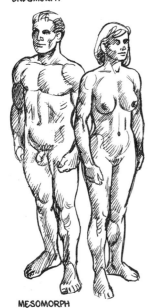

ENDOMORPH

MESOMORPH

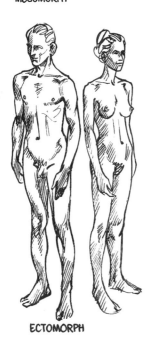

ECTOMORPH

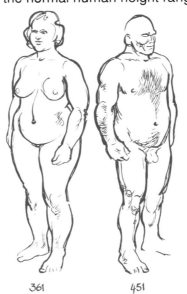

361 451

ENDOMORPHIC MESOMORPH

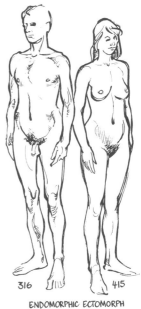

316 415

ENDOMORPHIC ECTOMORPH

Sheldon recognized that most individuals show evidence of any two or all three of these components in varying degrees, and devised a system of scoring, from a minimum of 1 to a maximum of 7, for the amount of each component evident in any individual. By always putting these score numbers in the same order (endomorphy first, then mesomorphy, then ectomorphy), every human body could be categorized in a significant way by a three-figure number. A pure endomorph, as shown here, would be designated a 711, a pure mesomorph a 171 and a pure ecto-morph a 117. These pure examples are not very common – about 1 in 200 of the population – and the vast majority of individuals exhibit evidence of all three components. Nevertheless, there is usually a predominance of one of them.

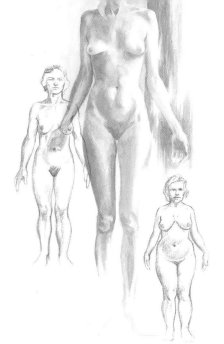

- *Endomorph*
In the endomorph there is a predominance of fat, giving an appearance of roundness and fullness of shape, with a smooth skin. The abdomen tends to bulge, and the limbs are short and tapering, with rather delicate hands and feet. The shoulders are narrow, full, rounded, and smooth in contour. The head tends towards the spherical, with an upright forehead and small features. Internally, the gut is large and sturdy, and the bones of the skeleton are small, with all their projections being rather rounded. The spinal column appears straightened.

- *Mesomorph*
The mesomorph tends superficially towards squareness, with predominant muscle. The shoulders are large, the abdomen small, and the limbs large and strong. The skin and hair are rather coarse. The face is large and the cranium small. Internally, the bones are heavy and the curvature of the spine is well defined.

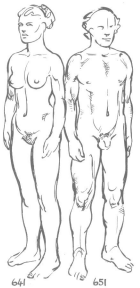

641          651
MESOMORPHIC ENDOMORPH

- *Ectomorph*
The ectomorphic figure is slender and fragile, and has a minimum of fat or muscle. The chest is narrow and the limbs are long and thin. The shoulders can be wide, but have a tendency to droop. The face is small but the cranium large. Internally, the bones are light and their protuberances are prominent. The spinal column has a slight lumbar and dorsal curve.

The drawings on these two pages show how the influence of all these three components, in varying degrees, gives rise to the wide range of differences in human bodies.

ENDOMORPH          MESOMORPH          ECTOMORPH

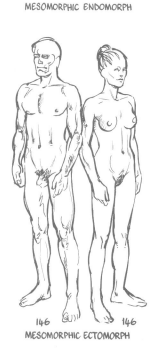

146          146
MESOMORPHIC ECTOMORPH

*Two pictures from Henry Siddons's* Illustrations of Rhetorical Gesture and Action: ***top*** *'Jealous Rage';* ***above*** *'Terror'*.

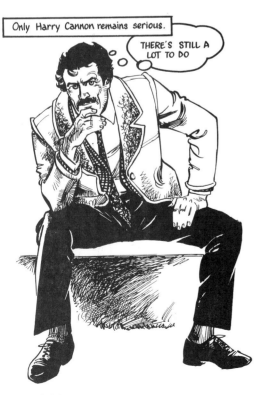

# Gesture

There will be times when the figure artist, like the actor, will wish to use gesture to show specific moods and emotions or convey a message. Posture and hand motions, as well as facial expression, are among the repertoire of signals by which we both understand other people and make ourselves understood.

The range of gestural expressions of emotion to be found in Gothic and Renaissance art is fairly small and appears to comprise a formalized set of accepted conventions. However – mainly for the benefit of actors and orators – a number of systems of expressive gesture have been formulated in the past 300 years. In the late 18th century a German 'rhetorician' called Engels, cited by Henry Siddons in the latter's *Illustrations of Rhetorical Gestures and Action* (1822), attempted a precise description of the actions of the body which 'most truly express' particular emotions. A single example (as translated by Siddons) will suffice to give the general trend of his writings: 'Choler [anger] adds energy to the arms which agitate themselves with convulsive violence. The inflamed eyes roll in their orbits and dart forth fiery glances. Hands and teeth manifest interior tumult by the grinding of one and agitation of the other . . .'

The French theorist François Delsarte (1811-1871), in the latter part of the 19th century, devised a series of exercises and offered actors a more subtle approach which gained some credence for a time but, like Engels's, eventually fell into disrepute.

In modern times, with television bringing us so close to the actor that the tiniest flicker of a quizzical eyebrow can be perceived and understood, we require a much more subtle approach to the physical expression of emotion, both in the theatre and in illustration.

The famous Stanislavsky method encourages actors to search their own experiences for feelings which parallel in some way the text they are working on, so that the actions and gestures they make arise from experience and understanding rather than from learned, rigid formal systems.

This is good advice for the figure artist, too. Melodramatic, overemphasized expressions of emotion look silly to the modern eye, and gestures are better played down than exaggerated. Such emotional content as a picture may be required to have can be emphasized in other, more subtle ways; we shall examine these in Chapter 7.

But, of course, gesture does play an important role in human social intercourse. Modern studies in nonverbal communication and unconscious gesture have produced valuable observations in this area, and they provide a rich source for the figure artist. Anthropologists in this field have coined the term 'body language'

to describe this subtle and profound means of communication. Desmond Morris's books *Manwatching* (1978) and *Bodywatching* (1985) are popular classics in this field.

Our ability to read the feelings and attitudes of our fellow human beings is probably better educated today than was generally the case in the past, and consequently we have to beware of emphasizing too strongly the message contained in the body-positions of the figures we draw.

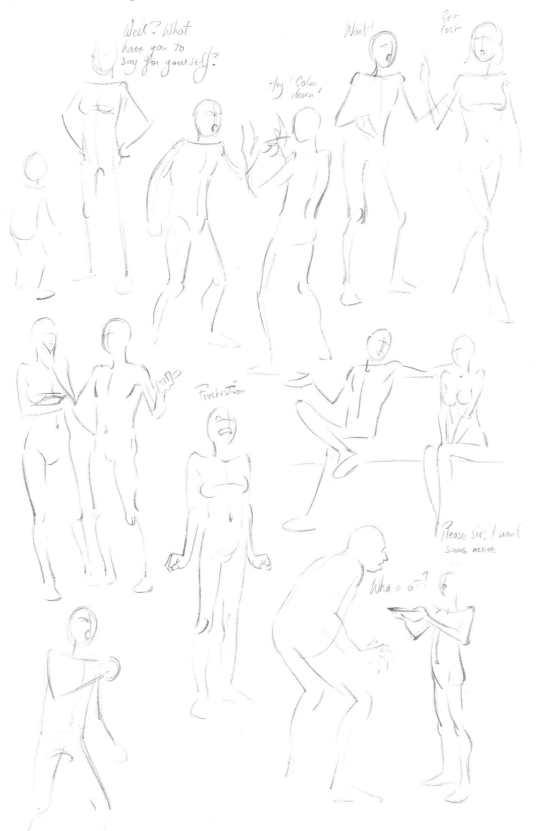

**This page:** *Sketches for* Mandamus,
*written by Bernard King.*
**Opposite**: *Sketches of Merlin and Uther
Pendragon for* Le Morte d'Arthur,
*written by Sir Thomas Malory.*

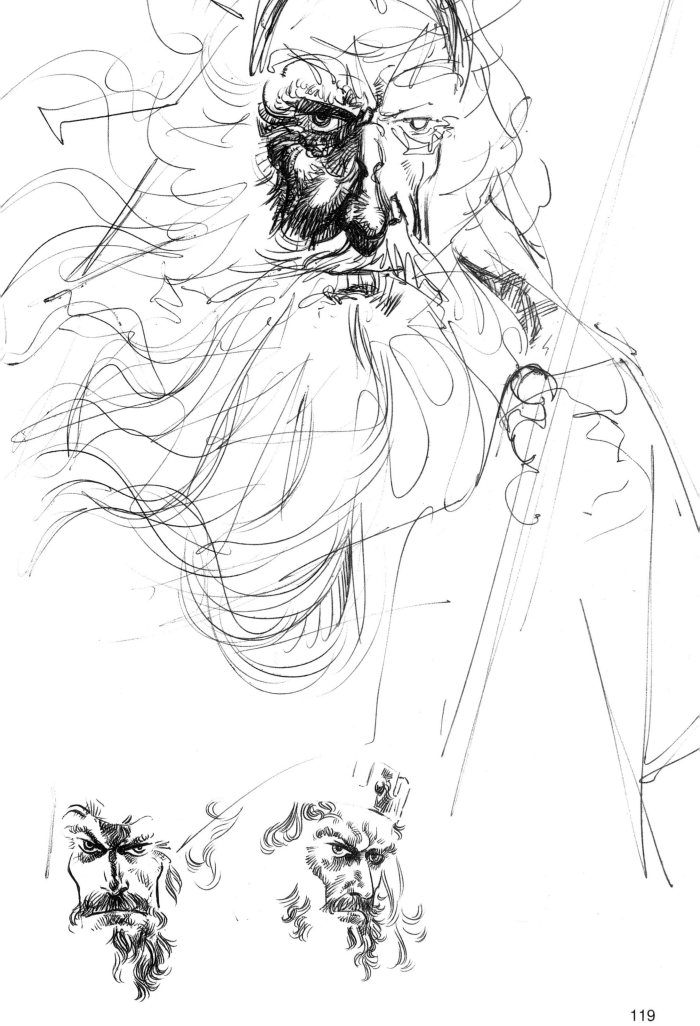

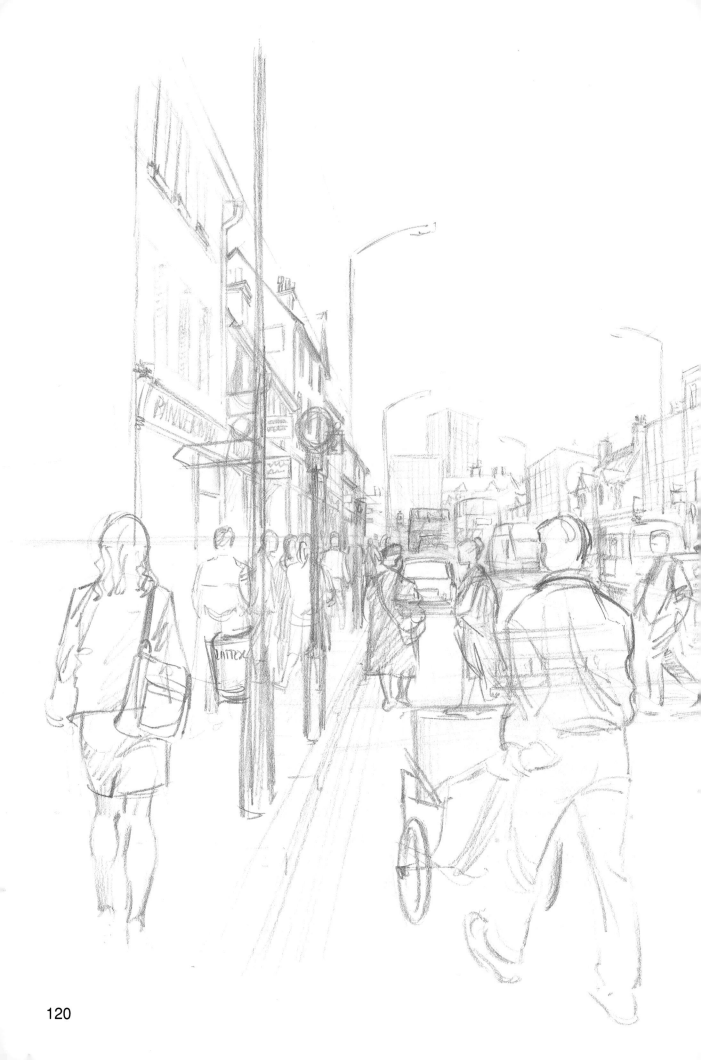

# PICTURE COMPOSITION

The word 'composition' refers to the way in which the various elements that constitute a picture are placed in relation to one another. The success or failure of a picture usually has more to do with how well it is composed than with how well each individual item within it is drawn.

So far I have dealt with the human figure drawn virtually in isolation, with just occasionally a little background to provide setting and atmosphere. But, as we saw on page 92, good pictures don't just happen through haphazardly shoving together everything you want to put in. Foreground, background and incidental objects, as well as the main centre of interest, all have a place within the picture area, and must therefore be intelligently arranged to create a unified whole. So, in setting out to create complete pictures involving the human figure, we have to consider some important practical aspects of picture composition.

Throughout the history of Western art a great many savants have set their minds to the task of providing the artist with a foolproof formula for composing perfect pictures. The Greek philosopher Aristotle (384-322BC) wrote that 'a perfect work of art is so composed that, if any part be transposed or removed, the whole will be destroyed or changed'. As a basis on which to judge a picture that's fine; but it's of little use as a guiding principle in *creating* pictures.

More useful advice has generally been offered in the form of mathematical ratios. Of these the most enduring is the Golden Mean or Golden Section, formally described by Euclid in the 3rd century BC. The contention is that a line which is divided in such a way that the smaller part is to the larger as the larger is to the whole provides the most aesthetically perfect proportions. A rectangle of these proportions is shown on page 122, the lengths of the sides being in a proportion of 1:1.618, or approximately 8:13. It is often claimed that most of the great paintings of Western art since pre-Renaissance times show evidence that artists were aware of this theorem; however, when precise measurements are taken, important picture elements usually prove not to be placed exactly according to the dictum. Evidently, even if they set out with the Golden Section in mind, artists ultimately resorted to relying on their own aesthetic judgement.

Anyway, it defies credibility to suggest that good pictures can be achieved only through precise calculation and measurement. As in our discussion of human proportion in Chapter 2, we find that something which started off as an exact mathematical definition of beauty and perfection proves in practice to be no more than a useful guide. Picture composition, by its very nature, has more to do with intuition than with mathematics.

*Imaginary street scene constructed according to the rules of linear perspective.*

*A rectangle constructed and subdivided according to the Golden Section. In theory a line divided so that the length of the shorter part (AB) is to that of the larger (BC) as the length of the larger (BC) is to that of the whole (AC) provides the most aesthetically perfect proportions. The ratio works out to approximately 1:1.618.*

# Linear Perspective

Linear perspective is an effective drawing system for representing three-dimensional objects in spatial recession on a two-dimensional surface. The system, as generally taught today, is a sophisticated version of the early-15th-century treatise *Construzione Legittima,* which is generally attributed to the early Renaissance architect Filippo Brunelleschi (1377-1446).

Put simply, perspective is the art of giving a picture apparent depth, to enable things drawn on a flat sheet of paper to be perceived as solid, three-dimensional objects in space.

Many modern artists reject this system, some preferring to create a spatial illusion of their own, while others consider systematic methods for creating the illusion of a third dimension irrelevant. For an accurate representation of the physical world, however, a knowledge of the basics of perspective is essential.

First, it is necessary to establish a horizon – a horizontal line representing the furthest visible distance, where – owing to the

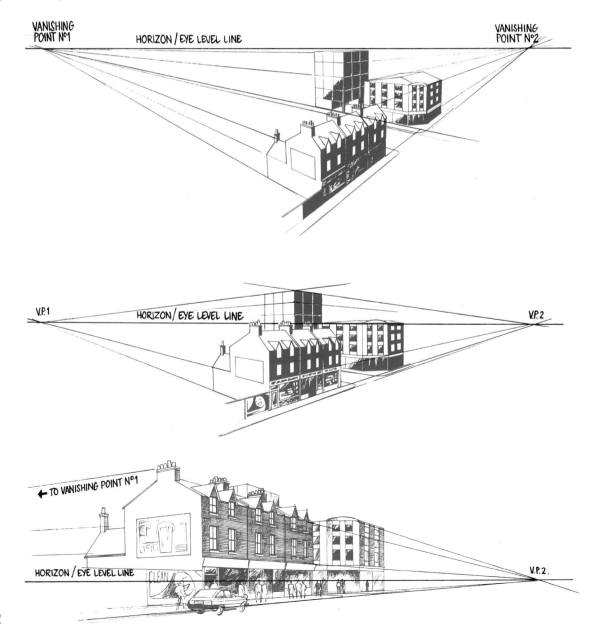

curvature of the Earth – sky and Earth appear to meet. Below this line is the ground; above it, the sky. Objects appear to get smaller as they recede away from us: they diminish in size towards a vanishing point on this line.

On the left is a sequence of three pictures of a group of buildings. In the first picture, they are viewed from high above ground level; in the second they are viewed from rooftop level; in the third they are seen from the eye level of a person standing in the street. Notice that, as our vantage point gets lower, the horizon line likewise gets lower; in fact, it is always at the same level in the picture as our eye level. For this reason, we call the horizon the eye-level line.

Since, normally, everything in one picture is viewed from the same place, the eye-level line is horizontal across the picture. It is not necessarily a line we can actually see as a horizon, for tall objects may obscure our view of the far distance, but we need to establish it so that we can refer everything we draw in the picture to it, and thereby ensure that the whole picture is consistent.

**Left:** *Illustration for an advertisement.* [*Copyright © ECC Quarries.*] **Below:** *The team arrives in Istanbul – illustration from* Canon, *written by Melvyn Bagnall .*

If you are a man of average height, your eyes will be about 1.7m (5ft 8in) above the ground, so your eye-level line will be roughly where it is shown in this first picture when you are standing upright on the street. The position of this eye-level line governs the position of everything in the picture. Everything taller than your 1.7m will be above this line; anything lower than 1.7m will be below it, wherever in the picture it is.

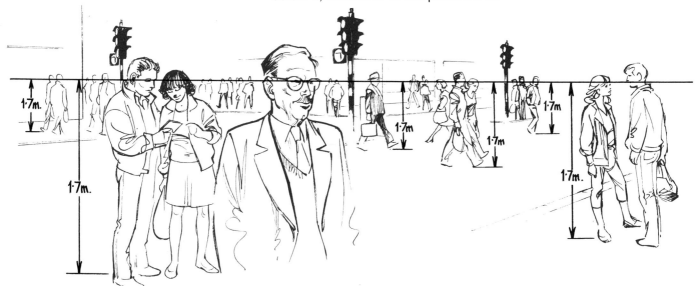

If someone of the same height as you stands directly in front of you, his or her eyes will be on the same level as yours, so they, too, will be on your eye-level line (A). If the person is taller than you, then your eye level may be only as high as his or her chin (B); if shorter, your eye level may be over the top of the person's head (C).

If these people now stand farther away from you, and the ground is flat, they will appear smaller (because they are more distant) but their height will be exactly the same in relation to your eye level, so your eye-level line will cut across them in the same place. Indeed, wherever they stand on flat level ground in your picture, they will retain this same relationship with your eye-level line.

However many people you have in your picture, they can be established at exactly the right size by the position they bear relative to your eye-level line. If the person you draw is taller than you, then his or her eyes will be at the same height above your eye-level line. If you draw a child, the top of his or her head will always be the same apparent distance below your eye-level line. The top of a door will be above the line, the top of a car below it. So every door and every car roof in your picture, no matter where they are, must be above and below your eye-level line accordingly.

If you decide to take a viewpoint that is higher than the average standing height – for example, you might consider yourself to be standing on a box 1m (3ft) high – your eye-level line will be 1m above that of all the people of your height in the picture. Likewise, if you kneel down, your horizon will be correspondingly low – at about everyone's waist level – so the waist of every standing figure in your picture will be on or near your eye-level line, however near or far from you they are.

# Aerial Perspective

Another useful technique in tackling the problem of recession and depth in pictures is to make use of the way in which distant objects appear to be paler and somewhat less distinct to the eye than objects that are close by. In drawings using only line, this less-distinct quality can be represented by the use of finer lines. In painting, less strongly contrasting colours are used to show distant objects. This practice is known as aerial perspective.

**Below:** *Use of aerial perspective in two frames from* Harry Black, Private Eye, *written by Ron Tiner.*

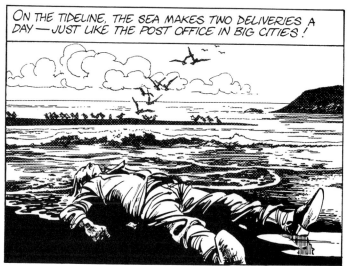

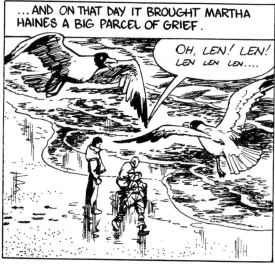

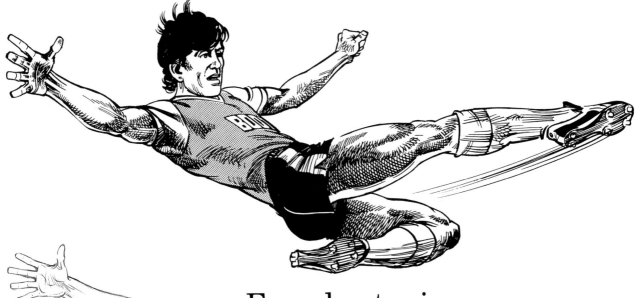

# Foreshortening

Perspective also involves the concept of foreshortening. It enables you to represent a figure so that it will look solid and three-dimensional rather than flat like the surface on which it is drawn.

If you look carefully at the drawing of the soccer-player at the top of this page you will notice that, in order for his right arm to make sense, it must be understood to be coming out of the picture plane towards us: his right hand must seem to be nearer to us than is his right shoulder. Of course, it is not *really* nearer to us, because the page he was drawn on is flat; but, if it is convincingly rendered, the arm will be accepted unquestioningly by the eye to be receding away towards his shoulder.

The three drawings to the left show the arm apparently reaching progressively more directly towards us. As it does so, it appears to get shorter, which is why this method of making something appear to be reaching out towards us is called foreshortening. The effect is achieved using two techniques. One is to emphasize

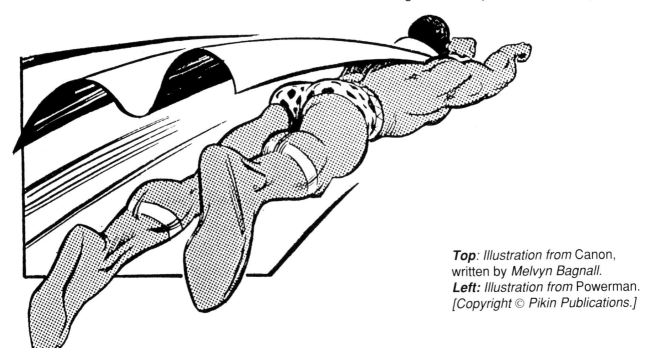

*Top*: *Illustration from* Canon, written by *Melvyn Bagnall*.
*Left*: *Illustration from* Powerman.
[*Copyright* © *Pikin Publications*.]

or even exaggerate the perspective: the soccer-player's hand is drawn larger to indicate that it is nearer to us than the rest of his body. The other is known as 'barrelling': emphasizing the roundness of his arm, by shading, and the round shape of the cuff of his shirt. Both of these help to establish that we are looking *along* the arm rather than at the side of it.

In the illustration of the superhero at the bottom of the opposite page, the whole body appears to be receding away from us. The solid muscular shape of his torso is accentuated by the belt around his waist. The same applies to his legs, the roundness of which is emphasized by the loop decoration around his calf muscles and by the line showing the leg of his shorts. The viewer subconsciously picks up these clues and naturally comprehends the figure as a three-dimensional form receding in space.

Drawing in line demands the use of hatching in order to show form or shadow. Any hatching lines which are drawn as though on the surface of the figure help to reveal its form and thereby convey the impression of depth.

**Above:** *Illustration from* Black Jack, the Footpad, *written by E. Cowan.* [Copyright © D.C. Thompson.]

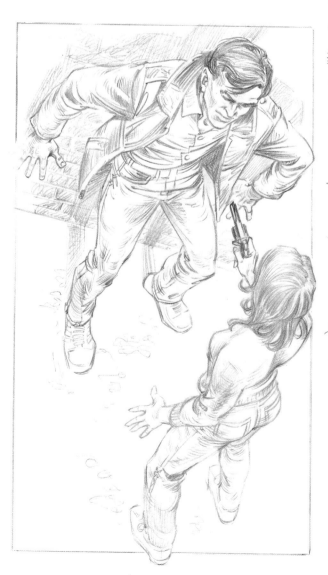

# The Centre of Interest

You, the artist, govern the way in which a picture is viewed. You control what is seen first, how the eye of the viewer travels round the picture, and what is perceived as important. With careful planning and organization, any figure or object in the picture can be given special prominence or played down, and aspects of character and mood can be emphasized.

The first thing to decide upon is your centre of interest. This is the object, figure or group that is the main subject of the picture – i.e., what the picture is actually *about*. Although not necessarily in the centre of the picture area, it is what the picture's composition determines that the eye is naturally attracted to. Of course, it will rarely be the *only* thing you want the viewer to be aware of, but your composition must ensure that the roles played by the less important details are merely supporting ones.

One of the simplest ways in which the centre of interest can be given special prominence is by relating the shapes of the subsidiary picture elements to each other.

In picture 1, at the top left of this page, all the shapes are similar to each other. They are not exactly the same but their shapes bear some relation – they are therefore called 'related shapes'. Although they are randomly placed, they appear to form a fairly uniform pattern: no single box-shape stands out from the rest. However, if we replace one of the box-shapes with a star – a shape completely *un*related to the rest – it stands out very clearly (2). The eye is naturally attracted to it so that it becomes the centre of interest.

If, conversely, most of the shapes in the picture area are stars (3), then it is the unrelated box-shape which becomes the centre of interest. The eye is naturally attracted to the shape that is different.

If all the shapes in the picture are very different from each other, as in picture 4, there is no single distinctive feature for the eye to pick out and so there is no centre of interest. Only by relating the less important picture elements to each other is any single item given prominence.

Pictures 5 and 6 show Little Red Riding-Hood walking through the woods. By relating the shapes of the trees to one another, we cause them to form a pattern, and Little Red Riding-Hood, as a completely unrelated shape, features clearly as the centre of interest. Wherever we place her within this pattern of related shapes, she catches the eye: she becomes the subject of the picture.

The natural tendency to perceive as important anything that is sufficiently distinct in shape from its surroundings can be used effectively in any picture composition. The diagram at top right shows how the seated figures in the final picture form a related-

shape pattern, so that interest is focused on the standing figures. The exchanged glance between the two young people is what the picture is about. In the illustration at the bottom left of the page, the chimneys form a related-shape pattern and so give prominence to the silhouetted figure.

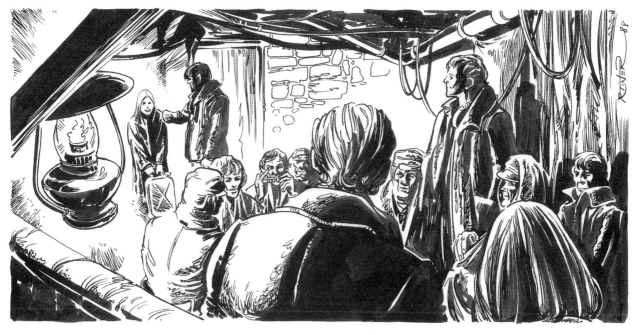

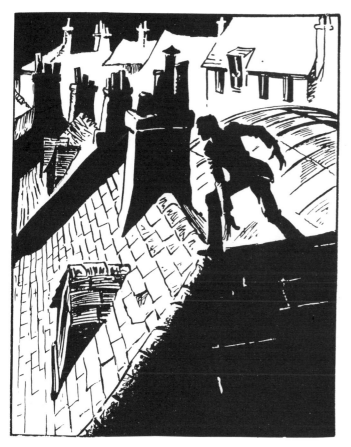

**Above:** *Illustration from* Brother in the Land, *written by Robert Swindells.*
*[Copyright © Carel Press.]*
**Left:** *Illustration from* Black Jack the Footpad, *written by E. Cowan.*
*[Copyright © D.C. Thompson.]*

129

Another way to make a feature of one part of a composition is to give that part greater liveliness and contrast. Any single area in which there is a concentration of contrasting shapes or tones immediately attracts the eye.

The centre of interest may be 'framed' by other picture elements, so isolating it within its own small, clear area. This device once again makes a special feature of a single picture element, which consequently appears more important.

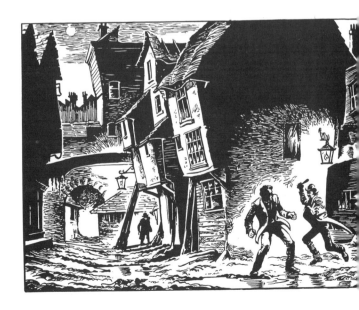

**Above:** *Illustration of skiers.*
*[Copyright © Fleetway 1991.]*
**Left:** *Illustration of the Ghost of Mrs Barwick from* Yorkshire Oddities, *written by S. Baring-Gould.*
*[Copyright © Smith Settle Ltd.]*
**Below:** *Illustration from* Black Jack the Footpad, *written by E. Cowan. [Copyright © D. C. Thompson.]*

**Right:** *From* Black Jack the Footpad, *written by E. Cowan.*
*[Copyright © D. C. Thompson.]*
**Below:** *Illustrations from* Hunters of Tropicanus.
*[Copyright © D. C. Thompson.]*

# Directional Lines

In looking at a picture, the viewer's eye is unconsciously directed around the picture area by the arrangement of lines and shapes. So far we have considered ways in which the most important item in the picture can be made to stand out, but we can guide the attention towards other areas too. In so doing we are able to give greater or lesser importance to other elements, as the meaning and purpose of the picture dictates.

**Above left:** *Illustration from* Black Jack the Footpad, *written by E. Cowan.* [Copyright © D. C. Thompson.]

In the pair of illustrations shown here, the picture elements consist of a man, a tree and a rabbit. In the example on the left the focal point – the centre of interest – is the man. Both tree and rabbit are subsidiary details – just part of the surroundings. In the second example, however, it is the rabbit that is important. By rearranging the three picture elements – and without altering the *size* of any of them – we have changed the entire message and meaning of the picture.

There are a number of ways in which this control of composition can be exercised. The most obvious is through the use of lines.

Lines can be used as pathways along which the eye will naturally travel within the picture area. They can also provide a link between one feature and another, controlling the viewer's perception of what is important and what is not.

Here again is Little Red Riding-Hood (picture 1). As we saw before, our eye naturally alights on her because everything else in the picture forms a related-shape pattern. If we now provide her

with a footpath to walk along and a patch of woodland flowers (2), our eye naturally travels along the pathway leading from the flowers to Little Red Riding-Hood. Flowers and girl are linked, and our perception is that she probably stopped for a while on her journey to pick flowers for her grandmother.

Now add a Big, Bad Wolf (3). By placing him where he is we ensure that the continuation of the woodland path directs the eye to him. Since the Wolf is looking at Little Red Riding-Hood, our attention is diverted back to her; but the direction of her walking returns the eye to him, and so on. Thus a static image – which is all any picture can be – produces a dynamic response in the reader/viewer, thereby creating a tension that enlarges the message conveyed by the picture.

It makes no difference if we add a bird in the branches or a clump of flowers by a foreground treetrunk (4). These are not important because they are not linked to the main centre of interest.

In the other three illustrations on this page, the footpath and the receding surfaces of the boat and the car are used to give the picture depth as well as to lead the eye towards the focal point.

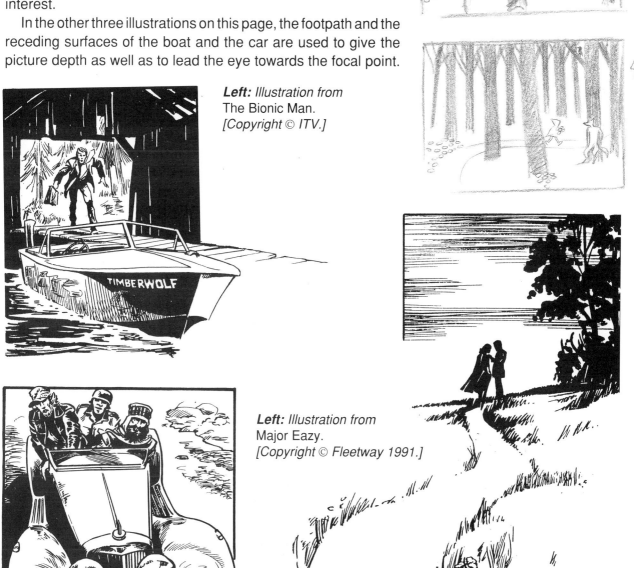

**Left:** Illustration from The Bionic Man. [Copyright © ITV.]

**Left:** Illustration from Major Eazy. [Copyright © Fleetway 1991.]

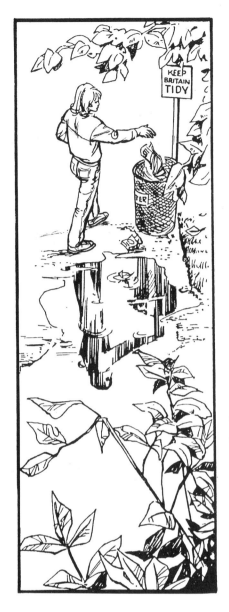

Single lines or obvious pathways are not the only means that we can use to lead the eye along a predetermined route within the picture area. A line of objects may be used, or even a number of items so placed that they direct the attention towards the focal point. The illustration at the bottom of this page is an example of this: the objects cluttered in the foreground all play a part in focusing attention on the two young women peeping through an aperture in the partition.

In fact, with a little imagination, almost anything can be utilized to direct the eye and mind of the viewer. Human beings are instinctively cooperative beasts (and this applies to almost everyone): no matter how perverse our individual nature might be, we will 'read' your picture in exactly the way you dictate. Our eyes will inevitably follow the path you lay out.

You can make use of the social nature of your fellow humans in other ways. Because we all have the natural tendency to involve ourselves in other people's business, if you draw someone in your picture looking towards the centre of interest you create invisible direction lines that urge our eyes to follow suit.

**Above:** *Illustration from* Mother is a Star. *[Copyright © D. C. Thompson.]*
**Right:** *Illustration for*
*John Cleland's* Fanny Hill.
**Opposite, top:** *Illustration from*
Major Eazy.
*[Copyright © Fleetway 1991.]*

SITTING ON THOSE LOW CASES, WE COULD SEE ALL (OURSELVES UNSEEN) BY APPLYING OUR EYES TO THE CREVICE WHERE THE PANEL HAD WARPE

**Opposite:** *Further examples of ways in which the viewer's eye can be directed towards the centre of interest.*

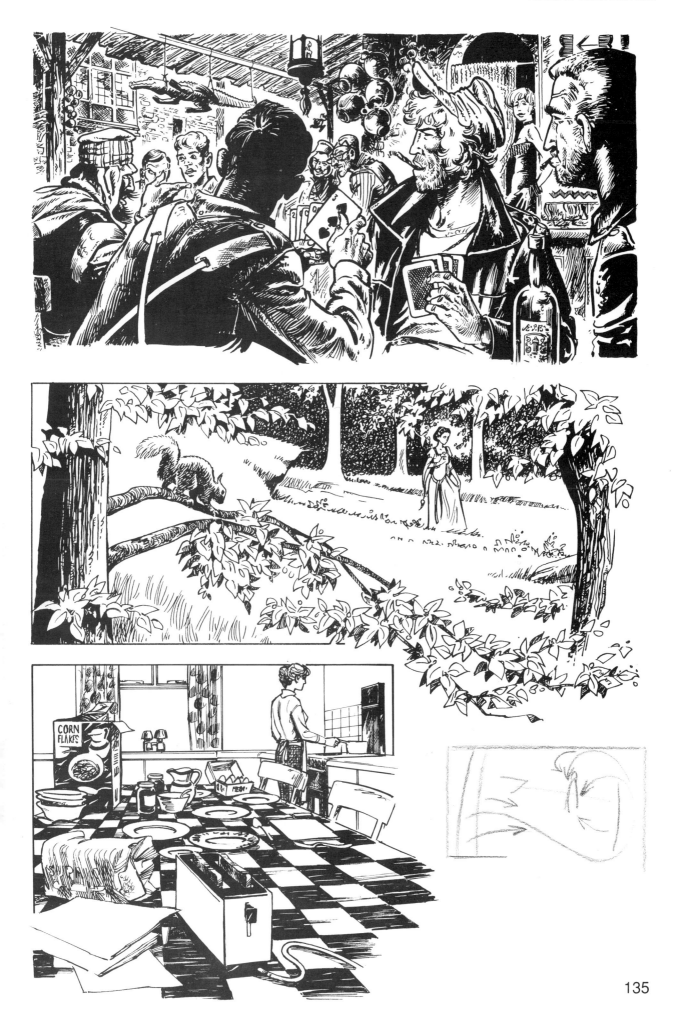

Creating pictures which catch the imagination demands more than a grasp of the principles of picture composition allied to the ability to draw convincingly. The picture must be so organized that it offers a visual experience which is in some way *new*. This is not to say that we must constantly be in search of novelty but rather that, however familiar our subject, we must find ways of making our drawing of that subject unique.

Every shape in a drawing has two functions: as a flat shape on the surface of the paper and as a representation of something. For example, the rhomboid at the top of this page is not just a rhomboid: it is also a representation in depth of a square table-top. For a composition to be successful, both these ways of looking at an image must be taken into account.

Shown at the left are two versions of the same illustration showing a monk buying seeds at a market-stall. The second one is evidently more successful than the first, but why? It is because the shapes it makes on the page are more interesting. To show

this up clearly I have painted everything in the second picture black. The silhouette that results is quite intriguing, with interesting projections jutting out in all directions and several small, oddly-shaped holes.

But this total shape is not all there is to it. The seemingly haphazard stack of primitive garden tools makes another intriguing shape, as does the shadow area on the monk's habit, and the combined outline of the people and stalls in the background presents yet another. All over this picture, elements are juxta-posed and overlapped in such a way that interesting shapes and patterns result.

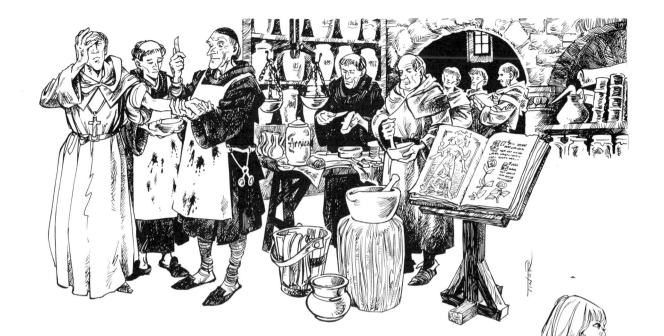

In all the other illustrations on these two pages the shapes of figures and objects are grouped, combined and overlapped to create interesting arrangements. These unfamiliar shape-combinations give us the means to make every drawing unique. Anyone who looks at it will be subconsciously aware of their effect, and thus attracted by the drawing. They are the means by which we stir the viewer's imagination. Without them, the drawing is dull.

**Top:** *Illustration from*
In a Monastery Garden,
*written by E. and R. Peplow.*
*[Copyright © David & Charles plc.]*
**Above:** *Illustration from* The Fox,
*written by Ron Tiner and M. Blanchett.*
*[Copyright © Fleetway 1991.]*
**Left:** *Illustration from* Clancy's
Casebook, *written by*
*B. Cassells and I. Lowden.*
*[Copyright © Oliver & Boyd Ltd.]*
**Below:** *Illustration from* The Rat Pack
*[Copyright © Fleetway 1991.]*
**Opposite, centre:** *Illustration from*
In a Monastery Garden.
*[Copyright © David & Charles plc.]*
**Opposite, bottom:** *Illustration from*
Black Jack the Footpad,
*written by E. Cowan.*
*[Copyright © D. C. Thompson.]*

This fundamental double-meaning of each ingredient is a means by which we may capture the viewer's emotions, too. Some objects may be drawn in such a way that the shapes they make on the paper are reminiscent of quite different objects. The threat posed by the bearded gentleman in the illustrations on the left is increased not only by the way the bayonet or the hand juts out towards us but also by the shape of his scarf fluttering about in the wind. Its shaggy ends are analogous to the groping shapes of skeletal hands or spiders' legs. In this way, intimations of horror are added to the threatening aspect in the message of the picture.

The large picture at the bottom right of this page is an illustration to the story of a man whose mind became unhinged when he was jilted on the eve of his marriage. He went to bed and never got up for the rest of his life. The crazy, distorted bed, in which he appears to be imprisoned, emphasizes the pathos of his predicament.

Similarly, jubilation is expressed in the courtroom scene by the lively, dancing shapes of limbs and faces.

**Above and Below:** *Illustrations from* Fatality (Hellblazer *no. 30),* *written by Jamie Delano.* *[Copyright © DC Comics Inc.]* **Right:** *Illustration from* Yorkshire Oddities, *written by S. Baring-Gould.* *[Copyright © Smith Settle Ltd.]* **Opposite, bottom left:** *Illustration from* Gumboot Practice, *written by John Francis.* *[Copyright © Smith Settle.]*

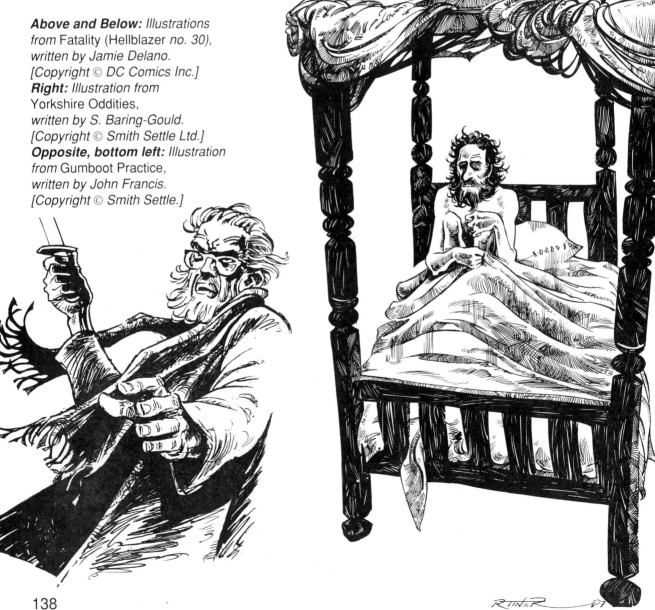

Of course, horror, pathos and jubilation are all sufficiently strongly defined emotional states for their visual equivalents to be readily identified, but every possible human feeling can be communicated in visual form by these means. We use the shapes of the things we draw and the shape-combinations created by overlapping, delineation of shadow areas, and so on, to communicate feelings on a subjective level.

There are other means whereby the emotional message of a picture may be communicated. The viewpoint we choose can add a great deal to the viewers' response to the subject.

In the first illustration of the small child with the teddy-bear she is warm, comfortable and secure. In the second she is obviously alone in the house; we take a high, downward view and place her in an empty area, away from the furniture, to emphasize her loneliness. The foreground banister adds depth, which again increases the feeling of loneliness.

In the third picture, her frightened vulnerability is stressed by accenting her small stature (through contrast with the height of the door) and by showing the threatening shapes of the dark shadows around her.

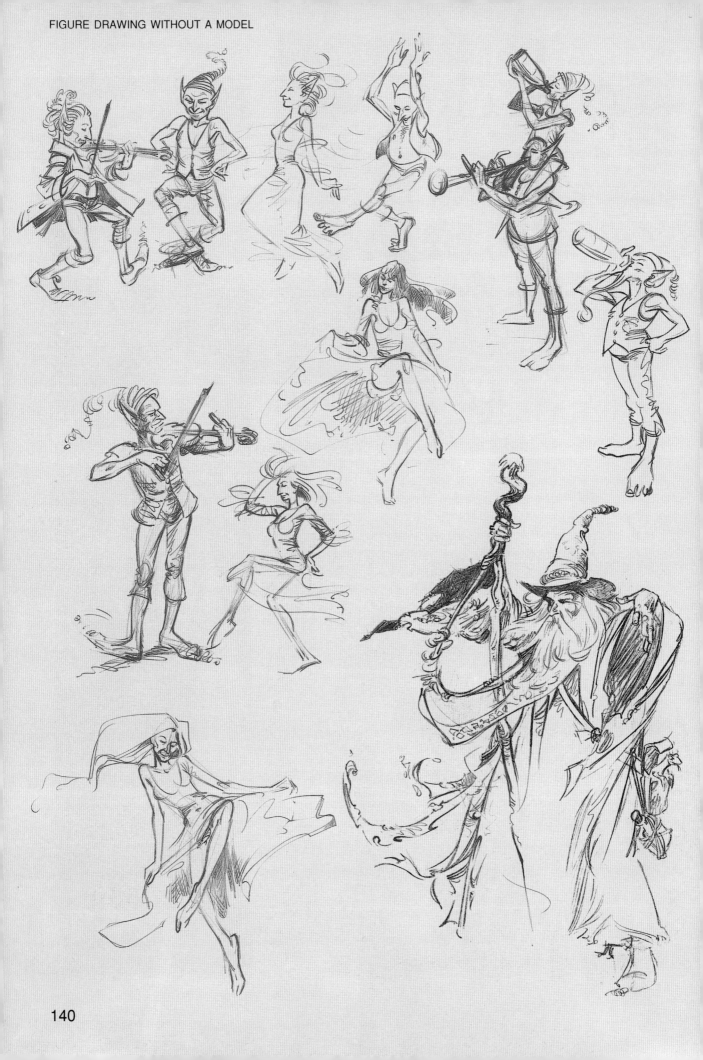

*The difficulty with the picture on this page was to place all the figures in a lively arrangement without allowing the big wizard figure to dominate too much. I'm not sure it was entirely successful. Perhaps the dancers should have been slightly bigger and the windblown garments of the wizard rather less heavy. Opposite are some preliminary sketches.*

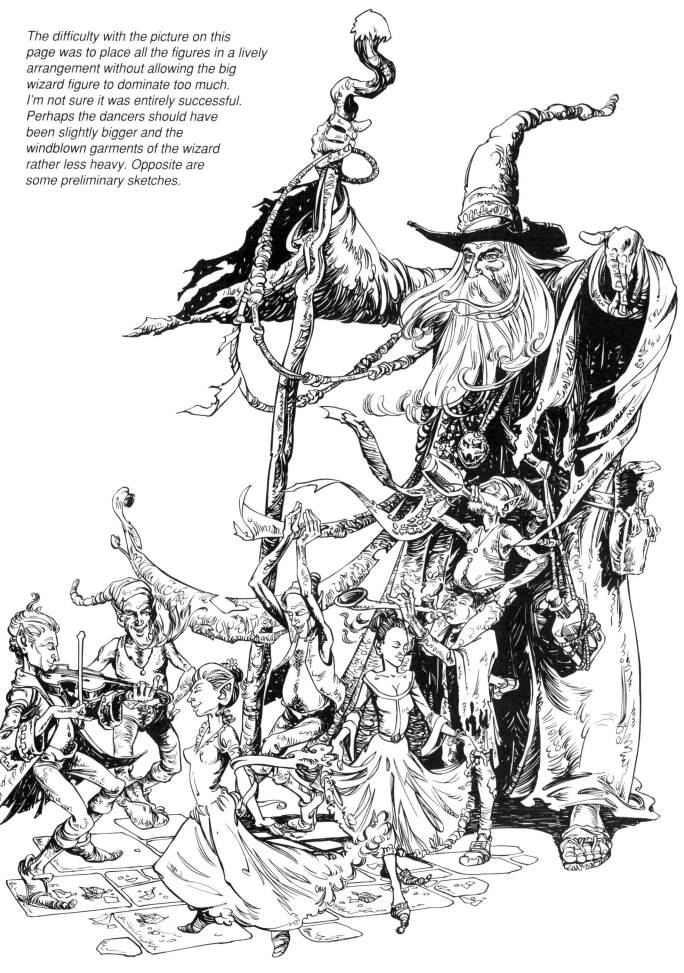

The requirements for this illustration presented another conundrum. The chief of police had to be depicted walking uninterestedly away from the scene of the murder. Showing him walking out of the foreground tended to lead the reader's eye away from the centre of interest. By ensuring that all other lines direct the eye towards the two main characters I attempted to diminish his significance in the composition. How would you have done it?

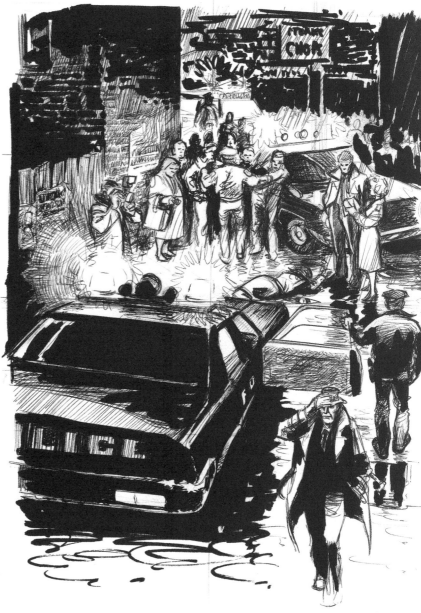

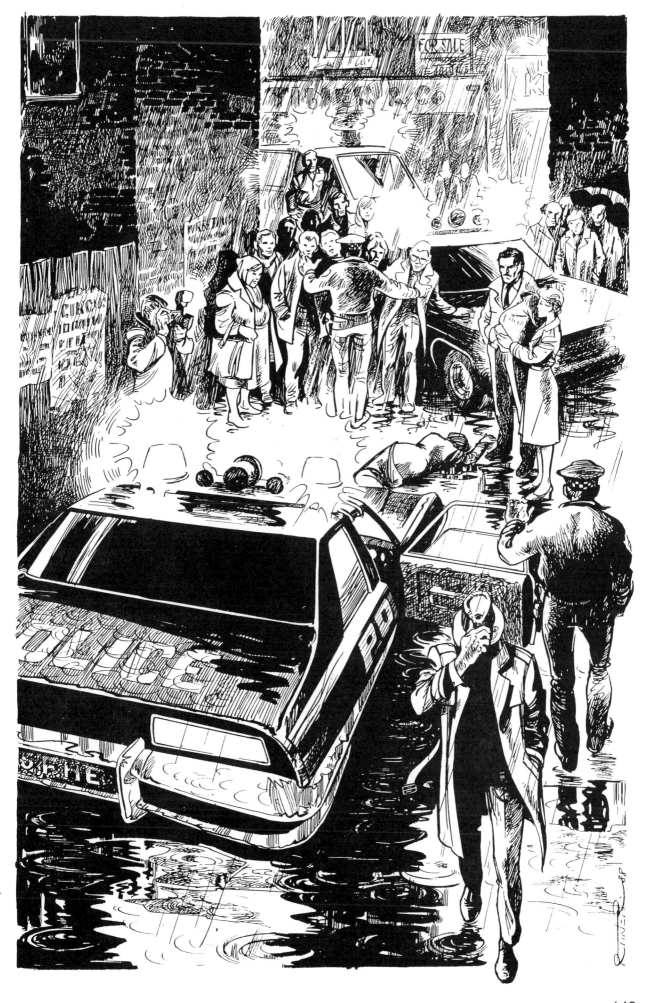

## CHAPTER 8

# GRAPHIC NARRATIVE

Graphic narrative, or what is commonly called comic-strip, uses words and sequences of images in tandem in order to tell a story. As an artform it lies roughly at the crossroads between literature, illustration and cinema, having much in common with all three and containing elements of each. It is like literature in that it is concerned with telling a story, like illustration in that it uses drawings to give visual information, and like cinema in that it uses a combination of words and images to carry its message. Only in the past few decades has graphic narrative been developed as a distinct medium; not until recently has its true potential begun to be investigated. It demands a talent for story-telling: a feeling for

- what words can do
- what pictures can do
- what part each most effectively plays
- the way in which word-and-picture combinations can provide a more profound aesthetic experience than either words or pictures alone

More than in any other field of illustration, artists in graphic narrative may find themselves subject to editorial constraints that can be both puzzling and frustrating. Editors, being word-specialists, appreciate the concept-patterns that words can stimulate in the mind but may occasionally show a surprising blindness to the subtle messages contained in the pictorial element of graphic narrative. Some, I think, suspect the artist of trying to obviate the need for words altogether – which is very far from true.

The success of any artform depends to a great extent on its unity – its consistency of form – and on its creators' skill in utilizing all the techniques at their disposal. Nowhere is this more true than in graphic narrative.

# Narrative Form

Stories have a structure, just as pictures do. If you started reading a good book and then lost it, you'd probably feel rather frustrated. If you look at the torn picture-fragment at top left you'll probably have the same reaction. But if you look at the fragment at the bottom of this page you'll likely feel less thwarted, because it contains more of what you expect from a picture: the part you can see is almost complete in itself.

When we subject ourselves to any work of art – novel, picture, symphony or whatever – we perceive our experience of it as a structured pattern. If you read a mystery novel, you recognize the puzzle at the beginning, and confidently expect that, through a series of depicted events, you will be led to the solution. It doesn't matter that this has nothing to do with real life, in which mysteries often remain unsolved.

Different rules apply in stories, and so we always approach them with a slightly different set of values and expectations. We expect the way any work of art is structured to provide an experience which is both consistent and complete in itself. This characteristic is referred to as the *form* of the piece.

Narrative form is the way a story is constructed so that each item of information that we need to know is made clear at the appropriate point along the way. We understand and identify with certain of the characters portrayed, and become concerned about the outcome of events affecting them. Once again, this is not a true mirror of real life. People whom we find fascinating in a story might be utterly repulsive to us if we actually met them, and of course the events of real life have a habit of occurring in an infuriatingly haphazard order!

In graphic narratives the artist has a very important part to play in giving the story form and structure. As with other aspects of drawing, the readers' experiences and expectations are guided and controlled, but here the control is exerted by an artist-and-writer team working together. In the way we govern narrative form we can make the reader feel certain emotions, sympathize with certain characters, or take the side we dictate in any conflict. Not only this, we can also create suspense, curiosity and surprise, and give places, events and people special significance: in short, we introduce our readers to a view of life – even a whole world – that may be completely new to them.

The examples opposite are from four very different kinds of story. The flavour of each is clearly evident not only in what is drawn but in the drawing style, page layout and narrative technique adopted.

In the first example, taken from *The Arabian Nights' Tales,* the ancient Near East is evoked by the use of exotic images and of a page-pattern that emphasizes the rich opulence of the scenario. The second is from a hilarious science-fiction tale by Alan Moore

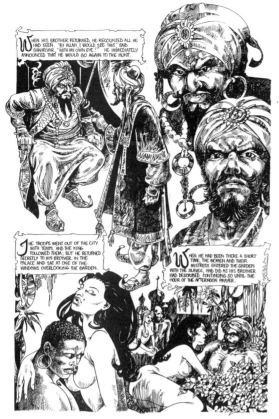

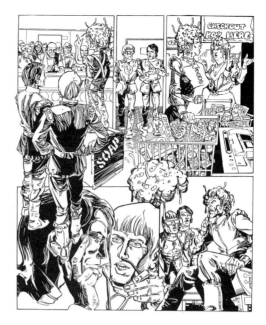

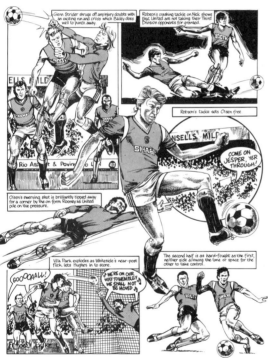

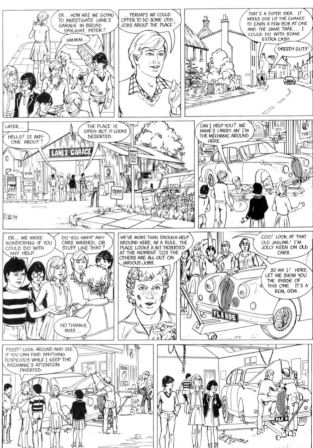

concerning weird synthetic brain-extensions worn on the head to multiply intellectual capacity; unfortunately these prove to be faulty, and everybody who wears one becomes increasingly odd in their behaviour. Both page layout and drawing style emphasize the off-beat humour of the tale. The third makes use of dynamic figure images to capture the excitement of the sports stadium. Finally, the fourth is an adaptation of one of Enid Blyton's re-creations of childhood, so the framing, the light, decorative line quality and comfy rural settings are used to achieve a gentle nostalgia.

*Pages from graphic narratives.*
**Clockwise from top left:**
The Arabian Nights,
*published by Galaxy Publications;*
Future-Shock,
*written by Alan Moore*
*[Copyright © Fleetway 1991];*
The Secret Seven,
*written by Enid Blyton*
*[Copyright © Gutenberghus];*
Canon, *written by Melvyn Bagnall.*

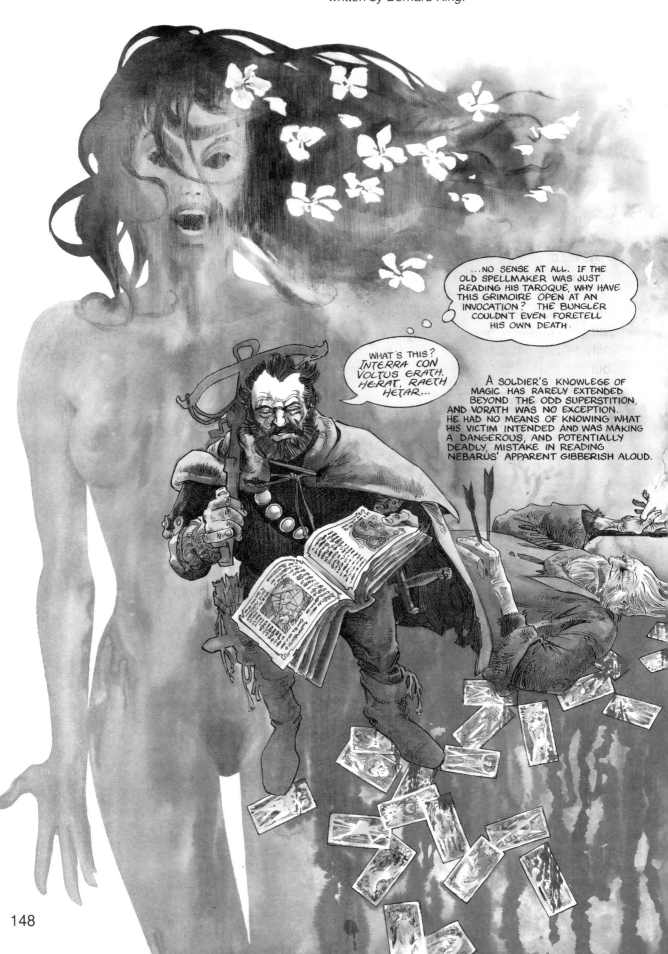

*A graphic-narrative page from* Thera – The Last Key, *written by Bernard King.*

# Single Viewpoint

In graphic narrative a large part of the story is told through pictures. But just putting together a number of pictures in the right order is not enough. As we've noted, you need to have a feeling for narrative and a grasp of what can be achieved through the use of both words and images in tandem. The reader must be led to *experience* the events in the story through your adoption of a consistent viewpoint. This does not mean that you must look at everything from the same angle but rather that you should make the succession of pictures lead the eye and mind of the reader logically through the sequence of events and ideas which make up each incident in the plot.

The fragment at the bottom of this page is from a story about an adolescent girl making her way through Nazi-occupied France during World War II. The story is told in the form of diary excerpts, and so all events are seen from her point of view. Each composition has a left-to-right movement (figures are seen moving from left to right, she looks to the right when watching the plane take off, etc.), so that the eye is guided naturally across the page. We identify with the girl through the way in which her experiences are recounted and the fact that she features in each frame.

To show how these decisions about picture viewpoint and content are made, I shall take as an example another incident in the same story. In this short extract our heroine must escape from a village without being spotted by the occupying troops. She has to get across an open space, but finds that it is being watched by a German guard. Two friends stage a mock fight to attract the guard's attention, so that she is able to run across the open space towards freedom.

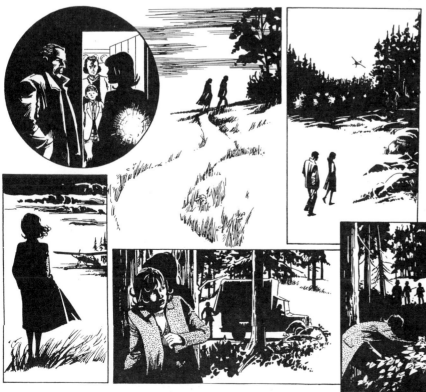

*Fragment from*
The Fifth Swan Child.
*[Copyright © D. C. Thompson.]*

149

In the first example, the girl is shown peeping round a wall at the guard, who is sitting on a step smoking. The next three frames show the men fighting, the guard's attention being caught by the fracas, and the girl running to freedom. But there is nothing to show the connection between each part of the incident. We can't tell where each one is in relation to the others, so captions are needed to carry the burden of the story – which could be told just as effectively without the illustrations at all !

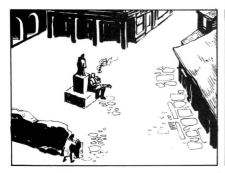 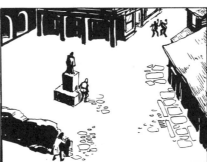 

So let's instead take a viewpoint that allows the reader to see everything. The second version shows us where everybody is, but the sequence is boring and repetitive – there's still no reader-involvement. We don't know whether to feel annoyed on behalf of the tricked guard or relieved on behalf of the fleeing girl.

In the third version we establish identification with the girl because we see the situation from her point of view. The expression on her face tells the reader how she feels about her predicament. The second frame shows her view of the soldier's notice being caught by the fight, and the third her escape while his attention is held. In this version words and illustrations both play a part in the story-telling.

*Left and below:* From The Fox, written by Ron Tiner and M. Blanchett.
[Copyright © Fleetway 1991.]

# Multiple Viewpoint

Of course, this is not the only kind of narrative. Not all stories recount every event from a single person's point of view. More often, the reader knows more about the causes and effects that make up the story than does any single character in it.

The story excerpt shown at the top of this page is an example of this. This story concerns a fox, and the profound effect his innocent vulpine activities have on two families. Throughout, no single individual or family group knows all the facts, so some parts of the story are told from one character's point of view, some from another's.

This is the opening sequence, in which we are introduced to the fox family and the scene is set. The first frame is called an 'establishing shot' because it establishes in the reader's mind the setting in which this part of the story is to take place. Whenever there is a scene-change there will need to be an establishing shot within the first two or three frames of that scene to orientate the reader.

Once we have been introduced to the vixen (our hero's mother) and her family, and have been shown that they live in the basement of a derelict house, we have a daylight scene in which

151

*Two versions of a story incident. Although the content of the pictures is very similar, only in the lower example is the narrative meaning clear.*

we see one of the human families moving in next door. Once again there is an establishing shot; in it the houses are seen from a similar angle to that of the first frame, so that the reader is immediately aware that this is the same row of houses.

The subsequent frames introduce family members and their relationships, so we now move in closer to see them settle into their new home. Their conversation tells us what we need to know to set the story off.

The manner in which each frame is drawn – whether it is a close-up or long shot, what mood it conveys, and so on – 'pulls' the reader into the story. The artist enables the reader to *experience* the story, rather than simply showing them what the characters and settings look like.

This process of achieving reader-involvement is not a difficult one. Everyone knows what forms narratives take, so they naturally look for relationships between characters, scenes and other story elements. Your readers will readily pick up any clues you give them as to the significance of any particular detail.

The two sequences above show a woman getting into a taxi. As she does so, we see – but she does not – that she is being watched.

The first example fails to involve the reader because no clue is given about what is going on. In the second, simply placing the parked car in the first frame is enough for the reader to understand that the woman is being watched. It *could* merely be a neighbour waiting for the garage truck to arrive to mend a puncture, but readers will discount this mundane possibility, knowing that such an irrelevance would not be included in any sensible narrative unless the author wanted to mislead them for some other plot purpose. That parked car is important; we know it because of the way it is presented to us.

The situation is rendered more dramatic by the fact that we can see that the woman herself is unaware of the other car and its implied threat. This makes her vulnerable, and her vulnerability helps to build up tension in the story.

Most narratives rely heavily on suspense as a device to keep the reader involved. Tension builds up, and the resulting suspense creates a climax. In the commonest form of narrative there are usually a number of minor climaxes culminating in the major one (the denouement) at the end. The emotional structure is therefore very like that of a symphony.

The artist can enhance suspense by using unusual 'camera angles', dramatic lighting effects and other techniques we discussed in Chapter 7. Climaxes are made effective in similar ways, with stark, dramatic close-ups and violent contrasts. However, these devices should be used sparingly. You should resist the temptation to make every frame 'count' in this way. Unbroken suspense and non-stop action soon jade the reader's palate, so that the result is – paradoxically – an emotional blandness. Remember, narratives need structure, just as pictures do.

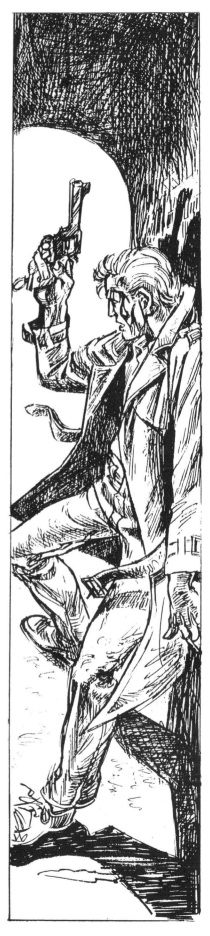

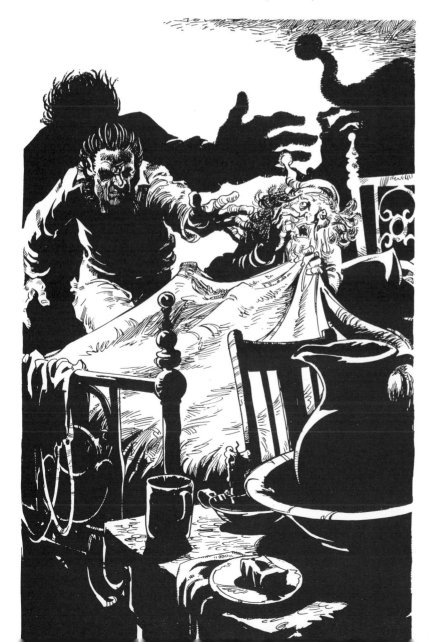

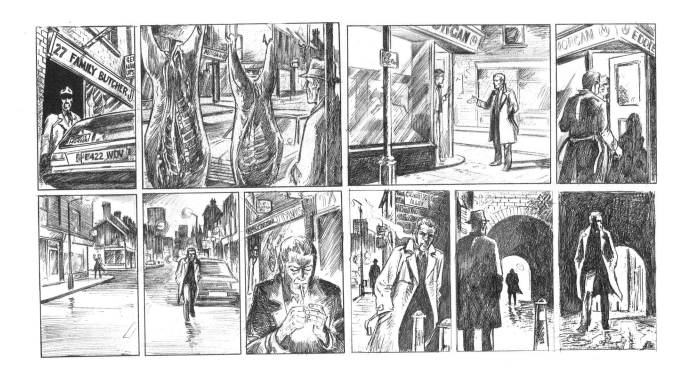

# Building up Tension

The ten-frame sequence above is an excellent example of tension build-up and suspense. It was scripted by Jamie Delano, one of the most highly skilled writers in graphic narrative today.

The man wearing the trilby hat in the first frame is already known by the reader to have murdered an entire family. In this scene, he lurks in a shop doorway after dark, waiting for the main character, John Constantine, to emerge from Morgan's corner shop, where he lodges. A little extra twist is added to the scene by the shop sign above the murderer's head in the first frame – the man really *is*, as it were, a 'family butcher'.

Writers sometimes call these little interlinking relationships between story-elements 'resonances'. They expect that many, perhaps most, of their readers won't consciously notice them – and of course it won't ruin the story if they don't. In graphic narrative such resonances can be especially effective. As an author acquaintance of mine says, it is the sum of all these little things that makes a novel 'sing'.

Put simply, suspense involves making the reader wait anxiously for the outcome of an event. This is achieved here by first setting up the ominous presence of the murderer across the street, then by staging an argument in the shop doorway as a delaying tactic. The following three-frame sequence, in which we see Constantine walk towards us across the street, builds tension because we know he is going to pass very close to the murderer. Only in the last of these do we actually see the killer come out of the shadows.

It was necessary, as the two characters turn into the alley, to show the scene from their points of view alternately. This can be confusing for the reader – especially if, as here, the two figures

are similarly dressed. To obviate this problem we make use of a 'marker' – in other words, of an object or landmark that is prominent in each frame and can therefore serve as a point of reference to tell us where we are. In this instance, I introduced the black-and-white striped bollards at the entrance to the alley. You may think you hardly noticed them, but in fact they are one reason why it is easy to know which raincoated figure is which.

In the two pictures at the side of the page, we cannot in the same picture show both the woman inside the house and the man outside it. This time the marker is the suspended ornament, which shows us that the window we are seeing from inside the room in the first frame is the same one that we see from the outside in the second.

# A Worked Example

Of course, there isn't enough room in this book to cover all aspects of graphic story-telling. So, to round off this chapter, I shall demonstrate by example through the use of the first few pages of another graphic novel involving the antihero John Constantine. Once again it was scripted by Jamie Delano.

It is presented here without any words, except for the title, for here I want to concentrate specifically on the drawing component of the artform. The second reason is that this is not the form in which the story was finally published.

The story concerns Jerry O'Flynn, a big, red-bearded, rumbustious man – one of those larger-than-life characters we have all met at some time in our lives. A local author has used him as a character in a novel and, as time passes, O'Flynn finds himself followed and beset by mysterious figures, who prove to be Sherlock Holmes, Doctor Watson and other classic characters from fiction. They claim that he now belongs in the ethereal world of literary characters rather than in the real world.

As the story opens (see sequence below) Constantine, who

**Opposite, top:** *Illustrations from* Sick at Heart *(* Hellblazer *no. 29), written by Jamie Delano.*
**Below:** *First draft of illustrations for* Larger than Life, *written by Jamie Delano.*
*[Copyright © D. C. Comics Inc.]*

has hitch-hiked down the motorway, gets out of a truck and walks into Northampton. In each successive frame on the page thereafter he is drawn closer and closer to the foreground in the course of his two-mile walk into the town. This device gives a feeling of purposefulness to his journey.

At the start of the next spread he has passed us and is walking through the town towards the residential area. In the foreground of frame one is a shadowy figure who might be familiar to you if you've seen the edition of *Treasure Island* illustrated by Mervyn Peake. This figure is Blind Pugh.

We owe a considerable debt to those great illustrators of the past who gave us definitive images of the classic characters of literature: E.H. Shepard's Winnie-the-Pooh, Sir John Tenniel's Alice, Sidney Paget's Sherlock Holmes . . . Always, when one of these characters is mentioned, it is the visual representation devised by the relevant artist that comes to mind. I decided to take this opportunity to pay homage to these artists. Each time a character from literature appeared in the story, I made one of my drawings of her or him a visual 'quote' from the original illustration.

We now follow Constantine into the suburbs, building up suspense as this frightening figure is sporadically glimpsed following him. Frames 4 and 5 of this spread show one side of a signboard and then the other. We obviously need a marker to forestall any doubt that it is the same one viewed from both sides; here the marker is the crooked sign. Each frame of the top row is

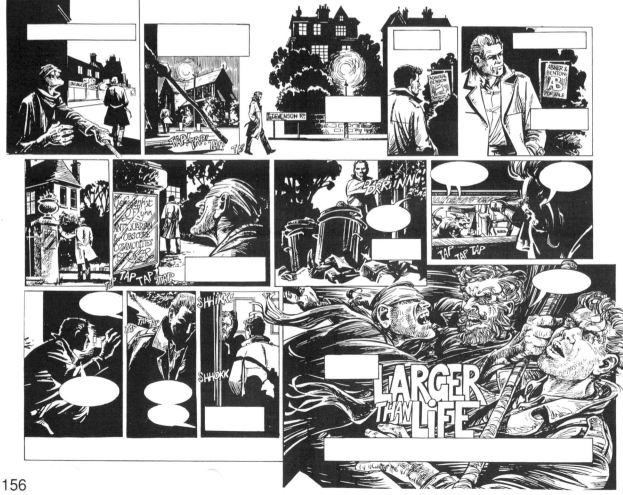

composed with a rightward movement, turning at panel 5 so that the eye is brought naturally to the second row. We follow Constantine to the gloomy old house where O'Flynn lives, still keeping up the suspense with glimpses of Blind Pugh. His sudden rush forward gives us a climax frame on which to letter the title.

Pugh thrusts a paper bearing the infamous Black Spot into O'Flynn's hand, and departs. The image of Pugh on this page is a visual quote of N.C. Wyeth's famous illustration. If you don't notice, it really doesn't matter, of course, but these little touches can add something to the reader's enjoyment of the story. To ensure that the eye easily negotiates the slightly unorthodox placing of this big central figure, we utilize the route formed by Pugh's right arm and his scarf to lead the eye across to panel 5.

Pugh runs in front of a car and vanishes. (By introducing the car as though part of the frame border, I wanted to give the feeling it was 'coming out of nowhere', so to speak.) Since the story is being told from Constantine's point of view, we now follow him into the house.

O'Flynn is portrayed as a dealer in unusual objects, so the big establishing shot of his living room includes a hoard of strange items. As the story will now begin to suggest that he belongs in the world of literature rather than the real world, all the objects in the room are 'not-real' objects – that is, they are objects that exist only in books, poems and the like: Mary Poppins's brolly and carpet-bag, Cinderella's glass slipper, the 'vast and trunkless

*The illustrations on these two pages are unpublished drawings for* Larger than Life, *written by Jamie Delano.*

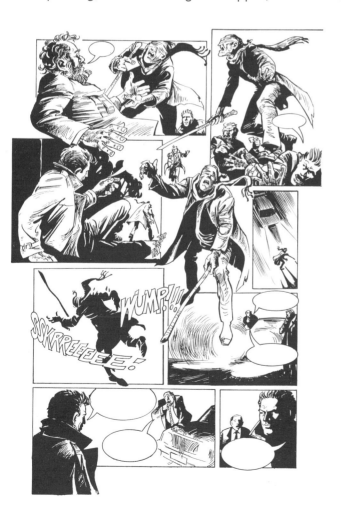

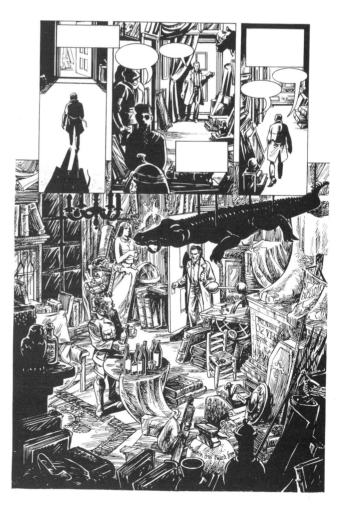

legs of stone' from Shelley's poem 'Ozymandias' . . . all of them resonances.

I have used the first three spreads of this rich and inspired tale of the supernatural both to demonstrate in detail the artist's contribution to graphic narrative and also to introduce you to just a little of the medium's potential. Graphic narrative is a fascinating area for the figure artist; indeed, one could go further and say that it is in graphic narrative that figurative art finds its greatest challenge.

# CONCLUSION

Surveying the contents of this book before finally sending it to press, I am aware of how much remains unsaid, the approaches that remain unexamined and the aspects of the subject that remain unmentioned. But I hope that, in sharing some of my own knowledge and experience, I have been able to open doors for you to some of the great pleasures and rewards I have found through drawing.

One of the oldest truisms about art is that the rules are only there to be broken. This sounds pretty silly on the face of it, but a case can be made that the rules or guidelines offered to you by any teacher or book of instruction will have fully served their purpose only when you have learned how you can successfully disregard them. That is why I hope I have encouraged the development of a streak of perversity within your approach to drawing – an urge to do things differently, even (or perhaps especially) when you have available a tried and tested method that has proved itself perfectly adequate in the past. So, if in reading any part of this book you have disagreed with what I have had to say – if you believed you could find better solutions to the problems I outlined – then it is achieving one of the things I wanted it to.

I set out to show that, through dispensing with the crutch of posed and constructed realities in the studio, you can encourage your imagination and inventiveness to grow. If I have been instrumental in causing you to take one step along that road, my efforts have been worthwhile.

Remember that the key to creativity is in the way you use your sketchbook. It is within its pages that your perceptions are sharpened. Playing with improvisations and exploring possibilities is the way to unlock the door of your creativity. If you draw constantly – relentlessly – until nothing in either the visible world or your imagination is beyond your ability to record, you will indeed have become gifted.

After all, paper is cheap. So are pencils.

# BIBLIOGRAPHY

Baring-Gould, S.:
*Yorkshire Oddities, Incidents and Strange
Events,* Otley, Smith Settle, 1987

Bordwell, D., and Thompson, K.:
*Film Art: An Introduction,*
New York, McGraw-Hill, 1979

Bradshaw, Percy V.:
*Come Sketching,* London, Studio, 1954

Braun, A.A.: *The Hieroglyphic Method of Life
Drawing,* London, Drawing Ltd, 1916

Broadbent, B.H. Sr, Broadbent, B.H. Jr, and
Golden, W.H.: *Bolton Standards of
Dentofacial Developmental Growth,*
St Louis, C.V. Mosby & Co., 1975

Cassells, B., and Lowden, I.: *Clancy's
Casebook,* Edinburgh, Oliver & Boyd, 1989

Darwin, Charles: *The Expression of the Emo-
tions in Man and Animals,* 1873

Delano, Jamie: *Hellblazer* nos 23, 29 and 30,
New York, DC Comics Inc, 1990

Dürer, Albrecht: *Human Figure – The Complete
Dresden Sketchbook,* New York, Dover, 1979

Dyson, Geoffrey: *The Mechanics of Athletics,*
London, Hodder & Stoughton, 1962

Eisner, Will: *Comics and Sequential Art,*
Tamarac (Fl), Poorhouse Press, 1985

Enlow, D. H.: *Facial Growth,* Eastbourne,
Saunders, 1978

Francis, John: *Gumboot Practice,* Otley, Smith
Settle, 1989

Henning, Fritz: *Concept and Composition,*
Cincinnatti, North Light, 1988

Johnson, Peter: *Front Line Artists,*
London, Cassell, 1978

Lavater, J. C.: *Essays on Physiognomy*
(trans. T. Holcroft), 1804

Moore, Alan, and Gibbons, Dave: *Watchmen,*
New York, DC Comics Inc, 1988

Morris, Desmond: *Bodywatching,*
London, Grafton, 1985

Morris, Desmond: *Manwatching,*
London and St Albans, Triad Granada, 1978

Muybridge, E.: *The Human Figure in Motion,*
New York, Dover, 1975

O'Neill, Rose Mellor: *Delsarte's Science and
Art of Speech and Gesture,*
London, C. W. Daniel & Co., 1927

Peacham, H., Gent .: *The Art of Drawing with
the Pen More Exactlie then Heretofore Taught,*
1606

Peplow, E., and Peplow, R.: *In a Monastery
Garden,* Newton Abbot, David & Charles, 1989

Raynes, John: *Figure Drawing,* London,
Hamlyn, 1981

Raynes, John: *Human Anatomy for the Artist,*
London, Hamlyn, 1979

Rubins, D. K.: *The Human Figure,* London, Vision
Press, 1953

Sheldon, William: *The Varieties of Human
Physique,* Darren (Ct), Hafner, 1970

Siddons, Henry: *Illustrations of Rhetorical
Gesture and Action,* 1822

# INDEX

Page numbers in *italics* refer to the sites of relevant captions